THE HARLEM RENAISSANCE

CIRCLES OF THE TWENTIETH CENTURY

Also by Steven Watson:

Strange Bedfellows: The First American Avant-Garde

THE HARLEM RENAISSANCE

Hub of African-American Culture, 1920-1930

STEVEN WATSON

PANTHEON BOOKS NEW YORK

Permissions acknowledgments are on page 221.
Illustration credits are on pages 222–24.

Library of Congress Cataloging-in-Publication Data

Watson, Steven.
 The Harlem renaissance : hub of African-American culture, 1920–1930 /
Steven Watson.
 (Circles of the twentieth century)
 p. cm.
 Includes bibliographical references and index.
 ISBN 0-679-42370-2
 1. Afro-American arts—New York (N.Y.) 2. Arts, Modern—20th
century—New York (N.Y.) 3. Harlem Renaissance. I. Title.
NX512.3.N5W38 1995
700'.89'9607307471—dc20 94-30380

Book Design by Cheryl L. Cipriani

Manufactured in the United States of America
First Edition
9 8 7 6 5 4 3 2 1

For David Miller

Who taught me, and many others, the pleasures of rigorous thinking

CONTENTS

FOREWORD "The history of the world is the history not of individuals, but of groups," wrote the eminent African-American intellectual W. E. B. Du Bois.[1] Henry James echoed this sentiment when he wrote that "the best things come, as a general thing, from the talents that are members of a group; every man works better when he has companions working in the same line, and yielding the stimulus of suggestion, comparison, emulation."[2]

As these very different figures suggest, key moments of cultural transition are driven not only by the individual artists and writers who give birth to new ideas but also by a complex nexus of editors, patrons, critics, and hostesses who introduce these ideas to the world. Before modernism had its own institutions, social constellations played the most instrumental role in its growth. Group affiliations were sometimes concretized by manifestos of revolutionary aesthetics, or inclusion in little magazines, or sometimes by less

Complex works of art speak not through individuals but ensembles.
—Paul Rosenfeld

formal connections founded on personal relationships and common enterprises. Whatever form they took, cultural "circles" were essential midwives of modernist culture, providing sources of psychological and financial support, organs for disseminating aesthetic formulations, and the group identity necessary for fomenting revolutionary cultural change.

The convention of parsing history in biographies of single figures, or dispensing theory in the gnomic vocabulary of academe, springs from the conception of the history of art and literature as a tale of individual genius, apart from social context. With the initiation of the series *Circles of the Twentieth Century,* Pantheon embarks on a task that complements the work of biographers, presenting history in-the-round, and offering individual lives within the complex social constellations that shaped them. The series' first three books chronicle movements and moments—the Harlem Renaissance, the Beat Generation, and Berlin in the 1920s. Each depicts the intertwining lives of the avant-gardists at critical cultural junctures, and elucidates the interdisciplinary nature of avant-garde advances.

Circles of the Twentieth Century is directed to both the general reader and the scholar. General readers will find a condensed and readable narrative of the Harlem Renaissance that depends neither on extensive prior knowledge of the subject, nor on the stamina required to navigate a voluminous tome devoted to a single life. Scholars will find not only the useful academic apparatus (footnotes, chronologies) to which they are accustomed, but also less conventional materials, such as diagrams of circles, maps, and glossaries of the period slang that freshly illuminate their periods. The scholar will probably discover little new about his or her subject of expertise, but he or she might discover something new about the milieu in which that subject thrived.

These books are, of course, indebted to the research of well-known scholars, whose work is credited in the notes and bibliography. Without such pioneering researchers on the Harlem Renaissance as Arnold Rampersad, David Levering Lewis, Robert E. Hemenway, Nathan Huggins, Bruce Kellner, and Wayne F. Cooper, for example, this volume would have been impossible.

THE HARLEM RENAISSANCE

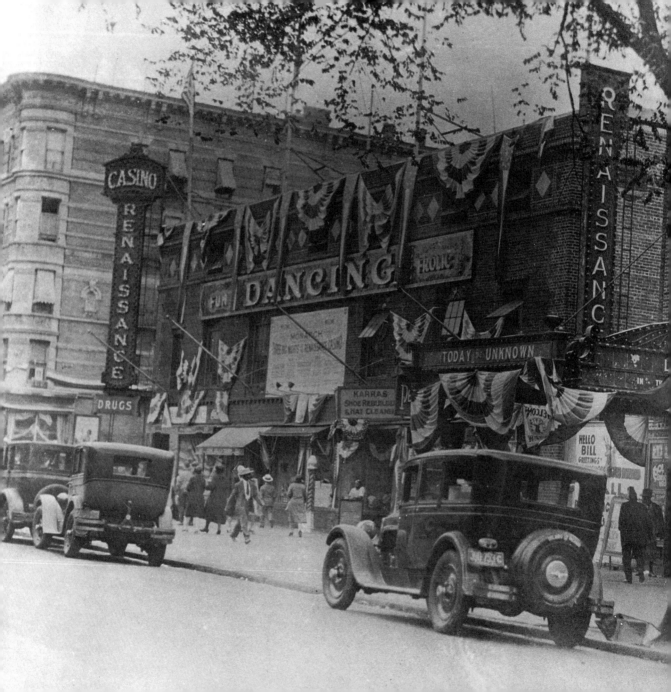

THE NEW NEGRO MOVEMENT IS BORN

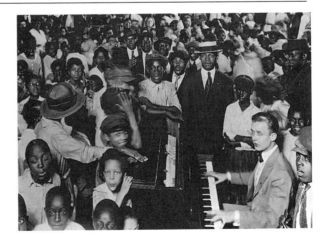

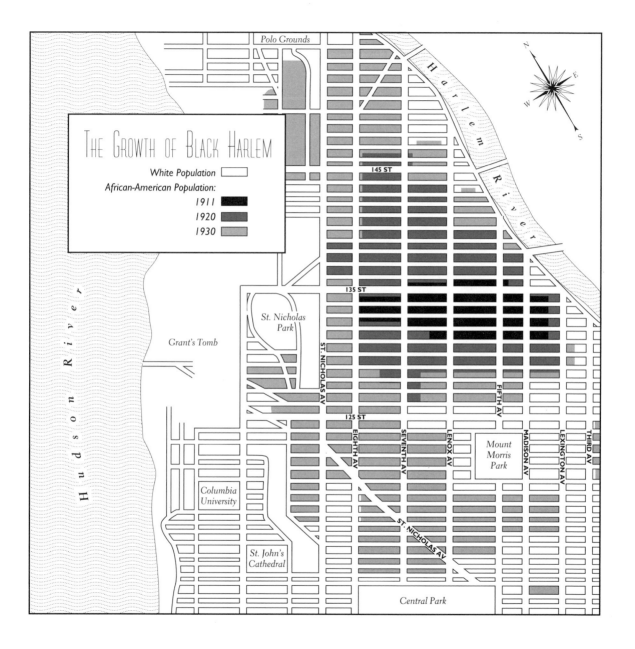

THE GROWTH OF BLACK HARLEM

White Population ▭
African-American Population:
1911 ■
1920 ■
1930 ■

Polo Grounds

Harlem River

N
E
W
S

145 ST

135 ST

St. Nicholas Park

Grant's Tomb

ST. NICHOLAS AV

125 ST

EIGHTH AV

SEVENTH AV

LENOX AV

FIFTH AV

Mount Morris Park

MADISON AV

LEXINGTON AV

THIRD AV

Columbia University

St. John's Cathedral

ST. NICHOLAS AV

Hudson River

Central Park

HARLEM **SNAPSHOTS 1928.** Harlem occupied less than two square miles of northern Manhattan, composed of a rough triangle bounded to the west by St. Nicholas Avenue, running from 114th Street to 156th Street, and to the east by the East River. The poorest and most crowded section of New York, Harlem was nevertheless the most livable of the city's ethnic ghettos. Freer of smoke and grime than the Lower East Side, it featured broad avenues flanked by solid brick and brownstone buildings erected by German and Dutch settlers, and its streets were animated by a parade of brightly dressed residents from the South, the West Indies, and Africa. Harlem offered a kaleidoscope of literary, political, and hedonistic activity unmatched anywhere in the United States. The snapshots that follow were all taken in 1928, at the height of the Harlem Renaissance.

In the fall of that year, in the heart of Harlem's toniest neigh-

Harlem, I grant you, isn't typical—but it is significant, it is prophetic.
—Alain Locke

Overleaf: Renaissance Casino exterior, c. 1928

What a crowd! All classes and colors met face to face, ultra-aristocrats, bourgeoisie, Communists, Park Avenuers galore, bookers, publishers, Broadway celebs, and Harlemites giving each other the once-over. The social revolution was on.

—Geraldyn Dismond,
on the Dark Tower

A seething cauldron of Nubian mirth and hilarity.

—Variety

A Note on Harlemese: *Black slang during the Harlem Renaissance is an extremely inventive oral art form. Zora Neale Hurston attributes black slang's richness to the "will to adorn" language. Not all of these words and expressions originated in Harlem—many had Southern roots—but they became urbanized and more widely disseminated during the 1920s. Harlemese was perceived at the time as an important contribution to the New Negro movement; many figures (Zora Neale Hurston, Wallace Thurman, Rudolph Fisher, Carl Van Vechten, and others) compiled and published glossaries of Harlemese slang. A sampling is included in this book's marginalia.*

borhood, Strivers' Row, silver-turbanned A'Lelia Walker transformed her Stanford White–designed town house into a parlor-cum-nightclub-salon. In deference to the leading lights of the Harlem Renaissance, she had named her extravagant establishment "The Dark Tower" after a newspaper column by black poet Countee Cullen, while a poem by Langston Hughes had been lettered by a local sign painter on an opposing wall. Walker's guest list, as one observer noted, "read like a blue book of the seven arts," mixing young black writers and singers with European royalty and Broadway performers. A'Lelia served the best bootleg liquor and champagne, and her guests could either remain downstairs listening to Jimmie Daniels or Alberta Hunter singing cabaret hits, or they could ascend to the third floor where more intellectual conversation was conducted.

A few blocks north, the two-year-old Savoy Ballroom was teeming, its block-long burnished mahogany dance floor filled with Lindy-hoppers and Shim-Shammers inspired by a pair of battling bands, for example Fletcher Henderson and Jimmie Lunceford vs. King Oliver and Fess Williams. This Uptown answer to the Roseland Ballroom held four thousand people and featured the most uninhibited social dancing in the world. The *gratin* of performers gathered in the northeast corner, known as "Cat's Corner," where their gyroscopic routines brought not only applause but occasional tips from white spectators seated behind a brass rail. "At the Savoy Ballroom," observed the *Amsterdam News*, "social, racial and economic problems fade away to nothingness."[1]

The stylish white crowd from downtown took the "A" train or ordered their Hispano-Suizas north to Jim Crow speakeasies along 133rd Street's Jungle Alley. Here reigned the Cotton Club and Connie's Inn, where chorines performed in Ziegfeldesque extravaganzas and Cab Calloway and Duke Ellington played, while waiters deftly

Charlestoned through the crowd, spinning their trays without missing a beat. The more adventurous downtowners might follow Carl Van Vechten, the Nordic self-appointed arbiter of Harlem chic, to the fringes of Harlem—the "buffet flats" which displayed a variety of sexual tableaux, the extravagant drag balls at the Rockland Palace, and the smoky speakeasies known as "rat cellars in raw cellars." As entertainer Jimmy Durante exclaimed, "You sort of go primitive up there."

Rent Party Advertising Slogans

Papa is mad about the way you do,
So meet the gang and Skoodle um
 Skoo.

If you can't Charleston or do the
 pigeon wing
You sure can shake that thing.

If you can't hold your Man,
Don't cry after he's gone,
Just find another.

You don't get nothing for being an
 angel child,
So you might as well get real busy and
 real wild.

*Dancing couple by Miguel Covarrubias,
c. 1928*

Chant another song of Harlem;
Not about the wrong of Harlem
But the worthy throng of Harlem,
Proud that they belong to Harlem;
They, the over-blamed of Harlem
Need not be ashamed of Harlem;
All is not ill-famed in Harlem,
The devil, too, is tamed in Harlem.
 —Anonymous, "Harlem"

267 was a house that just felt free to be in. . . .
 —Richard Bruce Nugent

Less affluent Harlem residents—the laundresses and cabbies, numbers runners and domestics—paid anywhere from a dime to a half-dollar for the impromptu gatherings called "rent parties." They were staged in their apartments to raise the monthly rent before the furniture was thrown in the street on Monday morning, the regular practice of many landlords. The lights were red and blue, the music was played by three-piece pick-up bands, and songs were belted by amateur torch singers, while boiled pigs' feet and hopping John, ham hocks, and cabbage were served up in the kitchen. As the piano player beat out rhythm with his feet and encouraged guests with his calls, the dancers slow-dragged around the crowded parlor as the floorboards sagged and creaked. The rent party, Wallace Thurman observed, "is as essential to 'low Harlem' as the cultured receptions and soirees held on 'strivers' row' [*sic*] are to 'high' Harlem."[2]

In the hothouse atmosphere of a bohemian boardinghouse at 267 West 136th Street, the alcoholic, suicide-threatening, homosexual writer Wallace Thurman was trying to convince fellow "New Negroes" to contribute to a radical little magazine called *Harlem*. The renovated tenement, dubbed "Niggerati Manor" by habitué Zora Neale Hurston, had become a local legend for its ribald residents, the bright phalluses painted on its walls, the sourmash rumored to fill all its bathtubs, and the gin that flowed from its taps. However exaggerated the local rumors were, they helped create the legend of Harlem as "a Negro Greenwich Village." Everywhere he looked Thurman found people *expressing* themselves—writing novels and plays, painting oils, singing spirituals and blues—and he hoped to funnel their creative energy into a journal that represented the younger generation.

The high-toned social event of the 1928 season was the marriage of Harlem's twenty-five-year-old poet laureate, Countee Cullen,

to Yolande Du Bois, the only daughter of the revered intellectual W. E. B. Du Bois. The ushers were distinguished black writers, the sixteen bridesmaids wore green and white georgette gowns, and the fantastic decor included caged canaries and tall palms. Nearly six thousand people gathered at dusk on April 9, and those who could not squeeze into the cavernous Salem Methodist Church spilled into the streets, vicariously experiencing this crowning event of Harlem aristocracy. Inside, the bride and groom kneeled on a white satin pillow as a soprano sang Teschemacher's "Until" and a white dove cooed overhead.

Six days a week Seventh Avenue was Harlem's Broadway, and for a few hours of the seventh it functioned as Harlem's Fifth Avenue. After church, Harlemites promenaded in their Sunday best. On the stretch between 138th and 125th streets, one recalled, "you would see every important person you ever knew."[3] They paraded their furs and feathers, their form-fitting dresses and bright shawls, checkered suits and gay parasols, their white spats and silk handkerchiefs protruding from a breast pocket—even a freshly washed gingham dress or a black suit looked elegant in the afternoon sun. Many wearing those elegant clothes earned less than a $100 a month in their jobs as waitresses, redcaps, and stevedores, and their sartorial aplomb owed a great deal to installment houses—and to the discounts offered by Harlem's ubiquitous "hot men." These local institutions offered strategies for achieving the public stylishness that was so valued in "lodge mad and procession wild" Harlem. The parade reached its climax on Sundays. As novelist Rudolph Fisher observed, "Indeed, even Fifth Avenue on Easter never quite attains this; practice makes perfect, and Harlem's Seventh Avenue boasts fifty-two Easters a year."[4]

Our camera could be focused on many other subjects in that

My whole deal was getting ready for church on Sunday and strutting down the aisle of Abyssinian Baptist Church, oh, sure.

　　　　—Isabel Washington Powell

Man, we strolled in Harlem. This was our turf.

　　　　—Elton Fax

Harlem High Fashion

White spats, striped pants, and walking stick
French lisle hand-clocked socks
Black custom-built brogues
Velvet-collared overcoats
Monkey fur collars for women
Georgette dresses with lace
Hats with egret feathers
Tan shoes with bulldog toes

Why, it is just like the Arabian Nights.
—Duke Ellington, on Harlem

Harlem heyday: on Jessie Fauset's genteel drawing room where young men and women discussed literature in French; on West Indian mobster Casper Holstein, "the Bolito King," whose thriving numbers operation at the Turf Club financed Harlem's *Opportunity* awards; on Pig-Foot Mary, who plied her culinary wares from morning until evening at the corner of 135th Street and Lenox Avenue, always wearing one of her two starched, checked gingham dresses; on James Van Der Zee's photographic studio at 109 West 135th Street, where Harlemites posed against romantic backdrops—a villa garden, a moonlit lake, a domestic fireplace.

Each of these snapshots contributed to the glittering mosaic of that fantastic decade when Harlem was in vogue.

THE HARLEM RENAISSANCE DEFINED. What we now call "the Harlem Renaissance" flourished from the early 1920s until the onset of the Depression, and it was then known as "the New Negro Renaissance." African-American writing existed before these years, of course, and many authors who first found their voices during the 1920s produced significant work in the years following. But the New Negro's organized, self-conscious phase lasted less than a decade. The use of the avant-garde buzzword, "new," reflects the catholic embrace of the budding movement. In the 1910s, when one spoke of "the New Woman" or "the New Art," it signified a manifestation that blurred the boundaries between aesthetics, politics, and life style; an archetypal "New Poet" of that period embraced not only *vers libre*, but cubism, the Industrial Workers of the World, free love, and bohemian dress. In like fashion, "the New Negro" movement embraced more than literature: it included race-building and image-building, jazz poetics, progressive or socialist politics, racial integration, the

Numbers: *a popular gambling game, the winning numbers of which are derived from the New York Clearing House as follows: the seventh and eighth digits (from the right) of the exchanges and the seventh digit of the balances. In* **Bolito** *one bets on two digits only.*

musical and sexual freedom of Harlem nightlife, and the pursuit of hedonism. ("Renaissance" was used only slightly less than "new" among the avant-garde, a term that expressed a cultural blooming in a young nation.)

The Harlem Renaissance was primarily a literary and intellectual movement composed of a generation of black writers born around the turn of the century. Among its best known figures were Langston Hughes, Zora Neale Hurston, Countee Cullen, Claude McKay, and Jean Toomer. They were not the first noteworthy black writers in America—for novelists Charles Waddell Chesnutt and James Weldon Johnson and dialect poet Paul Laurence Dunbar preceded them—but these younger writers constituted the first self-conscious black literary constellation in American history. The most effective strategy for race-building depended on art and literature, so a dual mission was thrust upon these writers: they were simultaneously charged with creating art and with bolstering the image of their race. Sterling Brown, a lesser-known Renaissance writer, has identified five themes animating the movement: 1) Africa as a source of race pride, 2) black American heroes, 3) racial political propaganda, 4) the black folk tradition, and 5) candid self-revelation. Evoking these themes, the Renaissance authors produced a body of literature which was not only exemplary in itself but also paved the way for succeeding generations of black writers who invoked the Harlem Renaissance as the roots of their cultural tradition. Indispensable to the movement was a supporting cast of editors, patrons, and hostesses—both black and white—who greased the movement's operation and trained a spotlight on its accomplishments.

Adding to the visibility of the literary phenomenon were jazz musicians, producers of all-black revues, and Uptown bootleggers. While African-American literature—especially poetry—drew a small

Other Harlem Renaissance Writers

Sterling Brown
Gwendolyn Bennett
Nella Larsen
Rudolph Fisher
Eric Walrond
Arna Bontemps
George S. Schuyler
Walter White

Harlem . . . Harlem
Black, black Harlem
Souls of Black Folk
Ask Du Bois
Little grey restless feet
Ask Claude McKay
City of Refuge
Ask Rudolph Fisher
Don't damn your body's itch
Ask Countee Cullen
Does the jazz band sob?
Ask Langston Hughes
Nigger Heaven
Ask Carl Van Vechten
Hey! . . . Hey!
". . . Say it, brother
Say it . . ."
 —Frank Horne, "Harlem"

Official words for "Negro": Then, as now, there was controversy about terms for the Negro race. **Negro, black,** and **colored** were common, although a Philadelphia group wanted to outlaw "Negro" as demeaning, suggesting "colored" in its place. The black periodical the Chicago Defender used **race man,** while others used **Afro-Americans, Aframericans,** and occasionally **Lybians** and **Ethiopians.**

readership, a much larger army responded to the call of Harlem's night world. In the heat of that moment the New Negro movement and Harlemania sometimes fused—and the Harlem Renaissance is still recalled in the public imagination as a golden era of jazz, poetry, liquor, sex, and clubs. While writers will dominate the story told here, a diverse and powerful group stands behind them.

The Harlem Renaissance participants did not promote a consistent aesthetic or write in a recognizably "Renaissance" style. Their work ranged from the most conservatively crafted sonnets to modernist verse to jazz aesthetics to documentary folklore. Their agenda was contradictory and dualistic: their mission was both race propaganda and "pure" art; they incorporated the high culture of literature with the low culture of cabaret and the blues; they forged identities as "writers" and as "Negro writers." Defining their selfhood—psychological, racial, and aesthetic—proved pivotal to the key Harlem Renaissance figures, and their task was made especially complex by the fact that most of their identities were twofold.

In 1903 W. E. B. Du Bois had described the African-American duality: "One ever feels his two-ness—an American, a Negro; two souls, two thoughts, two unreconciled stirrings: two warring ideals in one dark body, whose dogged strength alone keeps it from being torn asunder."[5] The key Renaissance figures were torn between being black and white (Toomer), Jamaican and American (McKay), Negro and homosexual (Cullen, Wallace Thurman), propagandist and artist (Hughes, Cullen). How these individuals traversed the complex social-psychological-aesthetic terrain of identity helps shape the story told here. Some of its protagonists lived far from Harlem, and the Renaissance constituted just one pivotal chapter in their lives. But the geographical mecca and the movement provided the spiritual and social foundation on which they built their literary careers.

HISTORICAL BACKGROUND. The Harlem Renaissance was driven not only by its artists and writers, of course, but also by economic and sociological forces of the early twentieth century. It is no coincidence that the Renaissance began in the wake of World War I, thrived during Prohibition, and died with the onset of the Depression. Shaped by urbanization, emigration, and employment trends of the 1910s, Harlem flowered in the 1920s, and saw its descent into slumhood in the 1930s.

The section of Manhattan known as Haarlem was originally settled by the Dutch and during succeeding eras was populated by Germans, Irish, and Jews. The first uptown Negro settlement can be pinpointed to an apartment house at 31 West 133rd Street in 1905. The combination of a national depression, overbuilding in Harlem, and a murder within the apartment house made rooms unrentable; the owner turned to a black realtor named Philip A. Payton, who filled the building with reliable Negro tenants who would willingly pay $5 more than any white renter (a common practice). Street by street, Harlem residents organized to fight the influx of blacks. The *Harlem Home News* in 1911 warned homeowners that "they must wake up and get busy before it is too late to repel black hordes that stand ready to destroy homes and scatter the fortunes of the whites living and doing business in the very heart of Harlem."[6] The president of the Harlem Property Owners Protective Association urged residents to take their stand by building a twenty-four-foot-high fence at 136th Street. Harlem's transition from a bourgeois German-style enclave to the multicultural haven for Southerners, West Indians, and African blacks ensured a cultural clash. "Gone are the comfortable *Weinstuben* where one could smoke his pipe and peacefully drink his glass of Rhine wine," recalled one of the outgoing residents. "Gone is the old *Liederstafel* and the hundred-and-one social organ-

It is the Mecca for all those who seek Opportunity with a capital O.
—Chester T. Crowell, on Harlem

Informal words for "Negro": In most cases these could be used without negative intent when employed by blacks, but were offensive and derogatory when used by whites: **nigger, spade, race man, zigaboo, jigaboo, jig** *(corruption of* **zigaboo***);* **Old Cuffee** *(genuine African word for Negro);* **brother-in-black, Russian** *(a Southern black up north; "rushed up here from Georgia," hence a Russian);* **booger, boogie** *(both contractions of "Booker T.");* **charcoal, suede, dinge, shine, crow, cloud, smoke, ink, dinky, spagingy-spagade** *(from theatrical hog Latin for* **spade***)*

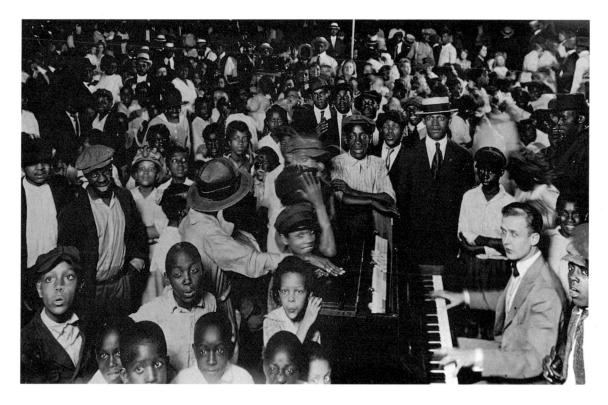

Harlem block party, c. 1910

izations, and the *Turnvereine* and the singing clubs where one could pass the evening peacefully."[7] The earlier residents of Harlem left behind the architectural legacy of sturdy Victorian brownstones, tree-lined boulevards, and the Harlem Opera House.

The "black belt," as it was known, originally ran the urban corridor between Fifth and Seventh avenues in the low 130s. By 1914, black residents lived within a twenty-three-block area, and the numbers continued to grow during the decade, reflecting a migration from the South, where the lynching of blacks, a boll-weevil infesta-

tion, and a depressed job market made the region a decidedly inhospitable place. During this decade, Harlem became colonized not only by black residents but by the organizations of Negro society—the Masons, the Elks, the churches, the National Urban League and black nationalist groups, black newspapers, the YMCA. The black cabaret culture began in the mid-1910s with afternoon tea and cocoa accompanied by ragtime music, and pioneering Barron Wilkins transformed these sober affairs into tango teas, where one could not only watch professionals dance the tango, one could also enter the dance floor or purchase liquor nearby.

Simultaneous with the establishment of Harlem as the black mecca, political organizations proposed their strategies for race-building. Chief among them were Marcus Garvey's African nationalist movement, the Universal Negro Improvement Association, the National Association for the Advancement of Colored People, and the socialist African Blood Brotherhood.

By 1920, Harlem's borders extended from 130th Street to 145th Street, from Madison Avenue to Eighth Avenue. There was the merest beginning of black ownership (about 80 percent of 135th Street between Lenox and Seventh avenues). "The saloons were run by the Irish, the restaurants by the Greeks, the ice and fruit stands by the Italians, the grocery and haberdashery stores by the Jews," wrote Claude McKay. "The only Negro businesses, excepting barber shops, were the churches and the cabarets."[8] Despite the paucity of economic ownership, Harlem had developed both the significant mass of residents necessary to forge an African-American identity and a number of strategies for doing so.

The World War I era ended on February 17, 1919, marking a new epoch in Harlem. On that afternoon, an all-black military band led the victorious soldiers of the 369th Infantry Regiment, known as

Whites: **fay, ofay** (derived from pig Latin for "foe"); **pink, dap, pinktail, Celt, Miss Anne, Miss Annie** (a white woman); **Mister Charlie, Mr. Eddie** (a white man); **Nordics** (used by both whites and blacks); **buckra; fagingy-fagade** (from theatrical hog Latin for **fay**)

I'd rather be a lamppost in Harlem than Governor of Georgia.
 —Folk saying

the Hellfighters, up Fifth Avenue. Under James Reese Europe's leadership the sixty musicians had been applauded throughout the Continent for lively syncopation. Today, saluted by Governor Al Smith and William Randolph Hearst, they were marching home to Harlem in precision formation, wearing their khaki uniforms and dented tin helmets for the last time. Led by drum major Bill "Bojangles" Robinson, the band and soldiers turned west at 110th Street and headed

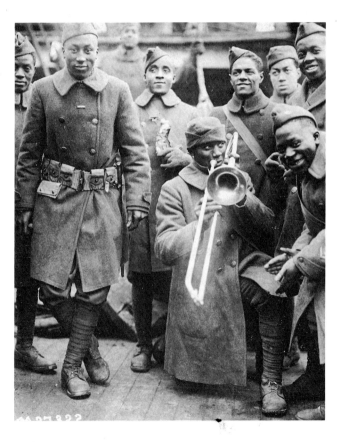

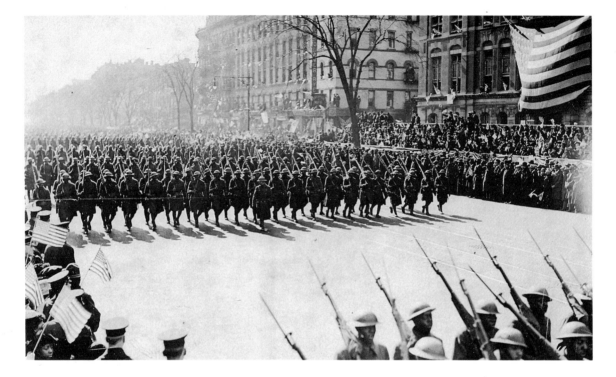

up the home stretch of Lenox Avenue. Crossing 130th Street, their gait palpably loosened and they dropped the martial music to burst into "Here Comes My Daddy." At this point sweethearts and family members invaded the ranks, and the thousands of spectators on low Harlem rooftops tossed pennants and slouch hats into the air. The *New York Age* wrote, "The Hellfighters marched between two howling walls of humanity."[9] Harlem's first pageant of celebration for its black heroes paved the way for the coming celebration of a different kind of Harlem hero—not the soldier on the battlefield, but the cultural nationalist in the parlor.

The 369th Infantry Regiment docks in New York (opposite page) and marches up Fifth Avenue to Harlem, February 17, 1919

The great mission of the Negro to America and the modern world is the development of Art and the appreciation of the Beautiful.
—W. E. B. Du Bois

How can a Negro be conservative? What has he to conserve?
—Marcus Garvey

FOREFATHERS AND MIDWIVES. Most avant-garde movements are fomented by the young against the old, with the forefathers representing an intractable and established enemy. The Harlem Renaissance, however, was actively nurtured by the previous generation of writers. Their support certainly reflected the fact that the existing established artists exerted little power and there was no literary tradition to cherish. Previously, a handful of black literary figures and intellectuals had operated in isolation or linked to an organization concerned with the social advancement of the race. The task of the New Negro movement was to identify and articulate a community consciousness rather than to overthrow existing institutions. The young writers that came of artistic age at the beginning of the 1920s—Cullen, McKay, Toomer, and Hughes—caught the public eye through the publications and organizations that their elders had established.

The preeminent figures in this ancestral constellation were the stern and intellectual patriarch, W. E. B. Du Bois, and the precious but steel-nerved uncle, Alain Locke. Rounding out this "family" were the nurturing matriarch, Jessie Fauset, the supportive uncle, James Weldon Johnson, and the enterprising elder brother, Charles S. Johnson. Their foresighted advocacy of young writers also provided them a means of controlling the direction of African-American literature; the forefathers hoped to judiciously measure out the Negro revolt teaspoon by teaspoon.

African-American Publications

Amsterdam News (1909–)
New York Age (1881–1960)
The Challenge (1916–1919)
The Crisis (1910–)
The Messenger (1917–1928)
Negro World (1918–1933)
Opportunity (1923–1949)

AFRICAN-AMERICAN PERIODICALS. During its initial phase the New Negro movement depended heavily on the periodicals of the black community, on whose pages was conducted a continuing conversation between writers and readers. Each publication represented

an organization—*The Crisis* was the organ of the National Association for the Advancement of Colored People, *Opportunity* expressed the politics of the National Urban League, and the *New York Age* functioned as the mouthpiece for Booker T. Washington. Other papers, such as *The Messenger*, *The Emancipator*, and *The Challenge*, represented the more radical wings of the black movement. These periodicals offered the only outlets for black writers. (When Claude McKay, in 1917, became the first black American to appear in a white avant-garde literary magazine, *Seven Arts*, he used the pseudonym Eli Edwards.) Newspapers and magazines constituted the primary written record of the race, for books were too expensive to reach a broad readership.

Any discussion of the Harlem Renaissance must begin with W. E. B. Du Bois, the towering Negro intellectual of the early twentieth century. Almost a decade before he founded a magazine, *The Crisis*, Du Bois wrote the classic work *The Souls of Black Folk*, a collection of essays that diagnosed the plight of black people in America. "The problem of the twentieth century is the problem of the color-line. . . ."[10] It was in Du Bois's words that many future Renaissance writers first heard their race described with dignity. James Weldon Johnson, for example, declared it the most instrumental book since *Uncle Tom's Cabin*, and poet Langston Hughes recalled, "My earliest memories of written words were those of W. E. B. Du Bois and the Bible. . . ."[11] Claude McKay, who found the book in a Topeka public library, later exclaimed, "The book shook me like an earthquake."[12]

The magazine that paved the way for the Renaissance, *The Crisis: A Record of the Darker Races*, was founded in November 1910. Its sponsor was the National Association for the Advancement of Colored People, but its sharp and magisterial voice was unmistakably

In a sea of fish Du Bois was a whale. . . .
—Richard Bruce Nugent

Dr. Du Bois stands on a pedestal illuminated in my mind.
—Claude McKay

The Talented Tenth

Episcopalian or Presbyterian

Republican

Entertained in their own homes

Aspired to be lawyers, dentists, doctors

Attended Fisk, Howard, or Atlanta universities

Joined Negro Greek-letter fraternities and sororities

Made formal debuts

Wore tweeds and slack suits of modest colors

Aspired to live on Strivers' Row

Du Bois's. In person he presented a Brahmin hauteur, and his handsomely modeled light brown face became, as one friend noted, "a kind of invisible barrier that said, 'so far, but no farther.' "[13] His affect was reserved for the pages of *The Crisis*, where his fiery polemics set the intellectual standards for the rising generation. The magazine's readership was large—circulation peaked at 95,000 in 1919—and largely middle class. His aspirations for the black race combined progressive race politics (African Americans should develop their own institutions, write about their own experience, embrace pan-Africanism) and elitist uplift (Howard University, domestic propriety, Dunbar Apartments). The bloc of socially aspiring Negroes about whom Du Bois wrote was known as the Talented Tenth (and derisively termed "the dicties"). In his theory of trickle-down cultural

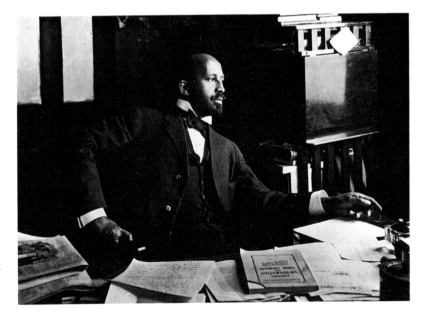

W. E. B. Du Bois, essayist, Crisis editor, and patriarch of the New Negro movement, in the Crisis office, c. 1910

development, Du Bois predicted, "The Talented Tenth rises and pulls all that are worthy of saving up to their vantage ground."[14]

A social scientist and political leader, Du Bois was also Harlem's first culture czar. He espoused the classical formula that he took to be universal among his race—that Art should be earnest, beautiful, and above all didactic. "Thus all Art is propaganda and ever must be, despite the wailing of the purists," he wrote.[15] He accounted Art to be an essential race-building tool, and he predicted that just as black music had won recognition in America, so too would Negro writers. In the spring of 1920, he sounded the inspiring call to arms: "A renaissance of American Negro literature is due; the material about us in the strange, heart-rending race tangle is rich beyond dream and only we can tell the tale and sing the song from the heart."[16]

JESSIE REDMON FAUSET. A year earlier, Du Bois had hired an editor named Jessie Redmon Fauset, for $100 a month, to develop a magazine aimed at instilling pride among Negro children. *Brownies' Book* appeared monthly from January 1920 to December 1921, but Fauset's influence on the Harlem Renaissance continued much longer.

The thirty-seven-year-old French teacher from Washington, D.C.'s Dunbar High School is typically portrayed as a genteel woman born of old Philadelphia black stock, known as "O. P."'s, and raised in material comfort. The truth is more complex. Her family was indeed an old one—the family Bible recorded ancestors in the United States in the 1700s—and her father was a revered minister. But she carried that less-pure strain of aristocracy in which the aspiration for respectability thrives. She was born *near* Philadelphia rather than in the city itself, she was the only black student in Philadelphia public

We want the earth beautiful but we are primarily interested in the earth.
—W. E. B. Du Bois

Talented Tenth: **dicty, dickty** (nouveau riche, swell, high-toned person); **strivers** reside at **Sugar Hill** (the northwest corner of Harlem near Washington Heights, near 409 Edgecombe); **hincty** (supercilious); **Astorpherious** (from the Astors, meaning high-hat); **muckty-mucks, kack** (sarcastic version of dicty); **arnchy** (a person who puts on airs); **lampblack whites** (blacks who aspire to white ways)

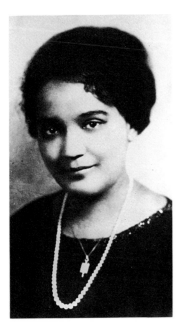

Novelist and Crisis literary editor Jessie Fauset, c. 1929

Blue-vein Circle: an organization of mulattos that excluded blacks, an early version of color discrimination

schools where she was snubbed for her racial identity, and her family appreciated haut-bourgeois values but didn't possess the funds to sustain such a life style. Until she married at the age of forty-seven, Fauset had to support herself. Plucky, bright, and shy, she thrived. After being denied admission to Bryn Mawr because of her race, she entered Cornell, and in 1905 she was the first Negro woman at the school to be elected to Phi Beta Kappa. She became a junior high school teacher and subsequently a high school French teacher in Washington, D.C.'s elite black Dunbar High School. "I have *had* to let people know that we too possess some of the best," she wrote W. E. B. Du Bois, "or else allow my own personality to be submerged."[17]

Du Bois was her chief mentor, beginning in 1903, when she began to write him, following her father's death. From the beginning of their relationship, Fauset regarded Du Bois with a respect that was rarely subservient. Even when she served as his apologist or romanticized his austere intellect—she declared in one poem that he was a "man whose lightest word/Can set my chilly blood afire"—Fauset saw Du Bois clearly.[18] "A man as just, as logical and as often correct as he," she wrote, "is bound to abrade and sting before he heals."[19]

Fauset served as the literary editor of *The Crisis* from 1919 until 1926. During these pivotal years of the Harlem Renaissance, she nurtured its young writers, declaring that "the portrayal of black people calls increasingly for black writers."[20] In her novels, such as *There Is Confusion* and *Plum Bun*, Fauset herself portrayed a single level of Negro society. Some compared her to Edith Wharton, while others regarded her sensibility as narrowly genteel. Whatever the limitations of her range, she presciently recognized the promise of Claude McKay, Jean Toomer, and of two men who were barely older than her high school students, Countee Cullen and Langston Hughes.

JAMES WELDON JOHNSON. James Weldon Johnson proved to be the most versatile elder statesman of the New Negro movement; he was not as brittle as Alain Locke, less polemical than W. E. B. Du Bois, and more broad-minded than Jessie Fauset. His abiding presence and cosmopolitan temperament proved essential to the stability of the unlikely conglomeration of whites and blacks, civil rights and art, the Dunbar Apartments and Niggerati Manor. Entering his fifties when he witnessed the first sparks of the New Negro, Johnson witnessed them from the broad perspective of a life fully and variously lived, and from study that linked the young generation to their nineteenth-century African-American literary heritage.

By 1920, he had already practiced nine careers; the following thumbnail sketch suggests the range of his accomplishment. The eldest son of a freeborn Virginian and Florida's first female black teacher, Johnson graduated from Atlanta University, and moved to Jacksonville, Florida. There, at the age of twenty-four, he founded and directed a large high school for African Americans; he edited America's first daily (and short-lived) newspaper, the *Daily American* (1895–1896); and he became the first Negro to be admitted to the Florida bar. He cowrote (with his younger brother, Rosamond) a Gilbert and Sullivan–derived opera on well-intentioned American imperialism. Beginning at the turn of the century, he moved to New York and wrote (with Rosamond and composer Bob Cole, a trio known as "Those Ebony Offenbachs") over two hundred popular songs; they included "Lift Every Voice and Sing," which was considered the informal "Negro national anthem." From 1906 to 1912 he served as a United States consul in Venezuela and Nicaragua (partly a reward for the campaign song, "You're All Right, Teddy," Johnson wrote for Teddy Roosevelt). He wrote a novel, *The Autobiography of an Ex-Colored Man*, published anonymously in 1912; a key work in

Songs Co-written by James Weldon Johnson, Rosamond Johnson, and Bob Cole

"Under the Bamboo Tree"
"Nobody's Lookin' But de Owl and de Moon"
"Tell Me, Dusky Maiden"
"The Congo Love Song"

the pre–Harlem Renaissance canon, it was the most psychologically shaded rendition of the African American yet written. In 1916, Booker T. Washington recruited Johnson to write editorials for the *New York Age*, but W. E. B. Du Bois soon lured him to the National Association for the Advancement of Colored People (NAACP). In 1920, Johnson became its chief executive officer, continuing in this position throughout the Renaissance, until he left in 1931 to teach at Fisk University.

The connections and abilities Johnson developed during his first fifty years proved extraordinarily instrumental—at the onset of the New Negro movement, he was uniquely suited to bridge its emerging factions. In his cosmopolitan learning, his statesmanlike style, and his remarkable accomplishments, he embodied the Talented Tenth. Descended from distinguished parents, he married into one of the wealthiest families in Harlem—the Nails; Grace Nail Johnson's brother, John E. Nail, had been a partner in Harlem's most successful real estate company during the boom period of the 1900s and the 1910s. Yet Johnson also intimately knew the lives of less-privileged African Americans.

Johnson worked for both the *New York Age*, associated with the conservative Booker T. Washington wing of the Negro movement, and its more progressive rival, the NAACP, where Johnson's editorial opinions were some of the only ones Du Bois respected. Johnson became the mentor of Walter White, a younger NAACP leader and author of *The Fire in the Flint*, one of the first books of the Harlem Renaissance. Through his contact with Republican politics, Columbia University, and diplomatic posts, Johnson traveled easily in white company. He became a link to the fashionable Downtown crowd through such close friends as Carl Van Vechten and Alfred Knopf. Johnson had presciently recognized the common battle

*Positive expressions: **solid!** (perfect); **cut, stroll** (both mean doing something well); **cold** (exceedingly well; "Yeah, man! He was cold strolling on that trumpet!" [Hurston]); **lightly, slightly, and politely** (doing something perfectly); **38 and 2** or **forty** (both mean "fine"); **kopasetee!** (an approbationary epithet somewhat stronger than "all right!" based on "copasetic"); **bardacious!** (marvelous); **the berries** (expression of approbation); **hot!** (wonderful)*

against discrimination fought by Jews and African Americans, and he had developed alliances with such prominent Jewish philanthropists as Julius Rosenwald and Joel Spingarn. At the same time, he contended that the white race "has never contributed one single element of what goes into modern civilization."[21] His belief that the energy of modern life depended on the more vital roots of African Americans was inspired by his earlier immersion in folk tales, ragtime, and spirituals, and he began "to speculate on the superstructure of conscious art that might be reared on them."[22]

By preserving his own study of black literature and music in two anthologies, he gave the new generation access to their cultural history in America. In 1922, the publication of his anthology *The Book of American Negro Poetry* proved an important event, and three years later his anthology *The Book of American Negro Spirituals* became a best seller. Johnson had described the historical literary foundation on which the New Negroes would build, and in his introduction to his poetry anthology, he articulated the tenet that guided them in the next half-dozen years: "The world does not know that a people is great until that people produces great literature and art. . . . And nothing will do more to change the mental attitude and raise his status than a demonstration of intellectual parity by the Negro through the production of literature and art."[23]

ALAIN LOCKE. No one presented a more ostentatious example of the Talented Tenth than Alain LeRoy Locke. His wispy figure could be seen briskly strolling through Harlem in perfectly tailored suits, with a tightly wound umbrella as his stick (and in later years as a form of protection), delivering erudite pronouncements in high-pitched rapid-fire sentences. Locke's ancestors from the pre–Civil

Pan-cake, handkerchief head, Uncle Tom: a humble, sycophantic black person

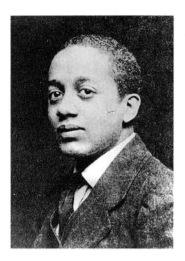

Alain Locke, teacher, essayist, and impresario of the New Negro movement, c. 1910

War era had been well-educated, and he had been drilled in the virtues of temperance, of Episcopalianism, and of avoiding the sun (Locke's grandmother religiously wore a sunbonnet and gloves when hanging the laundry). The seminal influence was his mother, who taught at Philadelphia's Institute for Colored Youth and inspired in her only child an appreciation of breeding and a passion for literature. (He lived with her until she died in 1922, and at her wake, Locke had her embalmed figure seated in his parlor.) The adolescent Locke was a voracious reader who set about molding himself into a gentleman of impeccable manners. Education was key to raising himself up, and Locke pursued it with a vengeance. He attended Harvard, where he graduated magna cum laude and Phi Beta Kappa in 1907, and at the beginning of the twentieth century he was named the first black Rhodes scholar (nearly sixty years would pass before another was named). During his years at Oxford he polished his identity as a homosexual, a dandy, and an intellectual, and developed the creed by which he would live his adult life: "Culture begins where compulsion leaves off."[24]

When he returned to America in 1912, Locke moved to Washington, D.C.'s Howard University, the nation's leading Negro college. Here he guided a younger generation in its pursuit of culture. He insisted that his students understand Greek and German language and literature, but he also encouraged self-expression and the study of black culture. In 1916, for example, he founded a student literary magazine, *The Stylus,* where Zora Neale Hurston published her first story, and Locke strongly (and unsuccessfully) advocated the study of black history long before the New Negro movement appeared.

My tragedy is that I cannot follow my instincts—too sophisticated to obey them, not too sophisticated not to hear them. . . .
—Alain Locke to Langston Hughes

Locke was the chief intellectual rival of W. E. B. Du Bois. His erudition could be overbearing and his scrupulous manners were frequently described as prissy, but even Locke's detractors conceded

that he was one of the brightest figures they had ever come across. He focused his prodigious energy on the brightest students, especially if they were attractive and male. (Some found his attentions aggressive; in contrast, he warned female students on the first day of class that they were likely to receive Cs.) From his perspective at America's most distinguished black university, he sensed the gathering momentum of talented young black writers. He wrote one of them in the early 1920s, "We have enough talent now to begin to have a movement—and to express a school of thought."[25] With this aspiration, Locke defined his role in the Harlem Renaissance as "a philosophical mid-wife to a generation of younger Negro poets, writers, and artists."[26] Seen as an artist manqué and a writer of real if not profound ability, Locke's chief contribution to the Harlem Renaissance was catalyzing others and crystallizing their ideas about the New Negro. Interweaving many skeins—African and European, classical and contemporary—Locke became the young movement's most articulate voice, its precious oracle, and the official mentor to its new recruits. As Charles S. Johnson would observe in 1924, "I regard you as a sort of 'Dean' of this younger group."[27]

This one who lives by quotations trying to criticize people who live by life.
—Zora Neale Hurston, on Alain Locke

I do like being in at the feast and watching the succession of the spirit. You and Cullen represent part of that.
—Alain Locke to Langston Hughes

OPPORTUNITY. If *The Crisis* planted the seeds for the New Negro movement, *Opportunity: A Journal of Negro Life* represented its flowering. *The Crisis* was dominated by black politics, while *Opportunity* focused on black culture. Although its peak circulation (11,000) never approached that of the older journal, its effect on the New Negro movement was as great. Founded in January 1923 by the National Urban League, the monthly magazine was edited by Dr. Charles S. Johnson. The thirty-year-old son of a minister, raised in middle-class surroundings and educated at the University of Chicago,

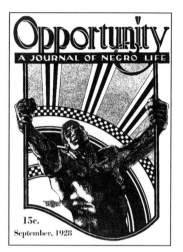

A cover from Opportunity, *September 1928*

Johnson is often cited as one of the most encouraging and inspiring midwives of the Harlem Renaissance. "With Charles S.," explained one writer, "you were something more like what you hoped you were than what you knew you were."[28]

From his sociologist's perspective, Johnson saw the entrenched barriers up against employing Negroes as skilled workers, as military officers, as union members. Johnson concluded that the only crack in the nation's racist armor was art and literature, and he set out to become its impresario. He was vigilantly attentive to the new generation of black writers, alert to the black characters beginning to appear in white novels, aware that Greenwich Village intellectuals had begun to romanticize Negroes as the potential salvation of commerce-ridden, soulless America. "His subtle sort of scheming mind had arrived at the feeling that literature was the soft spot of the arts," observed writer Arna Bontemps, ". . . and he set out to exploit it."[29] Johnson mobilized such fellow spirits as Alain Locke, writer Eric Walrond, and bank messenger–bibliophile Arthur Schomburg. He kept dossiers on all African-American writers whose names appeared in print, he organized regular informal meetings to discuss "books and things," he invited promising writers to New York, and he gave them key phone numbers and addresses to get started. (Harlem's most important address for newcomers was 580 St. Nicholas Avenue, a flat shared by Ethel Ray Nance, Johnson's secretary, and Regina Andrews, a librarian at the 135th Street branch; here were a couch, free meals, and the company that provided writers their first introductions.)

Most important to the New Negro movement, Johnson instrumentally fashioned *Opportunity* to the dictates of his sociological view, and he opened it to the diverse literary voices of beginning writers. Johnson knew that, without the imprimatur and patronage

of the white publishing establishment, Harlem's fledgling movement would remain an unrealized and strictly local phenomenon. These grim realities inspired in his keen mind a plan: he would stage a dinner that would formally introduce the New Negro to the white publishing world and position *Opportunity* at center stage. As Johnson observed, "Literature has always been a great liaison between races."[30] Looking back at the end of his life, he recalled, "What was necessary was a revolution and a revelation. . . ."[31]

SNAPSHOT: THE COMING-OUT DINNER. On March 21, 1924, the two great literary tribes—Uptown and Downtown—assembled at the Civic Club, whose policy of admitting to its dining room both whites and African Americans offered the only feasible gathering place for such a high-toned yet progressive evening. Charles S. Johnson had prepared a guest list that included the cream of publishers, magazine editors, and distinguished white writers along with a full roster of the most promising young black writers. In a politic bow to *The Crisis*, he gave Du Bois a prominent place on the program and ostensibly staged the dinner to celebrate Boni and Liveright's publication of Jessie Fauset's first novel, *There Is Confusion*. But Du Bois was subtly undermined by being described as a member of the passing generation, and Fauset was all but ignored, her place on the program usurped by Alain Locke. (It was from this point that Fauset began a long, silent feud with Locke, her fellow "O. P.") Johnson introduced Locke as the evening's master of ceremonies, calling him the "virtual dean of the movement." Before his distinguished audience Locke celebrated the promise of a younger generation to depict Negro life, "a spiritual wealth which if they can properly expound will be ample for a new judgment and re-appraisal of the race."[32]

Subtly the conditions that are molding a New Negro are molding a new American attitude.

—Alain Locke

*Clothes: **butt sprung** (stretched in the rear, of a suit or skirt); **young suit** (ill-fitting, too small; "You are supposed to be breaking in your little brother's suit for him." [Hurston]); **zoot suit with the reet pleat** (began early 1930s, more popular in 1940s: Harlem-style suit, padded shoulders, trousers 43 inches at the knee with cuff so small it needs a zipper to get into, high waistline, fancy lapels, bushels of buttons, etc. [Hurston]); **drapes, shags, righteous rags** (all in the style of the zoot suit); **draped down, togged down** (dressed in Harlem high style); **monkey back** (fancy dresser, from "monkey suit")*

What American literature decidedly needs at this moment is color, music, gusto, the free expression of gay or desperate moods. If the Negroes are not in a position to contribute these items, I do not know what Americans are.
—Carl Van Doren at Civic Club dinner

The Civic Club dinner provided the sort of pageant, played out before a mixed audience of cultural notables, that was necessary to the growth of the young movement. "A big plug was bitten off," observed Charles Johnson. "Now it's a question of living up to the reputation. . . ."[33] There were many outgrowths of the dinner: *Harper's* offered to publish poems by Countee Cullen, a Writers' Guild formed, and the *Survey Graphic* (a respected magazine that had heretofore ignored the Negro) decided to devote a full issue to "express the progressive spirit of contemporary Negro life."

Alain Locke was invited to compile the special issue; he was ideally equipped for the task by dint of his wide-ranging knowledge, his broad acquaintanceship, and the high-handed self-assurance requisite for a culture broker. The issue's contents drew upon poets, illustrators, and essayists, but it was firmly governed by Locke's cultural agenda. He wanted to wed the roots of the African-American folk spirit to the literary voices of the modern age, and to consolidate the position of Harlem as the world's race capital. The sixty-six-page special issue did not present the black race as a "problem," and their means of advancement were envisioned as cultural rather than economic or political. Harlem's urban life offered a model to supplant the agrarian myth of the black in antebellum South—embodying an alternative to Uncle Toms, Sambos, and Mammies. Locke hoped to promulgate a New Negro respectability that was richer than the "O. P." sensibility that he objected to in Jessie Fauset.

The *Survey Graphic* appeared in March 1925, sold out two printings, and became the most widely read issue in the magazine's history with an estimated readership of 42,000. Sales were boosted by a few white supporters of the New Negro movement—Albert Barnes, Joel and Amy Spingarn—who each purchased a thousand copies and freely distributed them to potential recruits to the move-

I'll be a cage of apes to you: *don't push your luck*

ment. Eight months later Albert and Charles Boni published an expanded version of the magazine between hard covers. *The New Negro* was widely acknowledged as the fledgling movement's first manifesto—even Du Bois called it the best Negro book in the past ten years. But he warily regarded Locke's emphasis on the central importance of culture in race advancement: "If Mr. Locke's thesis is insisted on too much it is going to turn the Negro renaissance into decadence."[34] Locke's volume identified the African roots of black art and music, but he emphasized the young generation of writers whose spirit would drive the Harlem Renaissance. "They are the first fruits of the Negro Renaissance," Locke wrote. "Youth speaks, and the voice of the New Negro is heard."[35]

In addition to offering a compendium of African-American essays, poetry, and fiction, *The New Negro* featured a selection of portrait drawings by Winold Reiss. This group portrait of the New Negro pantheon (pages 30–31) tellingly demonstrates how well-organized the movement was at the moment of issuing its first formal manifesto. With the exception of Zora Neale Hurston, the rising generation of canonical African-American writers all appear, and so do the movement's most influential forefathers. The key figures were all in place.

> The younger generation comes, bringing its gifts. They are the first fruits of the Negro Renaissance. Youth speaks, and the voice of the New Negro is heard. . . . Here we have Negro youth, with arresting visions and vibrating prophecies; forecasting in the mirror of art what we must see and recognize in the streets of reality tomorrow, foretelling in new notes and accents the maturing speech of full racial utterance.
>
> —Alain Locke

New York: **the big apple, the big red apple** (always used with the definite article)

THE NEW NEGRO PANTHEON AS SEEN
BY WINOLD REISS, 1925

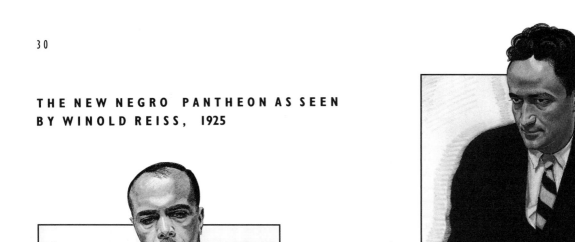

Jean Toomer

James Weldon Johnson

Alain Locke

Langston Hughes

Countee Cullen

Charles Spurgeon Johnson

W. E. B. Du Bois

CLAUDE MCKAY. The first celebrity of the Harlem Renaissance, dark-skinned Claude McKay habitually flashed a smile that broke into rollicking laughter, while his high, arched brows lent him a perpetual expression of ironic amusement. He was perhaps the purest example of the dual identity so common among the New Negroes: Jamaican and American, homosexual and heterosexual, Harlemite and Greenwich Villager, revolutionary and decadent, servant and celebrity.

McKay's formative years were spent in the luxuriant green hills of central Jamaica, and his work would always echo both the British colony's musical dialect and the sharp anger of its subject race. Born September 15, 1890, the youngest of eleven children, Claude McKay grew up in a stable farm family. Since they were literate, land-owning Presbyterians, the McKays aligned themselves with the local social elite usually restricted to those with lighter skins. Claude was a much-indulged child whose literary vocation first became apparent when, at the age of ten, he wrote a rhymed acrostic for an elementary-school gala. He soon wrote verses that mixed local West Indian folk songs with the strict meter and rhyme of church hymns; he loved the Jamaican dialect but regarded the Motherland English as the only legitimate literary tongue.

When he was seventeen he met a homosexual expatriate English gentleman named Walter Jekyll, who not only encouraged his writing but insisted that he use his native patois. (Jekyll collected and published Jamaican field-and-yard songs and folk tales.) Jekyll introduced his young protégé to the world of literature, ranging from the poetry of Browning and Baudelaire to the liberated sexual philosophy of Oscar Wilde and Edward Carpentar. When McKay once expressed his amazement at Jekyll's mentorly interest in him, Jekyll laughingly replied, "Oh, English gentlemen have always liked their peasants; it's

West Indian: **ringtail, monk, monkey-hip eater** *(from the legend that the favorite meal in Barbados is monkey hips and dumplings);* **monkey chaser; mon** *(derived from West Indian pronunciation of "man")*

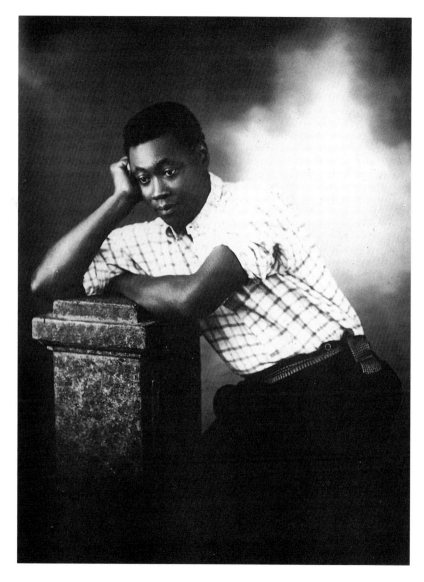

*Oh, Jamaica was a happy place for me
then. I thought I was walking always
with flowers under my feet.*
 —Claude McKay

*Poet and novelist Claude McKay,
c. 1915*

the ambitious middle class that we cannot tolerate."[36] At Jekyll's urging McKay wrote two volumes of dialect poetry, *Songs of Jamaica*, and *Constab Ballads*. Unknown to the twenty-two-year-old poet, these collections would signal his farewell to what came to seem in memory a lush pastoral idyll; McKay would never again set foot on his native island.

Financed by Jekyll, McKay emigrated to the United States in 1912 to study agronomy at Booker T. Washington's Tuskegee Institute. But within two months he had quit, bound for further agricultural study on the plains of Kansas. This marked the beginning of a peripatetic life that McKay lived on three continents. A quick summary of his early years in America includes a marriage that ended six months later and a child whom McKay would never meet. He ran an unsuccessful restaurant in the tough Myrtle Avenue section of Brooklyn, and he worked as a porter, a fireman, a dining-car waiter for the Pennsylvania Railroad, and a bar-boy. "I waded through the muck and scum with one objective dominating my mind," McKay recalled.[37] He wanted to be poet.

Through his travels McKay became bitterly familiar with America's Jim Crow laws and also with the sharper discrimination meted out to dark-skinned foreigners. McKay emigrated to New York in 1914 and settled in a rooming house on 131st Street, the center of New York's fledgling black belt during its years of booming development. "Harlem was my first positive reaction to American life," he recalled. ". . . It was like entering a paradise of my own people."[38] Harlem's cozy cellar cabarets and raucous street life provided the crucible in which he could overcome his inhibitions—he experimented with cocaine and opium (known as "Chinese tobacco") and with the brief, passionate homosexual and heterosexual affairs that would continue throughout his life.

Poor, painful black face, intruding into the holy places of the whites. How like a specter you haunt the pale devils! . . . The prison is vast, there is plenty of space and little time to sing and dance and laugh and love. There is little time to dream of the jungle.
—Claude McKay

There is a searing hate within my soul,
A hate that only kin can feel for kin,
A hate that makes me vigorous and whole,
And spurs me on increasingly to win.
—Claude McKay, "Mulatto"

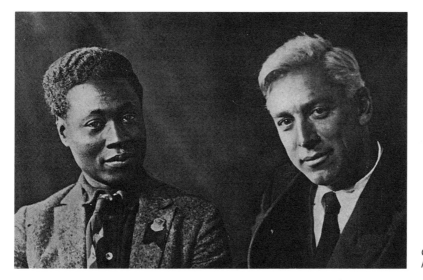

Claude McKay and Liberator editor
Max Eastman, 1923

The former British colonial began to develop a radical black consciousness and a literary voice that reflected his alienation from the United States. In October 1917, he debuted (under the pseudonym of Eli Edwards) in the white literary world of *Seven Arts,* a short-lived but seminal avant-garde magazine, and two years later Frank Harris allotted him a large spread in *Pearson's* magazine. McKay's generous embrace by Greenwich Village circles helped sustain his faith in himself as a man of letters, and it encouraged him to shape his estrangement from America into socialist politics. With thirty-six-year-old Max Eastman—editor of the radical *Masses* from 1913 to 1917, currently editor of its successor, *The Liberator*—McKay developed a bond that would continue throughout his life. In McKay's eyes the laconic, handsome, aristocratic Eastman appeared to be a political model and a sympathetic critic of his poetry. "I was glad to see how you live—so unaffectedly free—not striving to be like the

Pimps and men who commercialize their sex appeal: **jelly bean, P.I., mack, sweetback, sheik** (also any black man who dresses like a pimp); **creeper, Eastman** (a man who lives on women)

masses like some radicals, but just yourself," McKay wrote Eastman. "I *love* your life—more than your poetry, more than your personality."[39] As patron, mentor, and friend, Eastman became the enduring Village successor to Walter Jekyll.

Interracial friendships were accepted in the Village (except when it came to sex) but when McKay strayed from this bohemian oasis to work on the railroads, he grew frightened of the colorphobic hysteria that seethed just beneath the surface of American life. During the summer of 1919 newspapers described in gruesome detail the lynchings of African Americans that swept the land in the wake of World War I. McKay responded by writing his first overtly political poems; seven of them were published in *The Liberator* in July 1919. The most striking of these was a sonnet entitled "If We Must Die," an exhortation to black Americans unlike anything that had been written. It crystallized a poetic voice that combined militant politics with Victorian poetic form. One publisher later considered it too incendiary to include in a collection of McKay's poems, and Alain Locke regarded it as too radical to put into *The New Negro*. But through oral rendition and repeated publication it reached the Negro people unlike anything else he would ever write. "Indeed," McKay wrote in his autobiography years later, "that one grand outburst is their sole standard of appraising my poetry."[40]

In 1921, Max Eastman invited him to assume Floyd Dell's position as the paid associate editor of *The Liberator*. Suddenly McKay was not only contributing to a white magazine, but determining the fate of white writers. Eastman considered him "his best friend on the *Liberator*,"[41] and his other colleagues supported McKay's judgments and enjoyed his mixture of raucous laughter and newly acquired urbanity. He was on occasion rebuffed for making homosexual advances, but in this setting his color was embraced. When he ad-

IF WE MUST DIE

If we must die, let it not be like hogs
Hunted and penned in an inglorious spot,
While round us bark the mad and hungry dogs,
Making their mock at our accursed lot.
If we must die, O let us nobly die,
So that our precious blood may not be shed
In vain; then even the monsters we defy
Shall be constrained to honor us though dead!
O kinsmen! we must meet the common foe!
Though far outnumbered let us show us brave,
And for their thousand blows deal one deathblow!
What though before us lies the open grave?
Like men we'll face the murderous, cowardly pack,
Pressed to the wall, dying, but fighting back!

—Claude McKay, 1919

vocated more attention in the magazine to African-American issues, however, his suggestions were less warmly received. McKay reasoned that since Negroes constituted 10 percent of the population, they should receive proportional space in *The Liberator*; Eastman responded that "our white readers would dismiss the *magazine*, not the material."[42] Although McKay encouraged African-American writers —not only poets but also leaders of the NAACP—he was perpetually ill at ease in black American society, literary and political. He faulted the latter's rejection of radical socialism and the former's mandate

Harlem! . . . Its brutality, gang rowdyism, promiscuous thickness. Its hot desires. But, oh, the rich blood-red color of it! The warm accent of its composite voice, the fruitiness of its laughter, the trailing rhythm of its "blues" and the improvised surprises of its jazz.
—Claude McKay

for uplifting representations of black life, and he resented the light skins of the NAACP leadership. He developed a warm relationship with James Weldon Johnson, but concluded that "Jessie Fauset is as prim and dainty as a primrose," and experienced in W. E. B. Du Bois a "cold, acid hauteur of spirit, which is not lessened even when he vouchsafes a smile."[43] McKay sympathized with Harlem's Communist-affiliated African Blood Brotherhood, but he maintained his strongest ties with the American Left rather than with specifically black organizations. "And now that I was legging limpingly along with the intellectual gang," he recalled, "Harlem for me did not hold quite the same thrill and glamor as before."[44]

In the spring of 1922, Harcourt, Brace and Company published his collection of seventy poems, *Harlem Shadows*. The volume included nostalgic memories of Jamaica, love poems, but it was his charged racial poems that garnered the most attention. "They strike hard and pierce deep," wrote one reviewer. "It is not merely poetic emotion they express, but something fierce and constant, and icy cold, and fiery hot."[45] McKay instantly acquired the status of being the first significant black poet since Paul Laurence Dunbar; his book would soon be singled out as the first major contribution to the Harlem Renaissance.

Although he was hailed as an African-American icon and an acclaimed poet, McKay retained his abiding sense of being an "alien guest," cherishing each wound inflicted by Jim Crow. As Harlem Renaissance historian David Levering Lewis observed, "Claude McKay was the purest of that special breed that strives for success only to find it intolerable."[46] By the time *Harlem Shadows* appeared, Max Eastman had left *The Liberator*, and McKay felt at odds with his remaining colleagues, whose socialism seemed narrowly doctrinaire. Within a few months he resigned. McKay had published forty-two

poems in the magazine and eleven essays and reviews, and his tenure on *The Liberator* had been essential to his political and literary development. But now he wanted to move on: "Escape from the pit of sex and poverty, from domestic death, from the cul-de-sac of self-pity, from the hot syncopated fascination of Harlem, from the suffocating ghetto of color consciousness."[47] His feelings of alienation found a vehicle in militant politics, and McKay planned a trip to the Soviet Union to attend the Third Communist International.

James Weldon Johnson eased McKay's departure by soliciting $5 donations from leaders of the NAACP and the Village crowd. In September 1922, Johnson threw a farewell party, which he recalled as "the first getting together of the black and white literati on a purely social plane."[48] On the eve of his departure, McKay drank his way through his favorite Harlem speakeasies, and the next day America's black celebrity shipped out on a slow freighter, working his way across the Atlantic as a stoker. Twelve years would pass before he returned.

Go, better than stand still, keep going.
—Claude McKay,
on leaving America, 1922

In Russia, McKay found himself in an all-too-familiar position—a revolutionary discredited by his own party, sleeping in a dilapidated room furnished with broken windows and an army cot. The American Communist party refused to admit him as a delegate and campaigned for his expulsion from the Soviet Union. But McKay persisted, and he was admitted to the International as a special delegate largely through the vocal support of the Russian masses. On the streets of Moscow McKay had more cachet than in official chambers: he was regarded as an exotic symbol and an omen of good luck. On Moscow's teeming post-Revolution streets he was once bodily lifted and passed from civilians to sailors to soldiers, each group tossing him higher and higher, for a full block. "Never in my life did I feel prouder of being an African, a black, and make no mistake about it," McKay recalled. "I was like a black ikon."[49]

In America it is much less dangerous to be a Communist than to be a Negro.
—Claude McKay

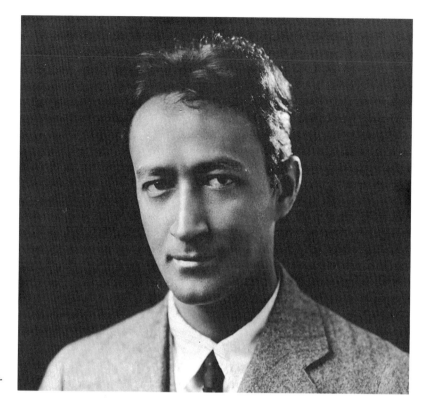

Advertising photograph for Cane *of novelist and poet Jean Toomer, 1923*

JEAN TOOMER. At the *Liberator* office, beginning in December 1921 and continuing into the spring, Claude McKay received stories by Jean Toomer. Throughout this time he assumed Toomer was a woman of modest talent, and he suggested that should Miss Toomer send "a very short sketch that could hold the readers' attention all the way through, we might be able to use it."[50] McKay was not the only one to receive manuscripts from the unknown writer that winter, for Toomer had sent manuscripts to Jessie Fauset at *The Crisis*,

and to the editors of the burgeoning avant-garde little magazines he submitted poems, stories, sketches, a play. Had all Toomer's pieces been read in concert, instead of parceled out to separate quarters, the author's ambitious design would have been clearer. It was only when Boni and Liveright published Toomer's brilliant shards all together as *Cane* that his mosaic portrait of the black American South could be seen. Twenty-nine-year-old "Miss" Jean Toomer suddenly looked like one of the brightest lights in modernist American literature; as his companion and mentor Waldo Frank wrote him, Toomer was "creating a new phase of American literature (O there's no doubt of that, my friend)."[51]

Jean was like a god.
—Richard Bruce Nugent

The author's photo showed a lean handsome man with chiseled patrician features, dark, liquid eyes, and lank black hair that defied racial categorization; he was variously described as Indian, olive, Japanese, lemon-colored, and Mediterranean. "In my body were many bloods, some dark blood, all blended in the fire of six or more generations," Toomer wrote. "I was, then, either a new type of man or the very oldest. In any case I was inescapably myself."[52]

Nathan Eugene Toomer was born December 26, 1894. His maternal grandfather had been a Republican Louisiana senator, his paternal grandmother a slave, and his father (whom Toomer met only once, for a few hours) a mulatto who "passed." Toomer grew up on Washington, D.C.'s wealthy, white Bacon Street, in a majestic Richardsonian house, its grounds kept by a former slave, its residents practicing luxuriously anachronistic manners. Toomer described his family as "an aristocracy—such as never existed before and perhaps never will exist again in America—midway between the white and negro worlds."[53] His upbringing was both unsettled and downwardly mobile, moving from Bacon Street to working-class neighborhoods in Brooklyn and New Rochelle, and eventually to an African-American

neighborhood near Howard University. "For the first time," Toomer wrote, "I live in a colored world."[54]

Outside of Harlem, Washington boasted the richest intellectual black milieu in the nation: Howard University and its imperious arbiter Alain Locke, the literary salon of poet Georgia Douglas Johnson, and the elite Paul Dunbar High School that employed teachers such as Jessie Fauset and poet Angelina Grimké, and produced such New Negroes as Toomer and Richard Bruce Nugent. But Toomer felt neither pride nor pleasure; he considered himself a deviant figure and wanted to spend a year at a prep school to conceal his attendance at "a colored school." His overweening alienation increased after graduation, and he began his lifelong search for his essential self. During his childhood years of moving about between neighborhoods and between races, Toomer had identified himself with three personal symbols—an arrow, an eagle, a heart—that sustained him. During the seven years after high school only a deeply held belief in his personal destiny could shore him up. His life was as peripatetic and random as Claude McKay's had been—seven years wandering in the wilderness while working as a bodybuilder, a welder, a student of agriculture, a Ford salesman, a physical-education teacher, a hobo. He had been everything but a writer. In the spring of 1919 Toomer collapsed of nervous exhaustion; he had hit bottom, and gradually nursed himself back to health through dieting and fasting.

The next summer he attended a Greenwich Village party in the home of *Broom* editor Lola Ridge, and in this crowd Toomer felt he had found an "aristocracy of culture, of spirit and character, of ideas, of true nobility."[55] Surrounding him were poets Edward Arlington Robinson and Witter Bynner and *Dial* editor Scofield Thayer, and an animated dark-eyed man with whom Toomer felt an instinc-

I am not like them. I see and feel more in life than they will if they live to be a thousand years old.

—Jean Toomer

I was a bit of chaos dressed in formal attire.

—Jean Toomer

tive and wordless connection. A week later Toomer happened upon this man again, in Central Park, and concluded that their meeting was destined.

The stranger was Waldo Frank, a now-forgotten novelist who was then a ringleader of Greenwich Village writers that included Hart Crane, Malcolm Cowley, and Gorham Munson. They were intent upon forging a new American Dream unsullied by soulless commercialism, and their collective vision was embodied in *Our America* (1919). Frank and his wife, Margaret Naumberg, had become emblematic figures of the modern generation—Naumberg had founded the radical Walden School and established a place for Freudian psychology in elementary education, while Frank had been a conscientious objector in World War I and had helped edit the seminal little magazine *Seven Arts*. Toomer cherished his first conversation with Frank as a beacon and regarded their destinies as entwined. Toomer settled upon a new identity—he would be a writer. He returned to Washington to care for his grandfather, and on a $5-a-week allowance he sat down at the family's large oak table and began turning out manuscript after manuscript in every conceivable form—poems, essays, plays, reviews. "The phrase 'trunk-full' is often used loosely," Toomer recalled. "I mean it literally and exactly."[56] All that the burgeoning piles lacked was focus.

Jean Toomer, bodybuilder, Ford salesman, hobo, c. 1920

You have definitely linked me to the purpose and vision of what is best in creative America.
 —Jean Toomer to Waldo Frank

SOUTHERN IDYLLS. In March 1921, Toomer received an invitation that led him out of his cul-de-sac. The Sparta Agricultural and Industrial Institute, modeled on Booker T. Washington's Tuskegee Institute, asked him to serve as substitute principal for the fall semester. When he stepped off the train in Hancock County, Georgia—eighty miles southeast of Atlanta—he found a sleepy town

Here were cabins. Here Negroes and their singing. I had never heard the spirituals and work songs. They were like a part of me. At times, I identified with my whole sense so intensely that I lost my own identity.
 —Jean Toomer

A house in Sparta, Georgia, photographed by Jean Toomer, c.1921

My seed was planted in myself down there. Roots have grown and strengthened.
 —Jean Toomer to Sherwood Anderson

The South: **Bam, down in Bam** *(the South);* **peckerwood, redneck** *(both mean a poor or unloved white Southerner)*

wreathed in smoke from the local sawmill, mist gathering at night over the pine-forested low hills. He lived outside the center of town, near the whitewashed houses and shanties of backwoods Negroes, and through his open windows he heard their spirituals, work songs, and "shouts." "There, for the first time I really saw the Negro, not as pseudo-urbanized and vulgarized, a semi-Americanized product, but the Negro peasant, strong with the tang of fields and soil," he wrote Waldo Frank. "Love? Man they gave birth to a whole new life."[57]

Toomer lived in Sparta for only two months, but during this brief sojourn he absorbed the black folk spirit that inspired his writing. He listened intently to the sounds of the trees and blues from neighboring shanties, and he visited the churches. ("The theology is a farce," he reported, "their religious emotion, elemental and for that reason, very near sublime."[58]) Through his experience Toomer arrived at a momentary resolution of the tangled skeins that made up his racial identity. "When I live with the blacks, I'm a Negro," he concluded. "When I live with the whites, I'm white, or better, a foreigner. I used to puzzle my own brain with the question. But now I'm done with it."[59]

The day before he left Sparta, Toomer wrote his first letter to Claude McKay at *The Liberator*. When he arrived back in Washington, he embarked on a euphoric burst of writing. The memories were vivid—the red sun at dusk, the smell of pine and sweet-gum trees, scythes and mules and bigots, and the joyous and moving song of black peasants. Through intense correspondence, Waldo Frank became Toomer's mystical brother, his mentor, and his critic. "Keep yourself warm underneath, in the soil, where the throb is," counseled Frank,[60] who was at the time working on *Holiday*, a novel about a Southern lynching. Toomer offered informed advice about Frank's depiction of the South as a means of expressing his gratitude. "You

tive and wordless connection. A week later Toomer happened upon this man again, in Central Park, and concluded that their meeting was destined.

The stranger was Waldo Frank, a now-forgotten novelist who was then a ringleader of Greenwich Village writers that included Hart Crane, Malcolm Cowley, and Gorham Munson. They were intent upon forging a new American Dream unsullied by soulless commercialism, and their collective vision was embodied in *Our America* (1919). Frank and his wife, Margaret Naumberg, had become emblematic figures of the modern generation—Naumberg had founded the radical Walden School and established a place for Freudian psychology in elementary education, while Frank had been a conscientious objector in World War I and had helped edit the seminal little magazine *Seven Arts*. Toomer cherished his first conversation with Frank as a beacon and regarded their destinies as entwined. Toomer settled upon a new identity—he would be a writer. He returned to Washington to care for his grandfather, and on a $5-a-week allowance he sat down at the family's large oak table and began turning out manuscript after manuscript in every conceivable form—poems, essays, plays, reviews. "The phrase 'trunk-full' is often used loosely," Toomer recalled. "I mean it literally and exactly."[56] All that the burgeoning piles lacked was focus.

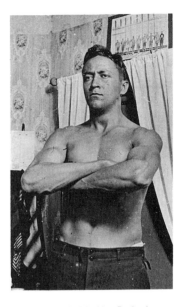

Jean Toomer, bodybuilder, Ford salesman, hobo, c. 1920

You have definitely linked me to the purpose and vision of what is best in creative America.
—Jean Toomer to Waldo Frank

SOUTHERN IDYLLS. In March 1921, Toomer received an invitation that led him out of his cul-de-sac. The Sparta Agricultural and Industrial Institute, modeled on Booker T. Washington's Tuskegee Institute, asked him to serve as substitute principal for the fall semester. When he stepped off the train in Hancock County, Georgia—eighty miles southeast of Atlanta—he found a sleepy town

Here were cabins. Here Negroes and their singing. I had never heard the spirituals and work songs. They were like a part of me. At times, I identified with my whole sense so intensely that I lost my own identity.
—Jean Toomer

A house in Sparta, Georgia, photographed by Jean Toomer, c. 1921

wreathed in smoke from the local sawmill, mist gathering at night over the pine-forested low hills. He lived outside the center of town, near the whitewashed houses and shanties of backwoods Negroes, and through his open windows he heard their spirituals, work songs, and "shouts." "There, for the first time I really saw the Negro, not as pseudo-urbanized and vulgarized, a semi-Americanized product, but the Negro peasant, strong with the tang of fields and soil," he wrote Waldo Frank. "Love? Man they gave birth to a whole new life."[57]

Toomer lived in Sparta for only two months, but during this brief sojourn he absorbed the black folk spirit that inspired his writing. He listened intently to the sounds of the trees and blues from neighboring shanties, and he visited the churches. ("The theology is a farce," he reported, "their religious emotion, elemental and for that reason, very near sublime."[58]) Through his experience Toomer arrived at a momentary resolution of the tangled skeins that made up his racial identity. "When I live with the blacks, I'm a Negro," he concluded. "When I live with the whites, I'm white, or better, a foreigner. I used to puzzle my own brain with the question. But now I'm done with it."[59]

My seed was planted in myself down there. Roots have grown and strengthened.
—Jean Toomer to Sherwood Anderson

The day before he left Sparta, Toomer wrote his first letter to Claude McKay at *The Liberator*. When he arrived back in Washington, he embarked on a euphoric burst of writing. The memories were vivid—the red sun at dusk, the smell of pine and sweet-gum trees, scythes and mules and bigots, and the joyous and moving song of black peasants. Through intense correspondence, Waldo Frank became Toomer's mystical brother, his mentor, and his critic. "Keep yourself warm underneath, in the soil, where the throb is," counseled Frank,[60] who was at the time working on *Holiday*, a novel about a Southern lynching. Toomer offered informed advice about Frank's depiction of the South as a means of expressing his gratitude. "You

*The South: **Bam, down in Bam** (the South); **peckerwood, redneck** (both mean a poor or unloved white Southerner)*

have definitely linked me to the purpose and vision of what is best in creative America," Toomer wrote Frank. "You have touched me, you have held me, you have released me to myself."[61]

By summer Toomer had written himself dry. He invited Waldo Frank to accompany him on a trip to South Carolina in order to mutually sharpen their perceptions of the South. They traveled as Negro blood brothers; since he was black-haired and tan, Frank could "pass." As Toomer's traveling companion he was automatically accepted as Negro, but both men understood the danger involved if he were discovered as a white man. Frank followed Jim Crow laws to a tee and dreamed he was Negro (and in the morning he "would spring from sleep reaching for my clothes on the chair beside the bed, to finger them, to smell them . . . in proof I was white and myself.")[62] The two men returned from their idyll with fresh ideas for their books, which they planned to appear on the same day.

CANE. Toomer's written fragments of the South composed an elegy for an archaic world; as he put it, "The folk spirit was walking in to die in the modern desert."[63] He initially intended his writings as discrete works, but reading them altogether inspired a new plan— to publish them as a single work between hard covers. A book could give him a place in the literary milieu: "I saw it as my passport to this world."[64]

Boni and Liveright published *Cane* in September 1923. In his introduction Waldo Frank called it "a harbinger of a literary force of whose incalculable future I believe no reader of this book will be in doubt."[65] *Cane* was unlike anything America had seen—a montage of impressionistic scenes and characters loosely unified by theme and lyrical tone. Toomer called it a "vaudeville out of the South," while

Spartanburg (how curiously, painfully creative is the South!) gave us each other perhaps as no other place could.
—Jean Toomer to Waldo Frank

The Negro of the folk-song has all but passed away: the Negro of the emotional church is fading. A hundred years from now these Negroes, if they exist at all, will live in art.
—Jean Toomer

For Toomer, the Southland is not a problem to be solved; it is a field of loveliness to be sung: the Georgia Negro is not a downtrodden soul to be uplifted; he is material for a gorgeous painting. . . .
—Waldo Frank

Black male: **hunky hunk** *(affectionate);* **Jasper** *(usually, an imperceptive male);* **Sam** *(diminutive of "Sambo")*

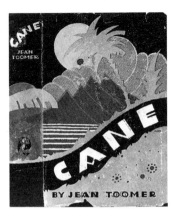

Cover of Jean Toomer's Cane, *published in September 1923*

SONG OF THE SON

Pour O pour that parting soul in song,
O pour it in the sawdust glow of night,
Into the velvet pine-smoke air to-night,
And let the valley carry it along,
And let the valley carry it along.

O land and soil, red soil and sweet-gum tree,
So scant of grass, so profligate of pines,
Now just before an epoch's sun declines
Thy son, in time, I have returned to thee,
Thy son, I have in time returned to thee.

In time, for though the sun is setting on
A song-lit race of slaves, it has not set;
Though late, O soil, it is not too late yet
To catch thy plaintive soul, leaving, soon gone,
Leaving, to catch thy plaintive soul soon gone.

O Negro slaves, dark purple ripened plums,
Squeezed, and bursting in the pine-wood air,
Passing, before they stripped the old tree bare
One plum was saved for me, one seed becomes

An everlasting song, a singing tree,
Caroling softly souls of slavery,
What they were, and what they are to me,
Caroling softly souls of slavery.

—Jean Toomer, 1923

most critics cited *Winesburg, Ohio,* the novel by Toomer's friend, Sherwood Anderson, as its closest ancestor.[66] But the mixture of forms, ranging from poems and sketches to a novelette-drama, was more far-flung than anything Anderson had attempted. *Cane* provided a neat contrast to Claude McKay's poetry—while McKay used the conservative sonnet form to express explosively radical subject matter, Toomer's work was backward-looking elegy in modernist form. The critical reaction ranged from positive to ecstatic. Among the avant-garde contingent, *Broom* editor Lola Ridge predicted Toomer would become the most discussed writer of his generation, and Sherwood Anderson proclaimed him the only black writer to possess a consciously artistic impulse. Among the African-American community, W. E. B. Du Bois declared himself "unduly irritated" by its abstruseness, but nevertheless predicted that it "would mark an epoch."[67] The first copy of the book was sold to Countee Cullen, and he wrote Toomer that it was "a real race contribution, a classical portrayal of things as they are."[68] Even conservative black critic Stanley Brathwaite rhapsodized: "*Cane* is a book of gold and bronze, of dusk and flame, of ecstasy and pain, and Jean Toomer is a bright morning star of a new day of the race in literature."[69]

There were only three things wrong with these prophecies of Toomer's career as a black writer. First, the book sold less than five hundred copies. Second, Toomer regarded the Negro movement as "something that has no special meaning for me"; he upbraided his publisher for calling him a Negro writer, insisting that "you never use such a word, such a thought again"; and when Du Bois and Locke urged him to make more "race contributions," he was exasperated.[70] Finally, and most devastatingly, Toomer would never again, in the forty-seven remaining years of his life, be published by a commercial house.

Some inner substance in the author moved while writing this tale.
—Paul Rosenfeld

"Cane" was a swan song. It was the song of an end. And why no one has seen and felt that, why people have expected me to write a second and a third and a fourth book like "Cane," is one of the queer misunderstandings of my life.
—Jean Toomer

Black race: **Aunt Hagar, Aunt Hagar's chillun**

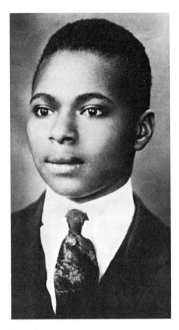

Poet Countee Cullen, New York, c. 1920

Bookooing: showing off (from "beaucoup")

COUNTEE CULLEN. Of all the young poets touted at the Civic Club dinner, twenty-one-year-old Countee Cullen was widely considered the great black hope. A few years earlier the Empire Federation of Women's Clubs had singled him out as New York's best young poet, and a pattern was set—Cullen soon garnered recognition from other organizations that mixed aesthetics with civic and racial pride in about equal measure. The outgoing Cullen—with his dark suit, tie, and always-ready-for-company good manners—presented a highly palatable image of a prodigy. With his lyric voice and love of beauty, some said he seemed to speak to his race directly on behalf of God. (He was well trained for this spiritual role by his adoptive father, the pastor of Harlem's huge Salem Methodist Episcopal Church.) Cullen was sensitive to the demands placed on young Negro poets to create a positive image, and he worked more slavishly than any of his compatriots to meet them: he was unfailingly reverent, impeccably dressed, courtly, and sunny. Inevitably described as "a perfect gentleman," Cullen seemed to represent the precocious flowering of the Talented Tenth.

The facts of Cullen's background, however, are shrouded in mystery. On different occasions he named three cities—Baltimore, New York, and Louisville—as his birthplace, kept his parents' identity secret, and even his adult height varied seven inches by his own varied accounts. After Cullen's father disappeared, his mother turned him over to his paternal grandmother, and on her death he was given, at the age of fifteen, to the Reverend Frederick Cullen, the pastor of Salem Methodist Episcopal Church, and his wife, Carolyn. Although the "adoption" was never legalized, Countee proudly took the Cullens' name, and when he eavesdropped on the elevated soirées held in their Harlem brownstone, or heard choir songs practiced on the grand piano, he felt he had finally found his true home. In his later

accounts, he marked his move to Harlem as the beginning of his life and this hard-driving fundamentalist and his graceful choir soprano wife as his "true" parents.

Cullen incorporated whatever accepted models were available to him; he adored his adoptive father, and subsequently W. E. B. Du Bois, the patriarch of the Renaissance. In his poetry he adhered rigidly to such stringent poetic forms as sonnets and villanelles. At the predominantly white De Witt Clinton High School, Cullen first showed a natural talent for the craft of poetry. At the same time he also became aware of his homosexual interests, and others began to make remarks about his high-pitched voice and his attachment to his handsome classmate, Harold Jackman.

After graduating from high school in 1921, Cullen discovered a community of fledgling black writers at the 135th Street branch of the New York Public Library, the literary center of Harlem. Here in a neoclassical basement room, a group of women—including librarian Ernestine Rose, *Opportunity* secretary Ethel Nance, *Crisis* literary editor Jessie Fauset, and writer Gwendolyn Bennett—organized an informal and intimate program of poetry readings and book discussions. In this nurturing atmosphere Cullen's performing instincts thrived, and the sight of so young a man earnestly declaiming his heroic couplets inspired aspiring authors in the audience. Among them was a writer whose poems Cullen had read in *The Crisis*; his name was Langston Hughes.

LANGSTON HUGHES. Nineteen-year-old Langston Hughes arrived in New York on September 4, 1921, on a steamer from Mexico, sharing his cramped compartment with an ancient Cuban and a large crate of chickens. He recalled, "There is no thrill in all the world like

If you asked any Negro what he found in Cullen's poetry, he would say: all my dilemmas are written here. . . .
—Owen Dodson

July jam: *very hot ("hot as July jam!"); also* **little sister** *("Hot as little sister!") [Hurston])*

I was in love with Harlem long before I got there.

 —Langston Hughes

entering, for the first time, New York harbor, coming in from the flat monotony of the sea to this rise of dreams and beauty."[71] At his father's insistence, Hughes planned to study mining at Columbia University, but the destination of his dreams lay some fifteen blocks northeast: ". . . Really I had come to see Harlem."[72] He hopped the Bronx Park subway to 135th Street, parked his meager belongings on the fourth floor of the local YMCA, and took his first stroll through the black mecca that would become so central to his life and career. He recalled, "The sheer dark size of Harlem intrigued me."[73]

After this tantalizing introduction, he settled in an all-white dormitory, Hartley Hall, on Columbia University's campus. Hughes was one of a dozen black students in his class, and the only one to talk his way into a white dormitory. But it was a Pyrrhic victory, for he was never to feel membership in the community of students. The fraternities, the Columbia *Spectator,* and the regimented classes offered little to the reticent black freshman. Only Jessie Fauset's invitation to visit the NAACP headquarters at 69 Fifth Avenue made him feel welcomed. Fauset had received poems and stories with an odd Mexican postmark from this unknown young man, and she detected great promise. Understandably eager to meet the author, Fauset had tracked him down through his new subscription address and introduced him to W. E. B. Du Bois. The imposing patriarch unbent slightly before this young man who was so shyly charming and about the age his dead son would have been. Also taken with Hughes was the *Crisis*'s homosexual business manager, Augustus Dill, and they became immediate and lasting friends. The pattern was set for Hughes's seduction of the Harlem literary world: he was a potential son, a potential writer, a potential lover. All of this he accomplished without conscious guile, for he had learned to expertly elicit the support that he never received from his estranged and scattered family.

First thing smoking: a train ("I'm through with this town. I mean to grab the first thing smoking." [Hurston])

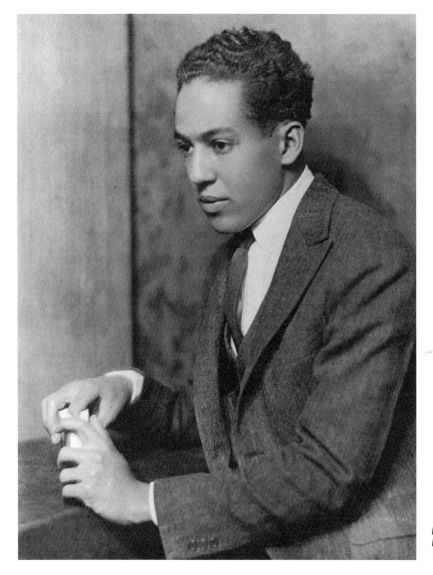

Poet, novelist, and essayist Langston Hughes by Nickolas Muray, New York, 1923

Nobody loves a genius child.
Kill him—*and let his soul run wild.*
 —Langston Hughes

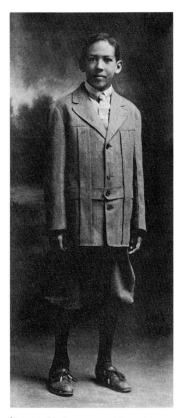

Langston Hughes as an adolescent

Hughes was born February 1, 1902, in Joplin, Missouri. A mixture of Indian, French, and African blood, he would always identify with the archetype of the tragic mulatto. The youngster was passed from one caretaker to another and from one town to another (Topeka; Chicago; Cleveland; Toluca, Mexico). He knew his Negro-hating father just well enough to despise him, and his feelings for his mother were only slightly more ambivalent. In and out of his life, she usually appeared in times of need. He was one of the only black students in most of his schools—and was subjected to everything from snowballs and jokes about eating too much licorice, to having to sit in restricted Jim Crow rows at school and in "Nigger Heaven" sections at the movie theater. Hughes managed to thrive in the diverse environments into which he was thrown—with his inveterate chuckle and boyish charm, he was a master of adaptation. By the time he reached his senior year in Cleveland's Central High School, he was elected the yearbook's editor-in-chief and the class poet. In this white crucible, Hughes managed to effectively accommodate himself: he was a model student, wore clothes that were always neatly pressed, and flashed an unfailingly infectious smile. His social success was certainly helped by his light, copper-colored skin, his boyishly handsome features, his curly (rather than nappy) hair, and what the yearbook called his "soulful eyes."

Privately he spent more and more time with books, which increasingly became his refuge. Dunbar and Longfellow provided early poetic models, and when Hughes began to write poetry in high school they were reverently imitated. His range of models soon broadened to include Carl Sandburg and Walt Whitman, as he moved away from the Anglophilia that dominated American verse of the day to pursue a native American voice. He subscribed to *The Liberator,* and from Claude McKay's militant poems he had his first taste of Negro rev-

olutionary attitudes. From a Kansas City band composed entirely of
blind black men he heard the blues, and their startling, sobbing music
lodged in his memory, to be drawn upon a few years later for his
poem "The Weary Blues."

In the spring of his senior year in high school, Hughes wrote
"When Sue Wears Red," his first overtly black poem, inspired by the
sight of a black junior high school student dancing in the high school
gymnasium in a red dress. The poem is striking for its celebration of
African-American beauty (virtually without model among poetry), its
sensual heat (which Hughes rarely displayed throughout his life), and
its already assured voice. But its infectious jubilance gave no hint of
the ancient and worldly tone of his next poem, written shortly after
graduation. Langston was bound for his father's home in Mexico
when his train crossed over the Mississippi River, whose muddy gran-
deur reflected the rays of the sun at dusk. He began to scrawl on an
envelope, and in a few minutes he produced the thirteen lines that
he would send to Jessie Fauset six months later, bearing the title
"The Negro Speaks of Rivers." "I took the beautiful dignified crea-
tion to Dr. Du Bois," Fauset recalled, "and said 'What colored person
is there, do you suppose, in the United States who writes like that
and is yet unknown to us?' "[74] This seminal poem was Hughes's first
adult creation to be published, and it would remain indelibly associ-
ated with Hughes, right up to its recitation as his body was wheeled
into the flames of a crematorium forty-seven years later.

Just over a year had passed between the time Hughes had
written that poem and met the black literati in New York who would
publish it. By this time he had grown less interested in Columbia
(although his grades were more than adequate) and more fascinated
by the activities of Harlemites. He repeatedly ascended to the upper
balcony of the Sixty-third Street Theater to see Florence Mills per-

*Why should I want to be white? I am a
Negro—and beautiful.*
—Langston Hughes

Poverty: **the Bear** *(always used with the
definite article; "Just like de bear, I ain't
nowhere [broke]/Like de bear's brother,
I ain't no further/Like de bear's daugh-
ter, ain't got a quarter." [Hurston])*

form in the epochal black revue *Shuffle Along,* and when black comedian Bert Williams died during Columbia's spring semester, Hughes attended his funeral in lieu of writing an examination. He began to haunt the lectures and poetry readings Ernestine Rose had organized at the 135th Street library. It was in this last setting that Hughes met his fellow wunderkind, the twenty-year-old poet Countee Cullen.

LOVE TRIANGLES: HUGHES, LOCKE, CULLEN. After their meetings at the 135th Street library, Countee Cullen and Langston Hughes shyly became friends. "His is such a charming childishness," Cullen confided to Alain Locke, "that I feel years older in his presence."[75] The relationship initially depended on letters and shared poems, for after his year at Columbia Hughes had signed on as a "saloon messman" on a freighter that anchored forty miles up the Hudson River. Aboard ship Hughes found both a democratic social life among sailors and the solitude to write. Within a space of a few weeks in early 1923, he wrote fifteen poems and mailed them to Cullen with the inscription, "To a fellow poet, these unpublished poems."[76] The handwritten manuscripts reflected the concentrated labor and the general feelings of unhappiness Hughes required to write well—and from his shipside perspective he could more clearly envision the Harlem of his dreams. Among his batch of poems was a triptych about Harlem, "The Weary Blues" as its centerpiece. This poem represented a first step in Hughes's campaign to wed the formal rhythms of poetry to the indigenous black vernacular of the blues. A few days later Cullen posted him a poem entitled "To a Brown Boy." It was dedicated "For L. H." Cullen's gesture introduced to the relationship an undeniably romantic note that made

*Male sex: **Georgia jumping-root, hambone, honey-stick; dat thing** (sex of either sex)*

Hughes so uncomfortable that he coyly declined to recognize it. "I don't know what to say about the 'For L. H.,' but I appreciate it, and I like the poem."[77]

Accepting Hughes's feigned obliviousness, Cullen loyally maintained the correspondence, sending clippings from the *Amsterdam News* and offering to recite Hughes's poetry at the 135th Street library gatherings. Hughes responded with a facetious primitive modern work entitled "Syllable Poem." "Tell them that it is the poetry of sound, and that it marks the beginning of a new era, an era of revolt against the trite and outworn language of the understandable."[78] Gracefully abdicating his pursuit, Cullen turned Hughes's address over to his new mentor, Alain Locke, and suggested that the two should meet. "You will like him; I love him," wrote Cullen.[79] Since Locke had heard the same prediction from Jessie Fauset, the thirty-seven-year-old professor began his epistolary siege on the twenty-one-year-old poet. "Countee already means so much to me," Locke wrote Hughes, "but he generously insists on deeding over a certain part of me to you."[80]

Suggesting a visit to Hughes's ship, Locke confessed his nervousness about their first encounter. In the lines that followed he described his "early infatuation with Greek ideals of life," noting that "I was caught up early in the coils of classicism," and declared his love of sailors, "of all men most human."[81] Locke wrote in a homoerotic code that was meant to be cracked, but Hughes played dumb (Was Mr. Locke married? he asked), and retreated behind his mask of virginal innocence. Locke was alternately irritated—counseling Cullen "to discontinue pampering his psychology"[82]—and tantalized by Hughes's feinting dance of teases and demurrals. Cullen persisted in his pursuit of Hughes, however, in part because he cherished the prospect of their intimate poetry coterie, what Hughes described as

*Sex: **scooter-pooking, jelly, ground rations, under rations, poontang, getting my hambone boiled, knocking the pad, balling** (having sex); **"Baby, how is the drawbridge? Any boats passing?" "What's on the rail for the lizard?"** (both suggestions for having sex [Hurston]); **hootchie-pap, stuff** (can also mean excretion); **swap spit** (kiss)*

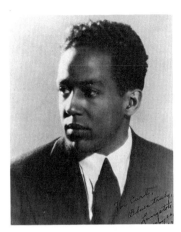

Langston Hughes by Nickolas Muray, 1927

Langston was like the legendary Virgin who walks through mud without soiling even the hem of her robe.
—Richard Bruce Nugent

For me it was the "Great Adventure."
—Langston Hughes, on trip to Africa

"some little Greenwich Village of our own."[83] Cullen suggested that the threesome travel together in Europe.

The trip would never happen—Cullen had little wanderlust, Locke declared himself game but "quiescently fatalistic" about Hughes's participation, and Hughes declined at the last minute, pleading the need to work. He continued to tantalize Locke, suggesting that perhaps he could ship out on a freighter to the Mediterranean. "And how delightful it would be to come surprisingly upon one another in some old world street!" Hughes wrote. "Delightful and too romantic!"[84]

LANGSTON HUGHES'S GRAND TOURS. On the afternoon of June 13, 1922—about the time Countee Cullen was heading for Atlantic City to work as a hotel busboy—Langston Hughes sailed out of New York Harbor, bound for the west coast of Africa. He was a crew member on a weathered freighter called the *West Hesseltine,* and before his first day was out he hauled up to the deck a box of books from his year at Columbia. One by one he pitched them into the sea, saving only Walt Whitman's *Leaves of Grass.* "It was like throwing a million bricks out of my heart," Hughes recalled, "—for it wasn't only the books that I wanted to throw away, but every thing unpleasant and miserable out of my past. . . ."[85]

Across the Atlantic were scheduled stopovers in the Azores, the Belgian Congo, Nigeria. At the age of twenty-one, Hughes was embarking on a grand tour that not even such pan-Africanists as Du Bois or Garvey had taken. When he saw the continent's low hills on the horizon, Hughes exclaimed, "My Africa, Motherland of the Negro peoples! And me a Negro! Africa!"[86] But his first closeup views of crude people in makeshift garments, and ostriches and naked chil-

dren stalking village streets, produced skepticism and ridicule. "It's a scream!" he wrote his mother.[87]

Over the next few months he laid over in Lagos and he sailed up the Congo to remote ports, where the *West Hesseltine* took on palm oil, cocoa beans, and mahogany logs. He repeatedly witnessed the ravages inflicted by European colonialism on the shabby tribal villages, where churches and shops warned "Europeans Only," children sold their sisters, and listless Africans bowed to gun-carrying traders. In the face of these degradations Hughes felt ever more deeply his kinship with African peoples. To his dismay, however, the natives looked on his copper skin and lank black hair and declared: "You—white man."[88] They could not fathom his desire to be identified as an African American. By the time Hughes returned to New York at the end of October 1924, accompanied by a wild red Congolese monkey named Jocko, the twenty-two-year-old had survived a rite of passage.

Four months later, Hughes shipped out again, this time as a cabin boy bound for Holland, where he deserted ship and headed for Paris. He had 150 francs in his pocket and Claude McKay's address on a scrap of paper. (Hughes had never met McKay but attributed his first revolutionary attitudes to the older writer who, alas, was out of town.) In Paris Hughes landed a job as a *chausseur*, wearing a blue and gold military hat at a tough lesbian-run cabaret called the Cozy Corner. He soon moved on to a more prestigious cabaret on the rue Pigalle called Le Grand Duc, where he washed dishes from eleven in the evening until seven in the morning. All night long, through the kitchen door, he heard the legendary Bricktop (Ada Smith) deliver her songs with more brazen personality than polished musicianship, and he heard expatriate black jazz musicians Buddy Gilmore, Louis Jones, Cricket Smith, and Frank Withers jam from 3:00 A.M. until

He is really squeezing life like a lemon.
—Countee Cullen,
on Langston Hughes

Langston is back from his African trip, looking like a virile brown god.
—Countee Cullen to Alain Locke

We'll dance! Let the white world tear itself to pieces. Let the white folks worry. We know two more joyous steps—two more ways to do de buck! C'est vrai?
—Langston Hughes to Countee Cullen

Alain Locke, 1926

dawn, at which point he joined them for a champagne breakfast. He lived first in a garret with an émigré Russian dancer named Sonya, and then with a homeless dope addict named Bob. Beneath the slanting eaves, he was living out the bohemian's dream, and he later wrote, "I began to say to myself that I guess dreams do come true, and sometimes life makes its own books."[89] But in his letters home to Cullen he confessed his homesickness for New York: "Kid, stay in Harlem!"[90]

At noon on July 31, 1924, Hughes awoke to a rap on his attic door and found Alain Locke standing before him. After eighteen months of correspondence, the two finally met face to face, one in disheveled pajamas and the other in spotless suit and spats. Locke steered Hughes out of Montmartre (which was not Locke's style) and toward the more tony precincts of Parc Monceau and the Opéra Comique. Talking excitedly about editing *The New Negro* issue of *Survey Graphic,* Locke solicited new work from Hughes. So strong a bond was established that Locke wrote Hughes, "I can only say that it is intense enough to be sad and premonitory of change or disillusionment."[91] They made tentative plans for Hughes to attend Howard University and move into Locke's house.

Hughes's next move in his skittish ballet was to visit friends in northern Italy. Locke sent him a letter there "to tell you how I love you,"[92] and proposed that the two meet in Venice. Hughes accepted. During those few days in Venice, Hughes was introduced to the frescoes of Titian, Tintoretto, and Caravaggio, and visited the Bridge of Sighs and the Doge's Palace—all accompanied by Locke's erudite and sometimes exhausting commentary. (Hughes began to long for some back alleys.) The elements of romance were abundantly present—all but the consummation—and it was at this moment of tantalizing frustration that Hughes was robbed of money and pass-

C.P.T.: *colored people's time; i.e., late*

port. Knowing that the last chances for intimacy were gone "before America with her inhibitions closes down on us,"[93] Locke struck out in frustration. He deserted Hughes in Genoa, an unemployed Negro without passport or prospects and only a few lire in his pocket.

For six weeks Hughes eked out meals by doing odd jobs and selling his alarm clock. Finally he signed on with the all-black crew of a ship heading back to New York and arrived in that familiar harbor with just 25 cents in his pocket.

He hopped a subway to Countee Cullen's house, and later that evening in his plaid mackinaw he attended a NAACP benefit at "Happy" Rhone's Harlem nightclub. Here Florence Mills and Alberta Hunter sang, Bill "Bojangles" Robinson danced to the jazz of Fletcher Henderson and his orchestra, and amidst the hubbub Langston was welcomed home by W. E. B. Du Bois, James Weldon Johnson, and a shambling Nordic-looking fellow he'd never met named Carl Van Vechten (who duly noted in his diary the next morning that

Kid, stay in Harlem! The French are the most franc-loving, sou-clutching, hard-faced, hard-worked, cold and half-starved set of people I've ever seen in life. . . . And do they like Americans of any color? They do not!!!
—Langston Hughes to Countee Cullen

See Paris and die. Meet Langston Hughes and be damned.
—Alain Locke to Countee Cullen

Harlem dancers by Richard Bruce Nugent, 1928

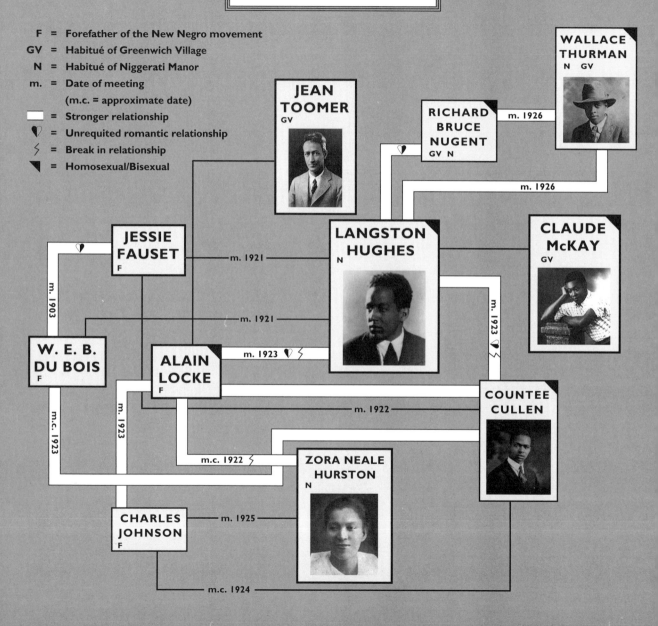

HARLEM RENAISSANCE

F = Forefather of the New Negro movement
GV = Habitué of Greenwich Village
N = Habitué of Niggerati Manor
m. = Date of meeting
(m.c. = approximate date)
▢ = Stronger relationship
❤ = Unrequited romantic relationship
⚡ = Break in relationship
◣ = Homosexual/Bisexual

WALLACE THURMAN
N GV

JEAN TOOMER
GV

RICHARD BRUCE NUGENT
GV N

m. 1926

m. 1926

LANGSTON HUGHES
N

CLAUDE McKAY
GV

JESSIE FAUSET
F

m. 1921

m. 1903

m. 1921

m. 1923

W. E. B. DU BOIS
F

ALAIN LOCKE
F

m. 1923

m.c. 1923

m. 1923

COUNTEE CULLEN

m. 1922

m.c. 1922

ZORA NEALE HURSTON
N

CHARLES JOHNSON
F

m. 1925

m.c. 1924

he'd met "Kingston Hughes"). A few weeks earlier he had been a wharf rat, now he was treated as a writer of importance. After traveling the world Hughes was reassured to find that Harlem was still the black mecca.

During the first week of his triumphal return, Hughes experienced a biting loss—his relationship with Countee Cullen. Cullen wrote Locke that " 'tis a pity that a sincere and devoted friendship should be knifed merely to dissemble."[94] A few weeks later Hughes similarly described a disquieting week "during which I lose my boyish faith in friendship and learn one of the peculiar prices a friend can ask for favors."[95] What dissembling? What peculiar price? It is a testament to the accomplished secrecy of both parties that, seventy years later, we know so little of what happened. The split between the two close friends may have resulted from frustrated sex, or from the prospect of competition between the two black wunderkinds, or perhaps behind the rupture lay Locke's fine Italian hand. Whatever the reasons, the first and most intimate stage of Hughes's life in the Harlem Renaissance was over. A larger, noisier, and more fashionable crowd soon beckoned.

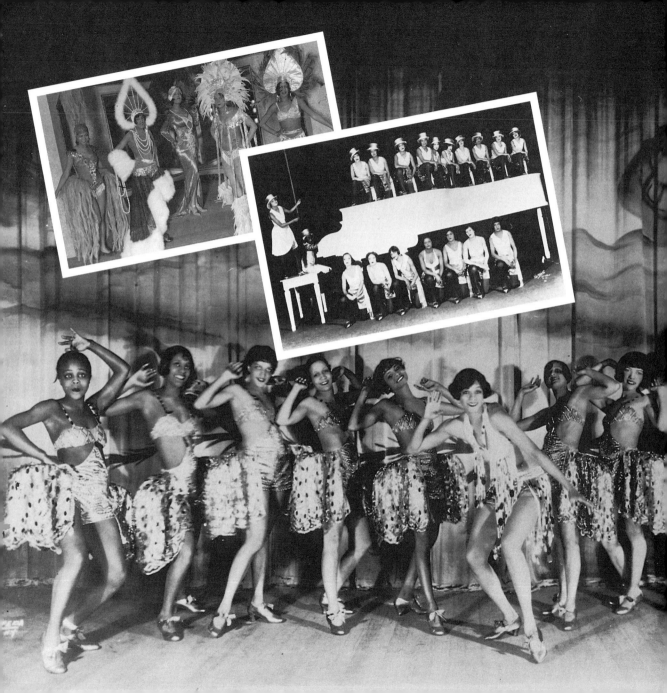

HARLEM IS FASHIONABLE

A NEW ERA BEGINS.. During the first years of the New Negro movement both the audience and the participants were almost entirely African American. Interest in race-building and African-American culture was restricted to the urban black community and a handful of whites concerned about the social welfare. When white supporters such as novelist Carl Van Vechten and philanthropist Charlotte Mason touted black literary and musical expression in the mid-1920s, they treated their discovery as something that was at once indigenously American and utterly exotic. In the wake of the Civic Club dinner, the New Negroes began to see their work published between hard covers, a new generation of black writers was lured to Harlem, and periodicals vied with one another to legitimize them by bestowing prizes. By 1926, Harlem became increasingly a property shared by the black community and a constellation of white philanthropists, publishers, and international style-

The New Negro

Oh! this New Negro Art;
This "peculiar" art;
On the gullible public
We've foisted our "Art."
By stupendous logrolling and licking of boots,
And fawning around influential galoots;
We have gotten a place 'neath the calcium flare.
And paying our room rent and eating good fare.

—George S. Schuyler,
"Ballad of Negro Artists"

In some places the autumn of 1924 may have been an unremarkable season. In Harlem, it was like a foretaste of paradise.
— Arna Bontemps

When rain threshes on the roofs of their Harlem flats they do not try to imagine what Wordsworth might have said about it.
— New York Herald Tribune, May 7, 1925

Negro stock is going up and everybody's buying.
— Rudolph Fisher, 1927

setters. It had evolved from an atomized gathering of Negroes to a self-conscious black mecca, the crucible of racial identity–building. In the succeeding phase, roughly 1925 to 1930, Harlem became a commodity as driven by its audience as it was by its participants. Harlemania set in.

The change was apparent at *Opportunity*'s first awards dinner in the spring of 1925. Shortly after introducing black writers and mainstream publishers at his Civic Club dinner, Charles Johnson announced the *Opportunity* awards for poems, short stories, essays, and plays. As he put it, "A new period in creative expression among Negroes . . . seems ripe for development."[1] Prizes offered economic incentive for writers, trained a spotlight on the fledgling literary movement, and institutionalized its achievements. Johnson shrewdly chose judges—among them Fannie Hurst, Robert Benchley, and Alexander Woollcott—whose mix of race consciousness, literary distinction, and social chic conferred credibility on the awards. Thereby, Johnson consolidated his drive for literary dominion.

On May 1, 316 people packed into the Fifth Avenue Restaurant on the corner of Twenty-fourth Street. The bill of fare wasn't impressive (chicken, mashed potatoes, and green peas) but the celebration of a New Negro literature drew notables from Paul Robeson and Fannie Hurst to A'Lelia Walker and Carl Van Doren. The awards were announced, selected from over seven hundred submissions, and James Weldon Johnson proclaimed, "No race can ever become great that has not produced a literature."[2] He read a letter from Casper Holstein, the West Indian king of Harlem's numbers racket, promising to finance more awards. The evening prompted the *New York Herald Tribune* to editorialize: "A novel sight that dinner—white critics, whom everybody knows, Negro writers whom nobody knew—meeting on common ground."[3]

Four people who attended that evening would play central roles in Harlem's fashionable phase. Langston Hughes and Countee Cullen represented the first wave of New Negro writers, Zora Neale Hurston the second wave, and Carl Van Vechten its Harlemania revelers.

It was not a spasm of emotion. It was intended as the beginning of something and so it was.
—Charles S. Johnson, on the first *Opportunity* awards

ZORA NEALE HURSTON. The recipient of the most *Opportunity* awards that evening was an unknown writer named Zora Neale Hurston; she won not only second prizes for drama *(Color Struck)* and fiction ("Spunk"), but also honorable mentions for two other works. She strode through the room filled with her fellow writers, unfurled her bright scarf, and reiterated the title of her play at the top of her lungs, "COLOR . . R.R STRUCK . . K.K!"[4] Encouraged by Charles Johnson, Hurston had arrived in New York a few months earlier with a single bag holding her manuscripts and her clothess and $1.50 in her pocket. Soon after the evening of the *Opportunity* prizes the former Washington, D.C., manicurist was hailed as one of the New Negro's most promising writers.

Hurston's rapid rise was speeded along by two women she met that evening: Fannie Hurst, the best-selling novelist currently at work on *Appassionata,* and Annie Nathan Meyer, a founder of Barnard College. The first hired Hurston as a secretary and chauffeur and the second arranged for her to attend Barnard on scholarship. Hurston was not a likely secretary, for her typing was execrable and her shorthand illegible, her filing "a game of find the thimble," and her attention to detail and timeliness distractedly slapdash.[5] When she didn't want to take dictation, she yawned and, between puffs on a Pall Mall, said to her boss, "Let's get out the car, I'll drive you up to the Harlem bad-lands or down to the wharves where men go down to the sea in

*Women: **broad, frail eel** (a pretty girl); **coal scuttle blonde** (a black woman); **Sheba** (a very attractive woman); **pe-ola** (an extremely light-skinned black woman); **pig meat** (a young girl)*

Zora would have been Zora even if she was an Eskimo.
— Richard Bruce Nugent

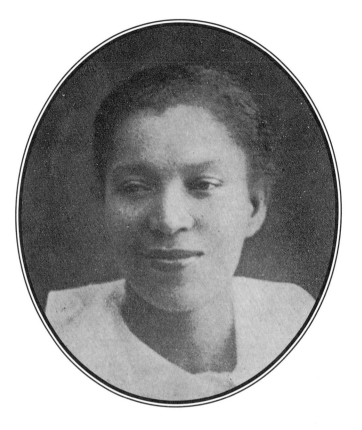

Novelist and anthropologist Zora Neale Hurston, c. 1925

I'm cracking but I'm facking: *I'm wisecracking but I'm telling the truth* [Hurston]

ships."[6] What she lacked in orthodox skills, however, this attractive, big-boned, and large-spirited woman made up for in her effervescent character, and in her impeccable rendition of ethnic folk stories. Perhaps she was paid "just to sit around and represent the Negro race," as Langston Hughes observed. "She was a perfect 'darkie,' in the nice meaning they give the term—that is a naive, childlike, sweet, humorous, and highly colored Negro."[7]

From "HOW IT FEELS TO BE COLORED ME"

But I am not tragically colored. There is no great sorrow dammed up in my soul, nor lurking behind my eyes. I do not mind at all. I do not belong to the sobbing school of Negrohood who hold that nature somehow has given them a lowdown dirty deal and whose feelings are all hurt about it. Even in the helter-skelter skirmish that is my life, I have seen that the world is to the strong regardless of a little pigmentation more or less. No, I do not weep at the world—I am too busy sharpening my oyster knife.

Someone is always at my elbow reminding me that I am a granddaughter of slaves. It fails to register depression with me. Slavery is sixty years in the past. The operation was successful and the patient is doing well, thank you. The terrible struggle that made me an American out of a potential slave said "On the line!" The Reconstruction said "Get set!"; and the generation before said "Go!" I am off to a flying start and I must not halt in the stretch to look behind and weep. Slavery is the price I paid for civilization, and the choice was not with me. It is a bully adventure and worth all that I have paid through my ancestors for it. No one on earth ever had a greater chance for glory. The world to bet on and nothing to be lost. It is thrilling to think—to know that for any act of mine, I shall get twice as much praise or twice as much blame. It is quite exciting to hold the center of the national stage, with the spectators not knowing whether to laugh or to weep.

The position of my white neighbor is much more difficult. No brown specter pulls up a chair beside me when I sit down to eat. No dark ghost thrusts its leg against mine in bed. The game of keeping what one has is never so exciting as the game of getting.

I do not always feel colored. Even now, I often achieve the unconscious Zora of Eatonville before the hegira. I feel most colored when I am thrown against a sharp white background.

—Zora Neale Hurston, 1928

Zora Neale Hurston, as a student at Howard University, c. 1920

Hurston's naive persona was disingenuous, and she had shaved a decade from her thirty-four years that remained undiscovered until she died. But her tales were the genuine article. She had grown up in Eatonville, Florida, a small town five miles from Orlando, forested with chinaberry trees and guava bushes and populated entirely by African Americans. Her father was the town's three-term mayor and its Baptist preacher, and in her early years Zora experienced relative material plenty (e.g., food on the table, a yard full of oranges and tangerines, five acres of land, and an eight-room house). Her mother, who treated Zora as a special child, always encouraged her. "Jump at de sun," she would say. "We might not land on the sun, but at least we would get off the ground."[8] Zora chased alligators and swam in the town's lakes, and she spent hours on the front porch of Joe Clarke's General Store where she heard guitars, banjos, the blues, and—most important to her development as a writer—endless "lying sessions." It was here that she was introduced to the rich oral tradition of the Old South.

Her tomboy's paradise ended when Zora was nine—her mother died, and Zora was perpetually at odds with her father and the subsequent Mrs. Hurston. She was sent away, lived with relatives, and by the age of fourteen Zora was left to fend for herself, working as a maid and as a wardrobe assistant for a touring Gilbert and Sullivan troupe. At sixteen she enrolled in a Baltimore high school, owning a single dress, one change of underwear, and a pair of tan oxfords. She erratically pursued her education and subsequently enrolled at Howard University. It was here that she came into the orbit of Alain Locke and his *Stylus* literary society. Although Locke rarely saw promise in young women, he detected talent in this roughhewn, ambitious student. She could provide the connection to the black folk heritage that Locke considered essential to the creation of a New

Negro literature. In the fall of 1924, he recommended her talent to
Charles S. Johnson, who urged her to come to New York.

Debuting at the *Opportunity* prizes dinner, Hurston became
within a month not only Fannie Hurst's secretary but a staple at the
parties of Carl Van Vechten, who declared her "one of the most
amusing people I have ever met."[9] She quickly broke into Harlem
circles, turning up at rent parties, attending gatherings at Wallace
Thurman's or A'Lelia Walker's, launching into perfectly mimetic
Eatonville-ese, and leaving stories in her wake. "I am just running
wild in every direction," she wrote a friend, "trying to see everything
at once."[10]

Hurston matriculated at Barnard in the fall of 1925; as its only
Negro student she called herself "a sacred black cow." During her
second round of undergraduate years she took anthropology courses
with the distinguished Franz Boas. Widely regarded as the world's
leading anthropologist, Boas immediately recognized Hurston's abil-
ity to collect black folklore. He advised her to become a professional
anthropologist, and she willingly submitted to his scientifically objec-
tive methods. (To confront the myth that Negroes had smaller brain
capacity, for example, Hurston stood on a Harlem street corner, bran-
dishing a calipers and measuring the craniums of passersby.) Hurston
was swept along not only by Boas, whom she considered "the king
of kings," but also by a realization that her Eatonville stories had a
place in such an altogether serious place as Barnard. Hurston would
describe her awakening in her first book, *Mules and Men:*

> From the earliest rocking of my cradle, I had known about
> the capers Brer Rabbit is apt to cut and what the Squinch
> Owl says from the house top. But it was fitting me like a tight
> chemise. I couldn't see it for wearing it. It was only when I

When Zora was there she was the party.

—Sterling Brown

Thousand on the plate: *beans*

was off in college, away from my native surroundings, that I could see myself like somebody else and stand off and look at my garment. Then I had to have the spy-glass of Anthropology to look through at that.[11]

TAKING UP LANGSTON HUGHES. The *Opportunity* awards seemed to underline the position of Langston Hughes and Countee Cullen as the Renaissance's youngest and brightest stars, and their dual rankings were confirmed by the awards: poems by Hughes and Cullen tied for third place, Cullen took second for "To One Who Said Me Nay," and Hughes won the $40 first prize for his poem "The Weary Blues." At the end of the formal ceremony, Carl Van Vechten made his way through the line of congratulators to greet Hughes. Later that night Hughes was drinking with Van Vechten and his friends around a table at the Manhattan Casino, and by five o'clock the next day, he was reading poems in the lush Fifty-fifth Street apartment of Van Vechten, who had become "Carlo." (Van Vechten had not gone to bed after the *Opportunity* dinner, having instead gone on to A'Lelia Walker's, the Manhattan Casino, Bamville, the Comedy Club, and driven home at sunrise through Central Park.) The following afternoon, Van Vechten pledged to find Hughes a publisher, and a week later Van Vechten sent word of his success with his friend Alfred Knopf. Only eighteen days passed between their meeting at the *Opportunity* dinner and the arrival of Knopf's contract. Van Vechten also called his friend Frank Crowninshield and arranged for the stylishly slick *Vanity Fair* to publish four of Hughes's poems. (The magazine spread followed close on the heels of Countee Cullen winning the 1925 *Crisis* award, another round in their competitive careers.)

The Weary Blues appeared in February 1926, with a bright

LITTLE DAVID PLAY ON YOUR HARP.

THANKS IMMENSELY THE SILVER TRUMPETS ARE BLOWING

—Telegram exchange between Carl Van Vechten and Langston Hughes upon Knopf's acceptance of *The Weary Blues*

I shot him lightly and he died politely: to outdo someone, hands down

Droning a drowsy syncopated tune,
Rocking back and forth to a mellow croon,
 I heard a Negro play.
Down on Lenox Avenue the other night
By the pale dull pallor of an old gas light
 He did a lazy sway . . .
 He did a lazy sway . . .
To the tune o' those Weary Blues.
With his ebony hands on each ivory key
He made that poor piano moan with melody.
 O Blues!
Swaying to and fro on his rickety stool
He played that sad raggy tune like a musical fool.
 Sweet Blues!
Coming from a black man's soul.
 O Blues!

In a deep song voice with a melancholy tone
I heard that Negro sing, that old piano moan—
 "Ain't got nobody in all this world,
 Ain't got nobody but ma self.
 I's gwine to quit ma frownin'
 And put ma troubles on the shelf."
Thump, thump, thump, went his foot on the floor.
He played a few chords then he sang some more—
 "I got the Weary Blues
 And I can't be satisfied.
 Got the Weary Blues
 And can't be satisfied—
 I ain't happy no mo'
 And I wish that I had died."
And far into the night he crooned that tune.
The stars went out and so did the moon.
The singer stopped playing and went to bed
While the Weary Blues echoed through his head.
He slept like a rock or a man that's dead.

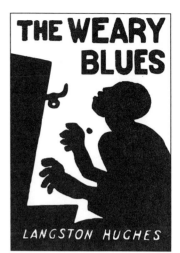

Illustration for Langston Hughes's The Weary Blues by Miguel Covarrubias, 1925

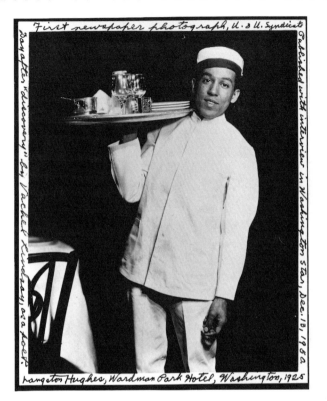

Langston Hughes as a busboy at the Wardman Park Hotel, Washington, D.C., just after meeting Vachel Lindsay, November 1925

Miguel Covarrubias caricature of a black piano player in red, black, and yellow on its cover. The critical reaction in the white press was cautiously enthusiastic, while Locke and Fauset spearheaded the praise in the black press. But in *The Crisis,* Cullen called the jazz poems "interlopers," and he objected to Hughes's heavy emphasis on Negro themes.

Hughes attained minor celebrity status as his book was published, and he simultaneously celebrated his twenty-fourth birthday —although he still supported himself on $55 a month working as a

busboy at Washington's Wardman Park Hotel. Reading his poetry at the hotel in late November 1925 was one of America's most popular poets, Vachel Lindsay. Hughes approached Lindsay at dinner, murmuring how much he admired Lindsay, and dropped on the table three poems he had hastily copied out in his best penmanship. At his reading that evening Lindsay announced in stentorian tones the presence of a poet in their midst—a Negro busboy poet to boot— and he then read all three of Hughes's poems. (For Lindsay, this episode must have had an air of *déjà vu*, for his own career had received a similar boost eleven years earlier, when William Butler Yeats had announced at a similar dinner gathering his discovery of the then-unknown Lindsay's genius.) Lindsay also offered the young poet some advice: "Hide and write and study and think. I know what factions do. Beware of them. I know what lionizers do. Beware of them."[12]

> I, too, sing America.
>
> I am the darker brother.
> They send me to eat in the kitchen
> when company comes,
> But I laugh,
> And eat well,
> And grow strong.
> —Langston Hughes, "I, Too"

This advice was well taken, for Carl Van Vechten was not the only one who regarded Hughes as an attractive protégé. Young, dissembling, impenetrable, well-spoken, attractive, and slim, Hughes was exactly the sort who might appeal to many parties, both black and white. Supporters included white philanthropist Amy Spingarn, who paid Hughes's tuition at Lincoln University, praised his poetry, and painted his portrait. The young generation associated with Niggerati Manor—Wallace Thurman, Richard Bruce Nugent, Aaron Douglas—considered Hughes an ally in their presentation of Negro art and literature that didn't portray the Talented Tenth. Even Alain Locke, after his romantic falling-out with Hughes, extolled his poetry and included Hughes in anthologies. Only Jessie Fauset and the *Crisis* contingent questioned the path he was pursuing. Hughes's widespread appeal led to a most delicate task: navigating the tangled course between Negro and Negrotarian factions.

Gut-bucket: *low dive, type of music or expression from same*

Hughes wrote prolifically during this period. Before his first season of fame was over *The Nation* published his finest essay, "The Negro Artist and the Racial Mountain," in which he addressed the creation of a black literary identity that demanded neither the compromises of false integration into white society, nor the moribund gentility of the Talented Tenth:

> Let the blare of Negro jazz bands and the bellowing voice of Bessie Smith singing Blues penetrate the closed ears of the colored near-intellectuals until they listen and perhaps understand. Let Paul Robeson singing "Water Boy" and Rudolph Fisher writing about the streets of Harlem, and Jean Toomer holding the heart of Georgia in his hands, and Aaron Douglas drawing strange black fantasies cause the smug Negro middle class to turn from their white, respectable, ordinary books and papers to catch a glimmer of their own beauty.[13]

Hughes tried to incorporate this manifesto into his poetry. He aspired to write in a personal voice that also reflected his race; to create literary forms that were modern without yielding to the obscurantism of much white modernist poetry; to portray African Americans with dignity without bowing to middle-class notions of respectability. His fellow New Negroes—Claude McKay, Jean Toomer, and Countee Cullen—pursued more circumscribed ambitions. McKay employed conventional forms for the radical content of his poetry; Cullen was traditional in both form and message; after his first book Toomer shunned issues of black identity. By contrast Hughes continued to portray the urban black life avoided by Cullen and Toomer and animate it with the liveliness of blues rhythms. The language he incorporated had grown out of the black experience but was closer to home than Africa, emotionally accessible to the masses

The mood of the blues is almost despondency, but when they are sung people laugh.

—Langston Hughes

Terms of endearment: **big sugar, small sugar, mama** *(girlfriend or wife);* **papa, daddy** *(husband or lover)*

without being simplistic doggerel. The blues had been a subject in such earlier poems as "The Weary Blues," but during the mid-1920s Hughes's work became increasingly inflected with its dark power.

The poems collected in his 1927 volume, *Fine Clothes to the Jew*, reflected the blues most starkly. Writing in an indigenous African-American idiom that provided an alternative to dialect poetry, Hughes portrayed scenes of sex and physical abuse, gin and harlots that many felt should remain secret. Most black critics responded with disgust and anger, calling Hughes a "SEWER DWELLER" and the "poet 'low-rate' of Harlem," and the book sold fewer copies than any in his life.[14] But a few readers acknowledged his achievement—Claude McKay congratulated him on having written his best book, Alain Locke noted that readers put off by its frankness "cannot distinguish clay from mire," and white reviewer Howard Mumford Jones noted that Hughes had "contributed a really new verse form to the English language."[15] Zora Neale Hurston carried his book with her to jook joints and turpentine plants throughout her travels in the South, and so pleased were those who heard its blues rhythms that they called it "the party book." In retrospect, *Fine Clothes to the Jew* is widely regarded as Hughes's most important achievement; Hughes's biographer, Arnold Rampersad, called it "comparable in the black world to *Leaves of Grass* in the white."[16]

COUNTEE CULLEN ACHIEVES RESPECTABILITY. When Richard Bruce Nugent, one of Countee Cullen's fellow Renaissance writers, saw him step up to accept his second prize at the 1925 *Opportunity* awards, he observed, "Cullen looks like one of the three pigs in swallowtails."[17] The remark was uncharitable but not altogether off the mark; Cullen strained for courtly refinement.

Blues Musicians

Gertrude "Ma" Rainey
Bessie Smith
Huddie Ledbetter ("Leadbelly")
Big Mama Thornton
Muddy Waters
B. B. King

Blues-Inspired Musicians

Duke Ellington
Count Basie
Billie Holiday
Mahalia Jackson
Little Richard
Aretha Franklin
James Brown

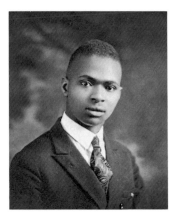

Countee Cullen, c. 1925

Speaking of aiming for the stars, you have virtually disarranged the entire solar system.

—Gwendolyn Bennett to
Countee Cullen

What is Africa to me:
Copper sun or scarlet sea,
Jungle star or jungle track,
Strong bronzed men, or regal black
Women from whose loins I sprang
When the birds of Eden sang?
*One three centuries removed
From the scenes his father loved,
Spicy grove, cinnamon tree,
What is Africa to me?*
—Countee Cullen, "Heritage"

The drive toward respectability that Cullen had demonstrated before graduating high school accelerated during his early adulthood. He remained the perfect child prodigy. (As Wallace Thurman imagined Cullen's working method: "eyes on a page of Keats, fingers on typewriter, mind frantically conjuring up African scenes. And there would of course be a Bible nearby."[18]) During November 1924 Countee Cullen's poems were published in four prominent white magazines—*Harper's, Century, American Mercury, Bookman.* His poems were also widely read—their lessonlike quality and singsong couplet rhythm lent themselves to repetition—even in universities. Carl Van Vechten observed that one of Cullen's lines was probably the most repeated of all contemporary black poets: "Yet do I marvel at this curious thing:/To make a poet black, and bid him sing."

Cullen's position was consolidated when Harper published *Color* in 1925. Both the white and black press responded favorably, some immoderately so. Alain Locke's encomium was no surprise: "Ladies and gentlemen! A genius! Posterity will laugh at us if we do not proclaim him now."[19] But a critic in the *Yale Review* carried the praise even further. "There is no point in measuring him merely beside Dunbar . . . and other Negro poets of the past and present: he must stand or fail beside Shakespeare and Keats and Masefield, Whitman and Poe and Robinson."[20] This was exactly the sort of review Cullen most cherished, for he wanted to be evaluated for his talent alone.

"If I am going to be a poet at all," he told a newspaper reporter, "I am going to be POET and not NEGRO POET."[21] Yet his books referred to color, even in their titles (*Color, Copper Sun, The Black Christ*), and his best poems usually dealt with race. Used by the New Negro movement during its most active period of race-building, Cullen would probably not have received such attention

YET DO I MARVEL

I doubt not God is good, well-meaning, kind,
And did He stoop to quibble could tell why
The little buried mole continues blind,
Why flesh that mirrors Him must some day die,
Make plain the reason tortured Tantalus
Is baited by the fickle fruit, declare
If merely brute caprice dooms Sisyphus
To struggle up a never-ending stair.
Inscrutable His ways are, and immune
To catechism by a mind too strewn
With petty cares to slightly understand
What awful brain compels His awful hand.
Yet do I marvel at this curious thing:
To make a poet black, and bid him sing!

—Countee Cullen, 1923

were he not African American. He was a figurehead New Negro, playing strictly by the rules and exemplifying (as Hughes did not) the racial and moral values of the Talented Tenth. His supporters ignored the morbidity that ran through his poems and feigned deafness at his refusal to be considered a Negro poet. Cullen continued the quest for the credentials that only prizes, degrees, and the older generation could bestow—and in a remarkably short time he won them all.

Hell: **Ginny Gall** ("Way off in Ginny Gall/where you have to eat cow cunt, skin and all." [Hurston]); **West Hell** (a suburb worse than Hell); **Belutha-hatchie** (next station beyond Hell); **Diddy-Wah-Diddy** (another suburb of Hell, where folks in Hell go for good jooking, barbecues, fish fries)

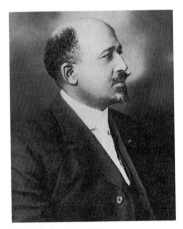

W. E. B. Du Bois, 1928

"Dig? Dig me? Do you collar the jive?" Do you understand?; and response: "I'll do like the farmer, plant you now and dig you later."
[Hurston]

In June 1925, he graduated Phi Beta Kappa from New York University (his key was always prominently sported), and in 1926 he received a master's degree from Harvard. He won nearly every award available to him: the *Opportunity* prizes, the Witter Bynner Poetry contest, the Amy Spingarn Award of *The Crisis* magazine, the John Reed Memorial Prize of *Poetry*, and a Guggenheim fellowship.

Cullen received his most public pedigree in the spring of 1928, when he married Yolande Du Bois, the daughter of W. E. B. Du Bois. Some members of Harlem society wondered whether the union could work, since Yolande Du Bois was infatuated with band leader Jimmie Lunceford ("The New King of Syncopation") and Cullen was more attracted to Harold Jackman, the urbane, handsome schoolteacher who had been his closest friend since De Witt Clinton High School days. Nevertheless the marriage was widely viewed as the merger of intellect and beauty. On April 9, guests began arriving three hours early at the Salem Methodist Church for a twilight wedding. Those with engraved invitations sat in the downstairs pews, while the masses thronged the balcony and the streets outside—thirteen patrolmen and two police sergeants kept the three thousand guests in order. The organist from Union Theological Seminary played the *Lohengrin* march as sixteen bridesmaids and ten ushers marched down the center aisle. (Among the ushers was Langston Hughes, whose rented tails and threadbare stovepipe trousers prompted him to vow "I will never go into society again if I have to rent my clothes."[22]) Cullen's father officiated at the wedding, while Yolande's father watched the procession with pride, all the while ticking off the number of college degrees among the wedding party. "It was the symbolic march of young and black America . . . it was a new race, a new thought, a new thing rejoicing in a ceremony as old as the world."[23] At 6:45 the groom's father pronounced the cou-

ple man and wife. (Du Bois wanted to punctuate the vows by releasing a thousand white doves, but even Countee Cullen recognized that this exceeded the tasteful limits of matrimonial pageantry.)

As it turned out, the wedding was not only symbolic, but *primarily* symbolic. The bride evinced little interest in her husband's poetry, and Cullen sailed to Paris a few months later with Harold Jackman. The marriage was probably never consummated, and it disintegrated before the year was out. Cullen lost a wife but retained a father-in-law; Du Bois blamed the breakup on his daughter's flightiness rather than questioning Cullen's adequacy as a husband.

CLAUDE McKAY, EXPATRIATE. The writers whose books heralded the New Negro movement—Claude McKay and Jean Toomer—were geographically distant from Harlem during its heyday. In the fall of 1922, Claude McKay had shipped out as a stoker, bound for Russia—and his peripatetic expatriate life continued for the next twelve years. After the Soviet chapter of his life had ended, McKay lived in Berlin, Paris, Marseilles, Tangiers, and Cap d'Antibes. He consorted both with his friend Max Eastman's stylish set on the Riviera and with sailors and layabouts in the old port of Marseilles. He conducted a life of sensual intensity and adventurous variety, mixed with concomitant poverty, near-starvation, and sickness. He did whatever was necessary to sustain himself in barest bohemian style. He survived not only through money from patrons such as Louise Bryant and a stipend from the Garland Fund, but also from a string of jobs as a valet, a domestic, a nude artist's model, an extra in *The Garden of Allah*. When he ran into members of the generation of New Negroes, McKay recalled, "I was an older man and not regarded as a member of the renaissance, but more as a forerunner."[24]

My destiny is to travel a different road.
—Claude McKay

Color-consciousness was the fundamental of my restlessness.
—Claude McKay

Unsheik: *divorce*

Why, you are wearing the same kind of gloves as I am!
—Alain Locke

Yes, but my hand is heavier than yours.
—Claude McKay

McKay received little support from Harlem's black intelligentsia. Alain Locke considered him a dangerously radical polemicist, and McKay in turn called Locke "a dyed-in-the-wool pussy-footing professor."[25] W. E. B. Du Bois couldn't understand why he didn't just "come home."[26] James Weldon Johnson continued his warm support, and Charles Johnson professionally conducted his *Opportunity* relations, but McKay had little confidence in black editors. In the past they had softened his poems, altered their titles, or had left them unpublished. While the younger bright lights of the Renaissance were winning awards and Negrotarian patronage, McKay continued on his marginal path. "I suppose I am in disgrace—a back number," he wrote.[27]

Although he was geographically remote, McKay proclaimed his American roots in his novel *Home to Harlem,* arguably the best of the spate of black novels that appeared in 1928. His picaresque tale offered working-class African-American characters set against the backdrop of Harlem streetlife and nightlife, and featured pimps, loan sharks, prostitutes, crap shooters, and Pullman car waiters. Notably absent from its pages were the Talented Tenth. The book's publication aroused the same storm as Carl Van Vechten's novel *Nigger Heaven* had two years earlier, and the camps divided along similar lines. White critics applauded it as "the real stuff, the lowdown on Harlem, the dope from the inside,"[28] and seventy-five-year-old philanthropist Charlotte Mason effused that "life and laughter is ready to burst into such brilliant sunshine that, in the end, all the world will be robed in beauty, and all the peoples of the world will be forced to recognize the powers of re-creation."[29] Du Bois was appalled by its depiction of the debauched Tenth and another black critic declared that it "out-niggered Mr. Van Vechten."[30] But the younger generation of Niggerati associated with the radical little magazine

Jacket cover by Aaron Douglas for Claude McKay's Home to Harlem, 1928

I created my Negro characters without sandpaper and varnish.
—Claude McKay

I feel distinctly like taking a bath.
—W. E. B. Du Bois, after reading *Home to Harlem*

Claude McKay as photographed by Berenice Abbott, Paris, 1927

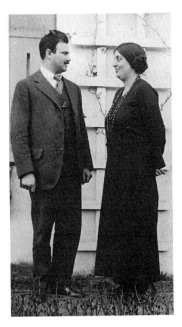

Waldo Frank and Margaret Naumberg, c. 1923

One ought to be something before one essayed to say something.
—Jean Toomer

Ever since I came to you that day at Darien there has been a most cruel silence on the sheer life-plane, on that plane where we have had such deep and sustaining contacts.
—Jean Toomer to Waldo Frank

Fire!! regarded McKay's novel as the truest picture of black life yet published, and Langston Hughes declared "it is the finest thing 'we've' done yet."[31] The public snapped it up, and within two weeks of its publication, *Home to Harlem* became the first novel by an African-American writer to hit the best-seller list.

JEAN TOOMER DECLINES RACIAL IDENTITY. At the time of *Cane*'s publication in 1923, Jean Toomer had reached the apex of his literary career. He enjoyed a quasi-mystical brotherhood with Waldo Frank, the approbation of literary colleagues and admirers, and a prominent place among his generation of young Greenwich Village intellectuals. The promise of his career disintegrated with astonishing rapidity.

Just before *Cane*'s publication Toomer visited Waldo Frank at his home in Darien, Connecticut, and for the first time he met Frank's wife. Earthy and dark-haired, Margaret Naumberg was blessed with the bedrock self-assurance Toomer lacked. Naumberg's mind had been filled with Toomer after reading the proofs for *Cane* and hearing her husband rhapsodize about its author—but neither she nor Toomer were prepared for the effect of encountering one another in person. They instantaneously beguiled one another and soon fell in love. Toomer underwent one of his cataclysmic changes. "The notion I once entertained of an isolated, self-sufficient art existence is exploded," he wrote Naumberg. "In its place I have the vision—I have something more than a vision—I have the vision and the *experience*, Marge, of a linked, interacting, completed Life."[32]

Toomer's relationship with Naumberg would last just a year, and in that time Frank would end his seven-year marriage and cut all ties to his friend. With Toomer's close-knit literary circle all but dissolved, he conducted his quest for identity in new landscapes. In

the spring of 1924, Toomer met the Russian mystic, Georgi Ivano-
vitch Gurdjieff. He quickly became a follower and subsequently a
leader of the movement that attracted so many key figures of pro-
gressive cultural circles. Beginning in the spring of 1925, Toomer
carried the gospel to Harlem, where he organized groups and taught
classes in the Gurdjieff method. Several New Negroes participated
—Wallace Thurman, Aaron Douglas, Nella Larsen, and Harold Jack-
man among them—but membership quickly dropped off, and after
a year of teaching Toomer stopped.

At this point Toomer's tenuous connection with Harlem
ended. A few years later Toomer denied his membership in the black
race and declared himself "simply an American."[33] In the remaining
four decades of his life Toomer would continue to write—among his
papers are endless autobiographical fragments in the form of novels,
poems, essays, and plays—and he continued his quest for self-
realization through psychoanalysis and East Indian religion. But by
the time of his death at seventy-two, this man who had yearned for
greatness had published very little. *Cane* had been reprinted only
once in his lifetime. By the time it was rediscovered as a literary
classic in the 1960s, Toomer was recently dead.

**WALLACE THURMAN AND THE YOUNGER GENERATION OF NIG-
GERATI.** Twenty-three-year-old Wallace Thurman arrived in Harlem
on Labor Day, 1925, as a friend observed, "with nothing but his
nerve."[34] His slender frame pulsed with frenetic, high-pitched laugh-
ter, and his barely accented speech was not only rapid-fire but usually
very smart. A friend remarked that his nature was "rich in what I
might call the Shelleyan essence."[35] He drank heavily, pursued public
sex (he was arrested in a subway toilet a few days after his arrival),

Followers of Gurdjieff
A. R. Orage
Muriel Draper
Jane Heap
Margaret Anderson
Aaron Douglas
Katherine Mansfield
Hugh Ferriss
Lincoln Kirstein
Gorham Munson

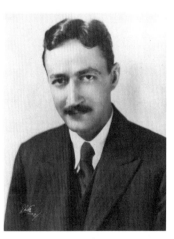

Jean Toomer, 1932

Wallace Thurman as a baby

Perhaps I am the incarnation of the cosmic clown.
— Wallace Thurman to Langston Hughes

Passing: *passing for white*

stayed up nights, owed money everywhere, and lent money when it came his way. Despite the personal disarray of his life, he worked very hard. Not the best writer of the New Negro's second generation (that was Zora Neale Hurston), nor its most exotic figure (for that was Richard Bruce Nugent), Wallace Thurman was regarded as the leader of the young constellation of literary bohemians and as the emblem of the movement's intense and quickly spent life. "We're all in the same bunch with Langston Hughes and Countee Cullen and the rest," Thurman told an interviewer. "But they've arrived and the rest of us are on the make."[36]

Thurman was born in 1902, was raised in Salt Lake City, and moved to Los Angeles during his adolescence. He wrote his first novel at the age of ten and tried his hand at movie scenarios. After the inevitable spate of writing college poems about "gypsies, hell, heaven, love and suicide,"[37] he had launched *The Outlet,* a West Coast publication for the New Negro. When the newspaper died after six months, Thurman headed East and survived financially as an elevator operator while pursuing his writing. Within his first year he became an editor for *The Messenger* and the first black editorial assistant ever hired by the white publication *The World Tomorrow* (in part because Thurman could, at least by reputation, simultaneously read eleven lines of print). As his obituary noted, "Almost overnight Thurman became the kingfish of Aframerican literature."[38]

When he arrived in Harlem, Thurman's identity as an outsider was already deeply ingrained. He was homosexual, alcoholic, effeminate, tubercular, and—most prominently in his mind—very, very dark. Thurman's sensitivity about color was far from neurotic, for it was not only among the white Cotton Club crowd that light-skinned Negroes were valued. Within the multihued world of Harlem itself, color hierarchies reigned. The fine calibration of degrees on the mel-

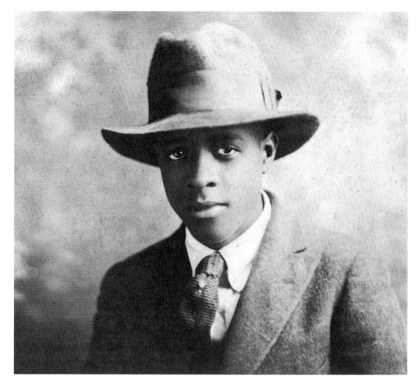

He was a strange kind of fellow, who liked to drink gin, but didn't like to drink gin; who liked being a Negro, but felt it a great handicap; who adored bohemianism, but thought it wrong to be a bohemian.
　　—Langston Hughes, on Wallace Thurman

He was black in a way that it's hard for us to recognize that people ever had to be black.
　　—Richard Bruce Nugent, on Wallace Thurman

Novelist and Fire!! editor Wallace Thurman, c. 1925

anin scale can be seen in novels, where fictional characters are identified by their precise shade, in the fascination with "passing" for white, and in the rich vocabulary—both formal and slang—developed to describe skin color. Some of the key novels of the period—Thurman's *The Blacker the Berry* and Nella Larsen's *Passing* and *Quicksand*—examined skin color as central themes in their narratives.

　　Although dark-skinned African Americans like Thurman, Countee Cullen, and Claude McKay felt rejection due to their color,

Lower class: **rats** (opposite of **dicty**)

Color

*The Harlem vocabulary for shades of pig-
mentation was highly nuanced, and the
color scale went like this:*

Light-skinned:
high yaller
yaller
pink
pink-toes
mustard seed
punkin seed
honey
lemon-colored
copper-hued
olive

Middle ranges of skin color:
high brown
cocoa brown
chestnut
coffee-colored
nut brown
maroon
vaseline brown
seal brown
sealskin
low brown

Dark-skinned:
blue
charcoal
ebony black
eight-rock
eight-ball
inky dink
dark black
low black
lam black
damn black

the color line also affected the light-skinned blacks who dominated the black intellectual establishment. Several of them, notably W. E. B. Du Bois, Nella Larsen, and Walter White, could have "passed"—and for Jean Toomer the issue of divided racial loyalties became a lifelong obsession.

When such a light-skinned Negro as Richard Bruce Nugent first encountered Thurman in a cafeteria, introduced by Langston Hughes, Nugent recoiled at the writer's blackness. "There was this little black boy with a sneering nose. . . . I couldn't eat." Shocked by his residual color chauvinism, Nugent excused himself and walked away thinking "How dare he be so black."[39] Nugent apologized, the two men became roommates, collaborators, and best friends—but Thurman never forgave him for their first meeting.

Thurman flaunted his otherness as a badge both in his social life and in his writing. Turning his back on the positive features of race-building, he cultivated what he called his "pet hates," and among them were "all Negro uplift societies, Greta Garbo, Negro novelists including myself, Negro society, New York state divorce laws, morals, religions, politics, censors, policemen, sympathetic white folk."[40] To Harlem's younger generation he became a symbolic alternative to the repressed dictydom of the Talented Tenth. "We used to call Wally our leader," recalled writer Dorothy West, and Nugent observed that he not only found his milieu but "in fact, he almost created the milieu."[41]

NIGGERATI MANOR. "I cannot bear to associate with the or-dinary run of people," Thurman wrote. "I have to surround myself with individuals who for the most part are more than a trifle in-sane."[42] He spearheaded a constellation of young artists and writers

who frequented a rooming house at 267 West 136th Street. Rooms were given out rent-free to artists, because the owner, Iolanthe Sydney, believed that indigence was essential to the artistic life. Zora Neale Hurston dubbed the rooming house "Niggerati Manor," and it became the headquarters of the Harlem Renaissance's vanguard wing. Among its company were the writers Hurston and Hughes (who lived there during the summer of 1926), the artists Richard Bruce Nugent and Aaron Douglas, as well as Thurman's white, blond lover, Harold ("Bunny") Stephanson and free-lance bohemians. The building's interior was done up in red and black with the gay abandon of a Greenwich Village flat: there were garish wicker furniture and hooked rugs, and brightly painted phalluses on the walls. The goings on at Niggerati Manor assumed the aura of legend. "The story goes out that the bathtubs in the house were always packed with sourmash, while gin flowed from all the water taps and the flush boxes were filled with needle beer," recalled one frequent visitor. "It was said that the inmates of the house spend wild nights in tuft hunting and in the diversions of the cities of the plains and delirious days fleeing from pink elephants." He concluded, "In the case of Niggerati Manor, a great deal more smoke came out of the windows than was warranted by the size of the fire in the house."[43]

AARON DOUGLAS. Artist Aaron Douglas had moved from Kansas City to Harlem in 1924, just in time for Alain Locke to commission his drawings for *The New Negro*. Douglas's new work was startlingly different from that of his midwestern years. Replacing more academic figuration was the modernist syntax of synthetic cubism and the age-old look of African sculpture. Locke declared him "a pioneering Africanist,"[44] and Douglas's teacher, white Bavarian artist

Those were the days when Niggerati Manor was the talk of the town.
—Theophilus Lewis

Thurman fitted into this crowd like a cap on a bottle of fizz.
—Dorothy West

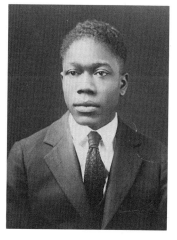

Artist Aaron Douglas, c. 1923

Your problem, Langston, my problem, no our problem is to conceive, develop, establish an art era. Not white art painted black. . . . Let's do the impossible. Let's create something transcendentally material, mystically objective. Earthy. Spiritually earthy. Dynamic.
—Aaron Douglas to Langston Hughes

Winold Reiss, pushed him in this direction. Douglas later wrote, "I clearly recall his impatience as he sought to urge me beyond my doubts and fears that seemed to loom so large in the presence of the terrifying spectres moving beneath the surface of every African masque and fetish."[45] The circle of influence had come full circle—the European Reiss had been inspired by African sculpture and in turn encouraged the African-American Douglas to incorporate his roots into his art. Douglas's art quickly came into vogue—Carl Van Vechten arranged commissions, publishers hired Douglas to illustrate books, and magazines ranging from *The Crisis* to *Vanity Fair* prominently featured his graphic work on their pages. Encouraged by Van Vechten and financially supported by Charlotte Mason, Douglas was soon regarded as the premier visual artist of the Harlem Renaissance, and that reputation has continued to the present.

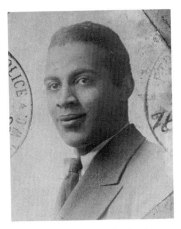

Photo of artist, writer, and bohemian Richard Bruce Nugent from the "Alien Registration" form, 1929

RICHARD BRUCE NUGENT. The homoerotic paintings on the walls of Niggerati Manor were the work of a lesser-known artist named Richard Bruce Nugent. The perfumed orchid of the New Negro movement, Nugent was born into a comfortable Washington, D.C., family, left home at thirteen, and became an openly gay bellhop at the Martha Washington Hotel, where he met many celebrities. By the end of his teens Nugent had become an extravagant decadent, and he began to draw in the style of Aubrey Beardsley. In *echt* bohemian fashion Nugent went about tieless, underwearless, sockless —and sometimes even shoeless—wearing a single gold bead in one pierced ear, sleeping in Washington Square or under Wallace Thurman's bed. Thurman observed that Nugent "never recovered from the shock of realizing that no matter how bizarre a personality he may develop, he will still be a Negro. . . ."[46] Nugent vaguely aspired

to be an artist and writer, and he frequented the lively Saturday-evening salons that poet Georgia Douglas Johnson organized for Washington, D.C., writers. Here, in 1925, he met Langston Hughes. "He was a made-to-order Hero for me," Nugent recalled. "He had done everything—all the things young men dream of but never quite get done—worked on ships, gone to exotic places. . . ."[47] Nugent recalled that on the night of their meeting, "he would walk me home and then I would walk him home and then he would walk me home and I'd walk him home and it went on all night."[48]

FIRE!! On those night-long perambulations, Nugent and Hughes talked of starting a radical little magazine of the New Negro movement. They invited Wallace Thurman to be its editor, and it was in his room and favorite hangouts that *Fire!!* took shape. By this time, stories, poems, and drawings by African Americans had appeared in both black and white publications, but Harlem offered no equivalent to the avant-garde little magazines that flourished in Paris and Greenwich Village. The quarterly magazine they planned over meals at Craig's restaurant on 135th Street would be "Devoted to the Younger Negro Artists."

Printed on fine cream-colored paper and sporting a dramatic red and black cover, the magazine appeared in November 1926. It celebrated jazz, paganism, blues, androgyny, unassimilated black beauty, free-form verse, homosexuality—precisely the "uncivilized" features of Harlem proletarian culture that the Talented Tenth propagandists preferred to ignore. *Fire!!* offered an alternative manifesto to *The New Negro*, undiluted by sociopolitical issues and race-building efforts. Nugent recalls that he and Thurman wanted to get the magazine banned in Boston, and it was determined that Thurman would

Fy-ah,
Fy-ah, Lawd,
Fy-ah gonna burn ma soul!
—Langston Hughes,
Foreword to *Fire!!*

Contributors to *Fire!!*
Langston Hughes
Zora Neale Hurston
Countee Cullen
Wallace Thurman
Aaron Douglas
Richard Bruce Nugent
Gwendolyn Bennett
Arna Bontemps
Helene Johnson
Waring Cuney
Lewis Alexander
Edward Silvera

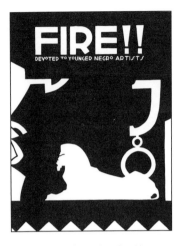

Fire!! cover by Aaron Douglas, November 1926

Let art portray things as they are, no matter who is hurt, is a blind bit of philosophy.
—Countee Cullen

Syndicating, woofing: *gossiping*

write about a prostitute and Nugent about a decadent à la Huysmans. Thurman's story, "Cordelia the Crude," featured a fifteen-year-old prostitute, and it later became the basis for Thurman's 1929 hit Broadway play, *Harlem.* Featuring fiction by Zora Hurston, Thurman, and Nugent; drama by Hurston; poetry by Hughes and Countee Cullen; illustrations by Aaron Douglas and Nugent, *Fire!!* offered up the young Harlem.

In retrospect *Fire!!* represents the Renaissance's vanguard wing at its apex. The Old Guard regarded the publication as a bilious symptom of the New Negro movement's slide from uplifting propaganda to suspect beauty to unalloyed decadence. (One critic labeled it "Effeminate Tommyrot."[49]) It was not their disapproval that caused the magazine's rapid demise after its initial issue but its high price ($1), its lack of institutional support, and the meagerness of a paying black vanguard audience. The magazine had cost $1,000 to produce, and hundreds of unsold copies burned in an all-too-fitting fire; Thurman spent four years paying off the printing bills, and he complained to Langston Hughes, "*Fire!!* is certainly burning me."[50]

CONTROLLING THE BLACK IMAGE. One consequence of the rising white interest in African-American literature was the black intelligentsia's drive to control its own image. Renaissance writers, intellectuals, and artists were charged with articulating a racial identity that not only plumbed indigenous black experience but simultaneously assumed a positive face for white society. The search for an appropriate black image was reflected in a continuing series *The Crisis* devoted to the question: "The Negro in Art: How Shall He Be Portrayed?," a questionnaire Carl Van Vechten devised at Jessie Fauset's request. Most crucially, the battle was waged through prizes for

black art and artists and writers. Awards were sponsored by periodicals (*The Crisis, Opportunity*), by white patrons (e.g., the Spingarn Medal, the Harmon Award, the Witter Bynner Prize, the Van Vechten Award, the Albert and Charles Boni Prize for the Negro Novel), and by black civic groups (black banks and insurance companies, the Federation of Colored Women's Clubs). These prizes helped shape the debate about appropriate representations of Negro life. The attitudes of these factions delineated the positions taken at the time of the New Negro Renaissance.

So many of the Negro elite love to mouth that phrase about "betraying the race"! As if the Negro group had special secrets which should not be divulged to the other groups.
—Claude McKay

Representing the Old Guard, W. E. B. Du Bois proclaimed that Negro literature must stress Beauty and Truth, and it was a sign of his own arrogance that he believed he knew precisely what these two abstractions meant. Publicly he offered ecumenical visions of Beauty—he told the NAACP that he found it embodied in the diverse forms of the Cologne Cathedral, a West African village, the Venus de Milo, and a Southern spiritual. But the novels he wrote and the works he supported suggested that his range was considerably narrower. Literature must, first and foremost, serve as a didactic and propagandistic tool for advancing African-American culture. Du Bois applauded portrayals of the Talented Tenth (exemplified by Jessie Fauset's novels of black gentility) and dramatizations of the clean-living, church-going, hard-working lower classes. As Countee Cullen, who hewed to Du Bois's line, expressed it, "Decency demands that some things be kept secret; diplomacy demands it; the world loses respect for violators of this code."[51]

I do not care a damn for any art that is not used for propaganda.
—W. E. B. Du Bois

Every phase of Negro Life should not be the white man's concern, The parlor should be large enough for his entertainment and instruction.
—Countee Cullen

African-American experience must be filtered through the lens of beauty and articulated in a vocabulary that did credit to the race. To Du Bois this meant high cultural forms rather than vernacular expression, and stories set in Strivers' Row parlors instead of Lenox Avenue cabarets. The very commodities that lured whites to Har-

Brick-presser: *an idler (literally, one who walks the pavement)*

lem—sex, jazz, alcohol—were proscribed from his canon, and he con-
sidered the best-selling Harlem novels—*Nigger Heaven, Home to
Harlem*—pernicious sensationalism. While Du Bois did not entirely
reject such African-American folk expression as the blues and the
black dance, he believed that they would assume more elevated "ar-
tistic" forms as the race evolved. From his perspective, there was little
place for Jelly Roll Morton or Bessie Smith, the blues or jazz, the elec-
tric energy of revival meetings or the inventiveness of Harlem street
slang, until these idioms had been transformed into "serious" art.

At the other extreme from Du Bois were the younger gener-
ation associated with Niggerati Manor: Wallace Thurman, Langston
Hughes, Zora Neale Hurston, and Richard Bruce Nugent. They em-
braced precisely the vernacular expressions that Du Bois hoped to
transform. They wrote in the urban idiom of Harlem street slang and
in the rural idiom of folklore; they presented prostitutes, homosex-
uals, and sweetbacks; they set their stories in rent parties, basement
cabarets, and Lenox Avenue tenements. They viewed such melodra-
matic features of black life as its most vital, its truest, and its greatest
hope for an indigenous black literature. Thus Hughes employed a
blues aesthetic in his poetry, Thurman wrote about urban working-
class figures, and Hurston presented the rural folk life of Eatonville.
Hughes's attack on Countee Cullen reflects this faction's aversion to
deracinated compromise: "One of the promising of the young Negro
poets said to me once, 'I want to be a poet—not a Negro poet,'
meaning, I believe, 'I want to write like a white poet'; meaning sub-
consciously, 'I would like to be a white poet'; meaning behind that,
'I would like to be white.' "[52]

The Harlem experience lent itself to such dichotomies be-
tween black and white, high and low, and Alain Locke tried to steer
a course between them. As a Rhodes scholar and devotee of Estab-

lishment culture, he exemplified the older generation's values. But he had also midwived the New Negro. He suggested that blacks hark back to their African heritage for inspiration, using atavistic themes transformed by modern consciousness. He favored realistic portrayals of black life that went beyond the genteel novels of Jessie Fauset; his version of black respectability was based on sympathetic portrayals of all the classes. For Locke, every aspect of the black heritage—from folklore to spirituals, from jazz to African sculpture—offered rich source material from which a black image might be fashioned. What distinguished him from Du Bois was his concentration on the transforming power of art; Locke envisioned Harlem as a cultural phenomenon rather than a political center, and the quality of the expression mattered more than its race-building "appropriateness."

Negroes in America . . . feel they must always exhibit specimens from the college rather than from the kindergarten, specimens from the parlor rather than from the pantry.
—Wallace Thurman

I discover therein that one had almost as well be civilized, since primitiveness is nearly so complex.
—Langston Hughes, on reading books about African art sent by Alain Locke

NEGROTARIANS. There were many white faces at the 1925 *Opportunity* awards dinner. So far they have been merely walk-ons in the story of the New Negro, but they became instrumental forces in the Harlem Renaissance. The two white supporters who play major roles in the coming pages—Carl Van Vechten and Charlotte Mason—are simply the most prominent within the small army that Zora Neale Hurston dubbed the "Negrotarians." Their ranks were united in little but their whiteness and their vaguely "progressive" beliefs; they encompassed two generations and both sexes, Jews and Christians, immigrants and landed gentry. Their conceptions of the African American varied widely. To different factions the Negro represented a revolutionary political recruit, a naturally sensuous animal, an indigenously spiritual being, an "authentic" American artist, a victim of civil rights abuse.

Dominating the early generation were Jewish capitalists, who

*Physical attributes: **can** (rump); **gut-foot** (bad case of fallen arches); **palmer house** (walking flat-footed, as from fallen arches); **liver lip** (pendulous, thick, purple lips; "He was called Liver-lip behind his back, because of the plankiness of his lips."); **gator-faced** (long face with large mouth); **battle-hammed** (badly formed about the hips),*

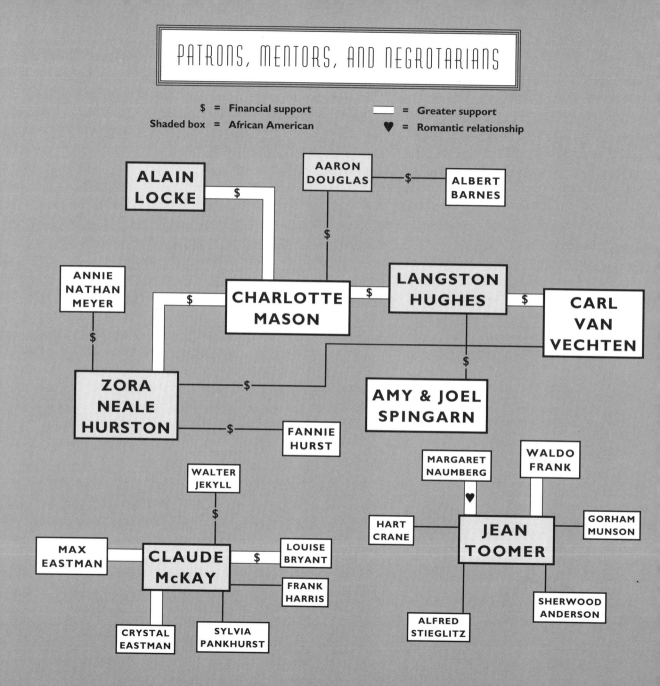

promoted education and civil rights. Their alliance with African Americans was formed, in part, in reaction to the enemies they had in common—embodied in the Ku Klux Klan—and also by a sense of identification with the Negro's plight. "The depths of that problem in all their horror, only a Jew can fathom," wrote Theodore Herzl.[53] Julius Rosenwald, for example, in 1910 spent some of his Sears, Roebuck & Company fortune on the construction of twenty-five YMCAs for African Americans. (Following Rosenwald's example, the Rockefellers built several YMCAs in New York.) The Spingarns—Joel, his wife Amy, and his brother Arthur—had been instrumental figures in the National Association for the Advancement of Colored People since its founding in 1910, and continued actively supporting Negro causes for several decades.

The 1920s introduced a new breed of Negrotarians. Many of the newcomers traveled in literary, artistic, and high bohemian circles. Their interest focused on the expressive powers they detected in the New Negro writers, and in black life itself, both urban and rural. Many writers of the twenties—including Sherwood Anderson, Fannie Hurst, Eugene O'Neill, Waldo Frank, T. S. Stribling, DuBose Heyward, and Paul Green—introduced black characters into their novels. Musicians such as George Gershwin and Paul Whiteman incorporated Negro idioms into compositions. Impresarios such as Florenz Ziegfeld hired black performers for their revues. Only a small minority of this group contributed money to Negro causes; historian David Levering Lewis described them as "Salon Negrotarians." Their genuine appreciation of black performing and literary arts and Harlem's exciting milieu was mixed with self-interested investment and attention to cultural fashion. Their influence proved essential to the growth of the movement. They offered the keys to the virtually all-white publishing industry, and they helped shape the fashion that

The Negrotarians have a formula, too. They have regimented their sympathies and fawn around Negroes with a cry in their heart and a superiority bug in their head. It's a new way to get a thrill, a new way to merit distinction in the community.

—Wallace Thurman

Negrotarian: *coined by Zora Neale Hurston to denote whites that support the New Negro movement*

attracted customers to cabarets. At that juncture in history it was important to hear African-American friends mentioned in conversation, to see black-related and black-authored features appearing in newspapers and magazines, and to witness images of Negroes on stage and in books. Many of those images today appear racist, but they represented a striking advance over the existing repertoire of stereotypes. The second generation of Negrotarians made the African American a more visible—if only slightly less stereotypical—character in the national imagination. As George Schuyler observed, the 1920s Negrotarians offered black writers and artists "recognition and acceptance from the top."[54]

Novelist, critic, and photographer Carl Van Vechten by Nickolas Muray, 1927

CARL VAN VECHTEN. The Negrotarian who most enjoyed the spotlight was Carl Van Vechten, a tall, ungainly, homosexual dandy in his mid-forties with corn-silk hair and protruding teeth. One acquaintance unflatteringly compared him to "an aging madonna lily that had lost its pollen and had been left standing in a vase which the parlor-maid had forgotten to refill with fresh water."[55] Van Vechten's support for the New Negro movement mixed literary appreciation, low-life voyeurism, race consciousness, sexual attraction, and a sensitive nose for fashion (which he set rather than followed).

But Van Vechten's interest in Negroes long preceded Harlem's vogue—his father cofounded Piney Woods School, the first black school in Mississippi, and Van Vechten had been enchanted early on by Bert Williams, had introduced black singer Carita Day to the University of Chicago, and as early as 1914 he hailed a play by a white author, Ridgely Torrence, about Negro life (*Granny Maumee*) as the "most important contribution which has yet been made to the American stage."[56] Beginning in the 1910s, Van Vechten's advanced

taste could be judged by the music he supported (Stravinsky), the dance he promoted (Isadora Duncan and, especially, Loie Fuller and Diaghilev's Ballets Russes), and the clothes he wore (puckered pastel shirts, sheer flesh-toned stockings, the first wristwatch in New York). He helped organize Mabel Dodge's legendary salon, where, in 1913, he introduced black cast members of J. Leubria Hill's *My Friend from Kentucky* to Greenwich Village. Dodge's shocked response to their cakewalks and "coon songs"—"appalling," "embarrassing"— suggested that even this bohemian hostess was not ready to accept African Americans into her home.

A decade later, inspired by reading Walter White's novel *The Fire in the Flint*, Van Vechten began frequenting Harlem. "Jazz, the blues, Negro spirituals, all stimulate me enormously for the moment," Van Vechten wrote in the summer of 1924. "Doubtless, I shall discard them too in time."[57] Among the progressive culturati he popularized the trend of Going Uptown. Harlem Renaissance writer Sterling Brown called him "one of the pioneers of the hegira from downtown to Harlem."[58] Osbert Sitwell described him as "the white master of the colored revels,"[59] and black lyricist Andy Razaf offered a simple directive in "Go Harlem," his 1930 hit song: "Like Van Vechten, start inspectin'." With his sterling-silver hip flask and jangly bracelets, his Dunhill lighter and English cigarettes, the writer became the Downtowner's guide to Harlem's exotic nighttime terrain. Among those whom he accompanied were Somerset Maugham, Alfred Knopf, Ina Claire, Edmund Wilson, Witter Bynner, and Muriel Draper—being with Van Vechten assured one of not only seeing those establishments that catered to white tourists, but also rent parties, basement clubs, and drag balls.

Van Vechten's reputation rode the wave of the Harlemania that peaked about 1928, and many accused him of using Harlem for

You can see I am hardly seeing any white people at all!
—Carl Van Vechten to Fania Marinoff

Sullen-mouthed, silky-haired Author Van Vechten has been playing with Negroes lately, writing prefaces for their poems, having them around the house, going to Harlem.
—Time magazine, 1925

And we'll get drunker and drunker, and drift about night clubs so drunk that we won't know where we are, and then we'll go to Harlem and stay up all night and go to bed late tomorrow morning and wake up and begin it all over again.
—Carl Van Vechten

White person who consorts with blacks: **jig-chaser; dinge queen** *(homosexual white attracted to black men)*

Carl Van Vechten by Miguel Covarrubias, 1926

If Carl was a people instead of a person, I could then say, these are my people.

—Zora Neale Hurston

his own advantage. If so, he returned the favor by his press agentry for the New Negro movement. He provided instrumental connections to Alfred A. Knopf, who heeded Van Vechten's suggestions to publish Langston Hughes, Nella Larsen, and Rudolph Fisher, to reissue James Weldon Johnson's *The Autobiography of a Colored Man*, and to commission covers by Aaron Douglas. On the pages of fashionable *Vanity Fair*, he trumpeted black blues (and its purveyors Bessie Smith and Ethel Waters) as an art form and introduced poetry by Countee Cullen and Langston Hughes. He was one of the first to suggest that blues songs be recorded before they were lost.

In his lavish apartment at 150 West 55th Street Van Vechten and his wife, the actress Fania Marinoff, hosted mixed-race parties; Marinoff told a reporter, "we are engaged in a crusade to break down the colour bar."[60] It was commonly believed within New York's high bohemian circles that, as one observer put it, "Negroes always make any party brighter and more amusing,"[61] and Van Vechten's were not the only parties that included black guests—for so did those given by Muriel Draper, Amy Spingarn, and Eddie Wasserman. "But only Carl Van Vechten's parties," Langston Hughes recalled, "were *so* Negro that they were reported as a matter of course in the colored society columns. . . ."[62]

The backdrop for these gatherings, Van Vechten's drawing room, offered a twenties' chic color scheme—raspberry, purple, and turquoise—and mixed such accessories as a Venetian glass chandelier; vases of calla lilies; Oriental rugs; and a perfectly controlled clutter of paperweights, silver fishes, and ceramic cats. On this set black writers and performers made connections with white culture brokers. African-American guests often performed (although Van Vechten never regarded it as a "sing for your supper" proposition). James Weldon Johnson recited poems from *God's Trombones*; Countee Cullen

read and gave after-dinner Charleston lessons; Bill Robinson tap-danced; Taylor Gordon and Paul Robeson performed spirituals; and Bessie Smith sang the blues. (When Metropolitan Opera diva Marguerite D'Alvarez returned the favor with an aria, Smith exclaimed, "Don't let nobody tell you you can't sing!") Caucasian guests included George Gershwin, Fannie Hurst, Horace Liveright, Theodore Dreiser, Helena Rubinstein, Hugh Walpole, Elinor Wylie, Nickolas Muray, and the three Stettheimer sisters, Carrie, Ettie, and Florine. Conversation was well-lubricated by the superior gin provided by Van Vechten's personal bootlegger, who ran a speakeasy in the West Forties. High bohemian and high-toned, these parties permitted liquor and sexual innuendo but prohibited drugs and sexual acting out. The social interchange between races had become so everyday that it gave rise to a widely quoted, apocryphal account of an exchange between a Grand Central Station porter and Mrs. Vincent Astor, whom the porter wished a good morning. "How do you know my name, young man?" she asked. "Why, ma'am, I met you last weekend at Carl Van Vechten's."[63]

. . . indubitably now is the psychological moment when everything chic is Negro.
—Carl Van Vechten to Langston Hughes

NIGGER HEAVEN. "Are Negro writers going to write about this exotic material while it is still fresh," Van Vechten asked, "or will they continue to make a free gift of it to white authors who will exploit it until not a drop of vitality remains."[64] When his query appeared in *The Crisis* in the spring of 1926, Van Vechten had completed three drafts of a novel that would do just that. Inspired by the novels of James Weldon Johnson and Paul Laurence Dunbar and his own Uptown research, he wanted to create a book that presented vivid slices of Harlem life.

Nigger Heaven appeared in August 1926, featuring a banal

Drinking: **hootch, smoke, juice, scrap iron** *(all cheap liquor);* **conk buster** *(cheap liquor, also derogatory term for black intellectual);* **peeping through my likkers** *(carrying on while drunk);* **your likker told you** *(misguided behavior while drunk)*

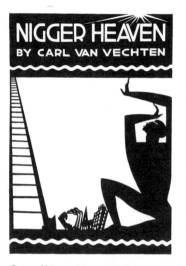

Cover of Nigger Heaven by Aaron Douglas, 1926

From NIGGER HEAVEN

Nigger Heaven! Byron moaned. Nigger Heaven! That's what Harlem is. We sit in our places in the gallery of this New York theatre and watch the white world sitting down below in the good seats in the orchestra. Occasionally they turn their faces up towards us, their hard, cruel faces, to laugh or sneer, but they never beckon. It never seems to occur to them that Nigger Heaven is crowded, that there isn't another seat, that something has to be done. It doesn't seem to occur to them either, he went on fiercely, that we sit above them, that we can drop things down on them and crush them, that we can swoop down from this Nigger Heaven and take their seats. No, they have no fear of that! Harlem! The Mecca of the New Negro! My God!

Carl Van Vechten, 1926

Cheap French romance, colored light brown.
—The Independent, on Nigger Heaven

Black person who consorts with whites: **pink-chaser, lippy-chaser**

dime-novel narrative driven by conventional love triangles and cardboard characters, seasoned by stretches of glittering prose and the author's insider's perspective. It became an instant best seller, going through nine printings in four months. Van Vechten introduced the exotic world of Harlem into living rooms across America, revealing family secrets and featuring both scandalous nightlife hoi polloi and Talented Tenth Negroes as the novel's main characters. Banned in Boston, the novel served as an informal pocket guide to those who went Uptown, in the jargon of the time, " 'van vechtening' around."[65]

The book split the black literary community, and some Harlemites felt it necessary to cover *Nigger Heaven*'s sky-blue cover in

plain paper wrappers, as if the book were pornography. The lines were drawn. Supporters included James Weldon Johnson, Langston Hughes, Wallace Thurman, Nella Larsen, A'Lelia Walker, and *Opportunity* editor Charles Johnson. In favor, they cited the novel's educated middle-class characters and the unidealized veracity of the milieu; one even suggested a statue of Van Vechten be erected at the corner of 135th Street and Seventh Avenue. The book's detractors included W. E. B. Du Bois, Countee Cullen, Alain Locke, and the rank-and-file Harlem reading public. Many couldn't get beyond the title, although it was a play on the term for restricted balcony seating for black theatergoers, and other recent novels—Clement Wood's *Nigger* and Ronald Firbank's *Prancing Nigger*—had also used the offensive term. The aggrieved contingent considered the book, in Du Bois's words, "an affront to the hospitality of black folk and the intelligence of white."[66] Friendships were broken over *Nigger Heaven*; Countee Cullen didn't talk to Van Vechten for fourteen years. An employee at the 135th Street library petitioned Mayor James Walker to ban distribution of the book, Van Vechten was snubbed at the Dark Tower and the Dawn Casino, and it was proposed that he be hanged in effigy.

But, whatever its literary value, the novel was a telling artifact of the period: it announced the advent of widespread Harlemania.

HARLEMANIA. The fascination with Harlem gathered steam in the mid-1920s and peaked just before the Wall Street crash in 1929. Its effect was felt not only Downtown, where black revues had become a Broadway staple throughout the 1920s, but also across the Atlantic in France, where dancer Josephine Baker was Paris's hottest ticket and black jazz bands dominated Montmartre's intimate caba-

Anyone who would call a book Nigger Heaven *would call a Negro Nigger.*
—New York News

It's Harlem—and anything goes. Harlem, the new playground of New York! Harlem—the colored city in the greatest metropolis of the white man! Harlem—the capital of miscegenation! Harlem—the gay musical, Parisian home of vice!
—Edward Doherty

Barron's Cabaret, a pioneering Harlem nightclub, c. 1921

Then Harlem nights became show nights for the Nordics.
　　　　　　　　—Langston Hughes

rets. Stylish Parisians fetishized blacks before their American counterparts. As Lincoln Kirstein remarked, "To us, Harlem was far more an *arrondissement* of Paris than a battleground of Greater New York."[67] Harlem drew not only those Negrotarians who earnestly supported the literary accomplishments of the Renaissance, but also those who sniffed the winds of fashion. Among the international high bohemian crowd who traveled to Harlem in their Stutzes and Daimlers were Princess Violette Murat, Cecil Beaton, Gertrude Vander-

bilt Whitney, Otto Kahn, Mayor James J. Walker, Lady Mountbatten, Libby Holman, Michael Arlen, Beatrice Lillie, Harry K. Thaw, Muriel Draper, and Harold Lloyd. As Wallace Thurman observed, the Harlem mix provided "a modern Babel mocking the gods with its cosmopolitan uniqueness."[68]

The fascination with Harlem was accompanied by the new objectification of the Negro as an exotic icon. As one observer put it, "To Americans, the Negro is not a human being but a concept."[69] In line with 1920s fashion, the new stereotype incorporated many of the derogatory qualities previously attributed to Negroes, but they were now given a positive spin. The dangerously licentious, over-sexed figure of earlier times was now idealized as an uninhibited, expressive being. Racist images of the Negro as a barbaric jungle creature transformed into those of the noble savage, the natural man exuding animal vitality. The Negro perfectly satisfied progressive America's psychological and intellectual needs of the moment—he represented pagan spirituality in a period of declining religion, native American expressiveness at the time the nation was forging its own aesthetic, and the polymorphous sensuality that exemplified the 1920s' loosening of behavior. A symbol of the Jazz Age, the Negro was enlisted by high bohemia in its war against the Babbitts, the bluenoses, and the Republicans who ruled the nation. Being promoted to icon status, however, did little to raise the financial fortunes of black Americans, nor did it break widespread Jim Crow laws.

Harlemania was distinct from the literary contributions of the Renaissance, and the forefathers of the New Negro movement looked disdainfully on it as a fad. (One called the "new stereotypes hardly better than the old."[70]) They valued high art (poetry, painting, classical music) over the popular culture (dancing, jazz, blues) that lured visitors to Harlem, and they disapproved of its drawing cards of sex,

Maybe these Nordics at last have tuned in on our wave-length.
—Rudolph Fisher

It was going to be necessary, he thought, to have another emancipation to deliver the emancipated Negro from a new kind of slavery.
—Wallace Thurman

Ecstasy seems . . . to be his [the Negro's] natural state.
—Joseph Wood Krutch

I couldn't forget
The banjo's whang
And the piano's bang
As we strutted the do-do-do's
In Harlem!

That pansy sea!
A-tossing me
All loose and free,
O, lily me!
In muscled arms
Of Ebony!

I couldn't forget
That black boy's eyes
That black boy's shake
That black boy's size
I couldn't forget
O, snow white me!
 —Anonymous Southern white
 woman, "Temptation"

drugs, and alcohol. But the vogue and the literature were inextricably linked: Harlemania trained publicity's spotlight on black culture. "Can it be that the Republic, emerging painfully from the Age of Rotary, comes into a Coon Age?" wondered the risible editor H. L. Mencken in 1927. "The colored brother, once so lowly, now ranks, socially, next after English actors."[71]

Interest in black performers accelerated in 1921 with the opening of the musical revue *Shuffle Along,* written by Eubie Blake and Noble Sissle, and performed by an all-black cast that included Florence Mills and Caterina Jarboro. Its success ensured the production of similar black revues on Broadway, but these formulaic hybrids of blacked-up comedians, mammy songs, and darky skits were a scant step beyond minstrel shows. Lamenting the opportunities these shows missed, Van Vechten offered a new prescription: spirituals, Bessie Smith, and a sequence about Strivers' Row. By the second half of the decade, black revues were joined on Broadway by plays written by whites about African-American life: Edward Sheldon and Charles MacArthur's melodrama, *Lulu Belle* (1926), DuBose and Dorothy Heyward's *Porgy* (1927, the source for Gershwin's *Porgy and Bess*), and Marc Connelly's *Green Pastures* (1930). Even Ethel Barrymore made up in blackface for *Scarlet Sister Mary.* (One index of the fashion for black performers is the fact that the Grand Street Follies featured "a burlesque Negro Spiritual to be sung in the death scene of *Camille* played as a Negro troupe would perform it."[72]) Written by white authors, these black-themed plays portrayed the Negro in attitudes that veered from lurid melodrama to childlike sentimentality. Harlem residents generally applauded the shows, in part because their large casts brought money into the community (among the extras in *Porgy,* for example, were Wallace Thurman, Richard Bruce Nugent, and many of the Dark Tower habitués). But it wasn't until

1929, when Wallace Thurman and William Rapp's *Harlem* became a hit, that a black-authored play was successfully produced for Broadway's white audience.

Black music—in the form of spirituals, jazz, blues—reached a new pinnacle of popularity. The lineup of now-legendary singers performing in Harlem clubs included Bessie Smith, Ma Rainey, Adelaide Hall, Gladys Bentley, Florence Mills, and Ethel Waters. Now-legendary jazz bands were found in expensive nightclubs and cheap basement clubs. One could hear Louis Armstrong and his band, accompanied by Ziegfeld-scale floor shows featuring "the cream of sepia talent"[73] at the Cotton Club. Such Fats Waller and Andy Razaf revues as *Keep Shufflin'* or *Hot Chocolates* could be seen at Connie's Inn. For just a quarter one could hear the pick-up combos at informal rent parties, where Willie "The Lion" Smith might drop in at 3:00 A.M. after his gig at Pod's and Jerry's Catagonia Club. There was big-band jazz by Duke Ellington (the "real" alternative to Paul Whiteman). European modernists such as Darius Milhaud, Maurice Ravel, and Igor Stravinsky began to incorporate black musical idioms into their "serious music." When Milhaud first heard Harlem performers, he declared the experience "different from anything I had ever heard before and [it] was a revelation to me."[74]

Dancing provided the perfect complement to black music, and Harlem boasted 300 female and 150 male dancers in clubs at any given moment. (Vernon and Irene Castle, the cutting edge of white nightclub dance, had always insisted on dancing to the music of James Reese Europe.) African-American performers pioneered both theatrical dance and nightclub dance. On the stage, such tap-dancing masters as John Bubbles and Bill "Bojangles" Robinson could be seen, as well as ecentric dancer Earl "Snakehips" Tucker. But it was not only professionals who gave riveting performances. Anonymous

The worship of jazz is just another form of highbrowism, like the worship of discord or the worship of Brahms. . . . It is our native gin, so to speak.
—Virgil Thomson, on jazz

Black Revues of the 1920s:

Liza (1922)
Runnin' Wild (1923)
How Come? (1923)
The Chocolate Dandies (1924)
In Bamville (1924)
Lucky Sambo (1925)
My Magnolia (1926)
Rang Tang (1927)
Bottomland (1927)
Keep Shufflin' (1928)
Blackbirds of 1928 (1928)
Bamboola (1929)

First we got jazz;
Then you got jazz;
All God's chillun—Black, white—
Got their jazz!
 —Lorenz Hart, "Bugle Blow"

**Popular Dances Pioneered by
African Americans**

Turkey Trot
Ballin' the Jack
Eagle Rock
Black Bottom
Truck
Shim Sham
Susie Q
Big Apple
Boogie Woogie
Shag
Bim Bam
Snake Hips

work-a-day Harlemites thronged the dance floors of clubs, developing elaborate Lindy-hop routines and distributing printed cards advertising themselves as dance teachers. "No dance invented by white men has been danced at any genuinely high-toned shindig in America since the far-off days of the Wilson Administration," H. L. Mencken archly observed in 1927.[75] When choreographer Frederick Ashton needed dancers for *Four Saints in Three Acts,* the epochal modernist opera by Gertrude Stein and Virgil Thomson, he headed straight for Harlem's Savoy Ballroom.

The following portrait gallery of 1920s African-American performers merely hints at the extraordinary riches of Harlem clubs and international black revues. The photographs also suggest some ways in which blacks were portrayed—the subjects frequently exude verve, joy, and unabashed sensuality that one rarely found in photographs of white performers. Some of these performers, such as Bessie Smith, Bill "Bojangles" Robinson, and Duke Ellington, have become deeply influential figures; it is impossible to imagine American music without them. Less universally known figures include Adelaide Hall, Clara Smith, and Earl "Snakehips" Tucker, who added variety to Harlem's glittering after-dark landscape. Assembled together, this group helped create the most intensely and joyously creative moment in the history of American popular music.

JOSEPHINE BAKER (1906–1975): *In 1920s Paris, Baker reigned as queen of "le jazz hot." To Europeans the star of the Revue Nègre and the Folies Bergère represented the high-voltage comic energy and primitive passion thought to characterize the Negro race. Although she seemed to achieve stardom overnight, she had been rejected early on at American auditions—for Shuffle Along, for one—because she was small, skinny, and unacceptably dark. Beginning at age thirteen, Baker worked as a dresser for traveling shows before being elevated to the chorus line. Clowning, dancing out of step, arms akimbo and eyes bugged out, she drew sufficient attention that she was dubbed "that comedy chorus girl." The composer-writer team Sissle and Blake created a part in Chocolate Dandies (1924) to take advantage of her comic persona, but in her New York performances she remained in the chorus line. In 1925 she moved to France to appear in the Revue Nègre. Making her entrance upside down on the shoulders of a large black man, dressed only in a pink flamingo feather between her legs, she was an immediate sensation. Parisians embraced her comic, loose-limbed style and imbued her with their romantically primitivizing conception of blacks. On seeing Baker, for example, art dealer Paul Guillame was prompted to write: "We who think we have a soul will blush at the poverty of our spiritual state before the superiority of blacks who have four souls, one in the head, one in the nose and throat, the shadow, and one in the blood." (Photograph 1926, at the Folies Bergère)*

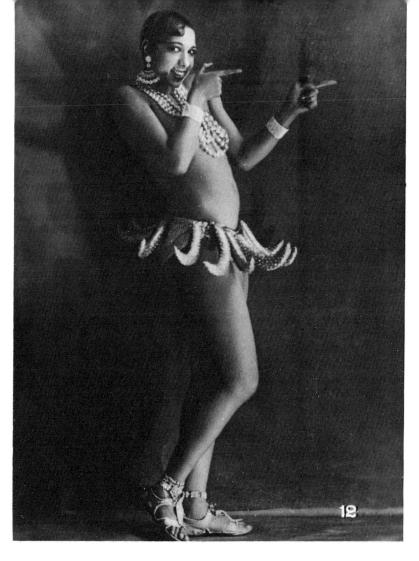

Songs associated with Josephine Baker:

"Yes, We Have No Bananas"
"Two Loves Have I"

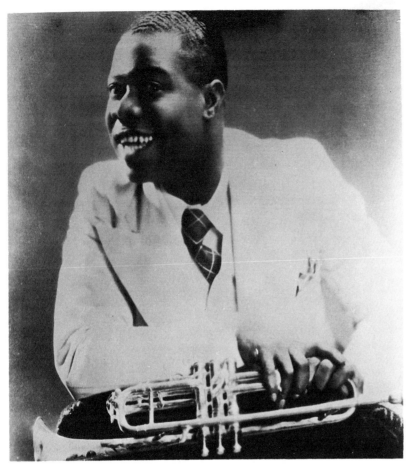

LOUIS "SATCHMO" ARMSTRONG (1901–1971): *Born and raised in New Orleans, Armstrong received his training in the band of the Coloured Waifs' Home and spent his teenage years playing the cornet in Storyville clubs and on Mississippi riverboats. In 1922 he began playing in King Oliver's Chicago band. He first played New York in 1924 with Fletcher Henderson's band at the Roseland Ballroom. At that time he switched to trumpet and developed a virtuoso high register and a smooth vibrato, complemented by exhilarating sandpaper scat-singing vocals. By the end of the 1920s he was the headliner at Connie's Inn, performing such hits as "Ain't Misbehavin'" in the lavish production of Hot Chocolates. (Photograph c. 1925)*

Songs associated with Louis Armstrong:

"When It's Sleepytime Down South"
"Rockin' Chair"
"Basin Street Blues"
"Save It Pretty Mama"
"When You're Smiling"

DUKE ELLINGTON (1899–1974): *Ellington was known as "Duke" from his childhood days because he paid so much attention to his clothes; elegant style became an Ellington trademark. In 1923 his six-member band, the Washingtonians, played at Barron Wilkins's downtown cabaret, the Kentucky Club. In 1928 he began a twelve-year association with the Cotton Club. In his custom-made tails he led the eleven band members dressed in satin-trimmed beige tails. Ellington was successful enough to persuade the club to relax its color barrier. He wrote a few songs during the 1920s, but the compositions that ensured his prominent place in music history were written in the years after the Harlem Renaissance. (Photograph 1927)*

Songs:

"Mood Indigo" "In My Solitude"
"Black and Tan Fantasy" "Cottontail"
"Creole Love Call"

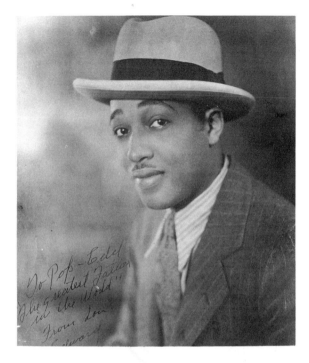

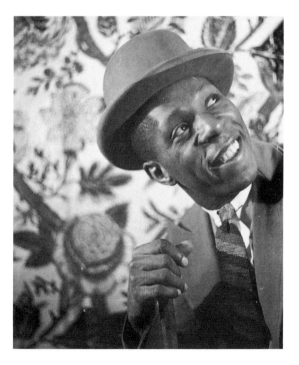

JOHN BUBBLES [JOHN WILLIAM "BUBBER" SUBLETT] (1902–1986): *By the age of eight, dancer John Bubbles had created a routine called "Walking the Dog," and at ten he joined with six-year-old Ford Lee Washington to form an act, Buck and Bubbles, that would play for many years on the Orpheum circuit. Bubbles sang at first, but increasingly he danced. He came to Harlem at the age of eighteen, and was laughed out of the Hoofers' Club ("You're hurting the floor!" his fellow dancers shouted). But two years later he pioneered a style known as "rhythm tap," in which he cut the tempo and doubled the number of taps to each bar, creating a rich field for improvisation. Bubbles was known for percussive counterpoint, cramp rolls on the offbeat, and effortless complexity of rhythm. As his tap-dance colleague Baby Laurence observed, "He was like Coleman Hawkins in sound." In 1935 he played Sportin' Life in Porgy and Bess, and he continued dancing until he was confined to a wheelchair, from where he taught rhythm tap to a younger generation. (Photograph by Carl Van Vechten, 1935)*

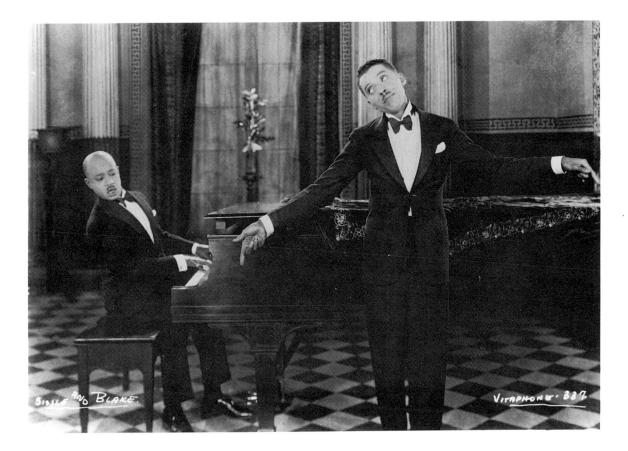

EUBIE BLAKE (1883–1983) and **NOBLE SISSLE (1889–1975):** *One of the most fertile songwriting teams of the 1920s, Sissle and Blake came together about 1915 and called themselves the Dixie Duo. Before becoming partners, Sissle was drum major for James Reese Europe's 369th Regiment band, and Blake played the Keith vaudeville circuit. Their first musical, Shuffle Along, opened on Broadway in 1921 and became a runaway hit, stimulating interest in black revues. None of their five other shows—among them Chocolate Dandies and Keep Shufflin'—were as successful, but their partnership resulted in hundreds of songs. During the Depression they toured Europe as "American Ambassadors of Syncopation." Blake outlived his partner, dying five days after his one-hundredth birthday. By that time he had been accorded honorary doctorates from seven universities and Eubie!, a Broadway show, in his honor. (Photograph c. 1925)*

Songs:

"I'm Just Wild About Harry"
"It's All Your Fault"
"Memories of You"
"You're Lucky to Me"
"You Were Meant for Me"

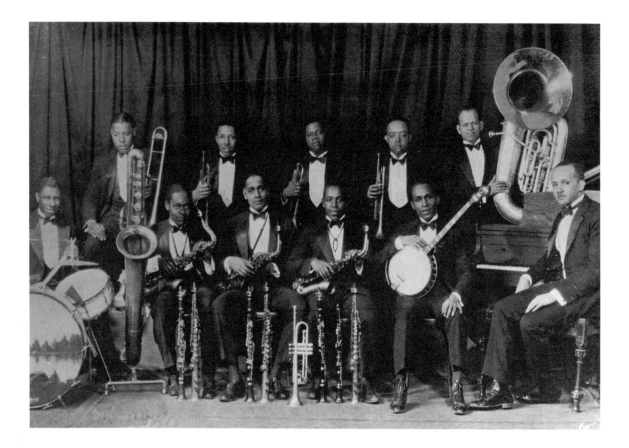

FLETCHER HENDERSON (1897–1952): *Henderson was the best-known band leader purveying dance music, and his orchestra played all over Manhattan, from Roseland to opening night at the Savoy Ballroom. His early refined jazz style echoed that of bandleader Paul Whiteman, and he pioneered the "big band" sound. At different times, his band included Louis Armstrong, Coleman Hawkins, Benny Carter, Roy Eldridge, and Fats Waller. This photograph shows, left to right: Howard Scott, trumpet; Coleman Hawkins, tenor sax; Louis Armstrong, trumpet; Charlie Dixon, banjo; Fletcher Henderson, piano; Kaiser Marshall, drums; Buster Bailey, clarinet; Elmer Chambers, trombone; Bob Escudero, tuba; Don Redman, alto sax and arranger. With the dawn of the Depression Henderson's career declined. He later became an arranger for Benny Goodman and continued to perform until two years before his death. (Photograph 1924)*

ADELAIDE HALL (1901–1993): Beginning a Broadway career in her teens, Hall appeared in such popular shows as Shuffle Along, Runnin' Wild, and Blackbirds of 1928. Critic Brooks Atkinson described her this way: "Adelaide Hall introduces the customary high-calorie diversions with a style that fairly steams, whether she is singing 'Diga, Diga, Do,' in Jungleland or recounting the varied accomplishments of her man." After the Harlem Renaissance era, she established her own nightclubs in London and Paris. She continued singing throughout her life, and her last performance was held on her ninetieth birthday. (Photograph 1928)

Songs associated with Adelaide Hall:

"I Can't Give You Anything but Love"
"Drop Me Off in Harlem"
"Baby I Must Have That Man"
"Ill Wind"

NORA HOLT (c. 1890–1974): During her reign as a nightclub glamour queen in New York, Chicago, Paris, and Shanghai, chanteuse Nora Holt was known as "The Mamma Who Can't Behave." Her six husbands included a wealthy elderly hotel owner, a musician named Sky James, and a food-concessions manager; her myriad love affairs were tabloid material. Holt was the first African-American woman to receive a master of music degree; she was a long-time music critic for the New York Age, and the founder of the National Association of Negro Musicians. Her persona lives on as the model for Nigger Heaven's erotic dynamo, Lasca Sartoris. (Photograph 1930)

ALBERTA HUNTER (1895–1984): *Hunter ran away from home at the age of eleven, supporting herself first as a cook, then singing in sporting houses, moving up the ranks of Chicago nightspots from Dago Frank's Club to the Dreamland. In 1916 she performed W. C. Handy's "Beale Street Blues" to loud acclaim, and she was at her best singing earthy, funny, sophisticated blues. "The blues? Why, the blues are part of me. To me, the blues are—well, almost religious. . . ." Hunter played Queenie in the London production of Showboat, and replaced Josephine Baker at the Folies Bergère. She spent twenty years working as a practical nurse until she was rediscovered at the Cookery in New York in the late 1970s and began a new singing career in her eighties. (Photograph 1923)*

Songs associated with Alberta Hunter:

"Down-Hearted Blues"
"My Castle's Rocking"

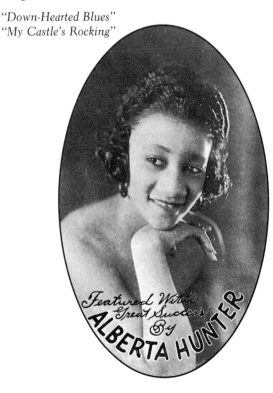

FLORENCE MILLS (1895–1927): *Mills won dance contests at five, and at eight sang "Miss Hannah from Savannah" on a Washington stage. She toured in Southern vaudeville, then joined "Bricktop" and Cora Green as the Panama Trio. Overnight stardom came in 1921 in Shuffle Along. In all her Broadway shows (Plantation Review, Dixie to Broadway, Blackbirds of 1926) she captivated audiences with her dainty wistfulness. She died suddenly of appendicitis in the fall of 1927. A choir of 600 sang at her funeral and 57,000 mourners filed by her casket. Florence Mills's theme song was "I'm a Little Blackbird Looking for a Bluebird." (Photograph c. 1923)*

EARL "SNAKEHIPS" TUCKER (1905–1937): *When he applied for his first job at Connie's Inn, Tucker said, "Lissen, man, my name is Snakehips. I dance, and if I don't stop the show you can fire me." Before the 1920s were over he was known as the first male non-tap-dancing headliner. (Dancing that wasn't tap, jazz, or ballet was known as eccentric dancing.) Tucker wore a loose white silk blouse and bell-bottoms and focused attention on his pelvis, where a long tassel was attached to his sequined girdle. After he slithered on stage and warmed up with a routine known as "Spanking the Baby," Tucker's pelvis gyrated so elastically and the tassel twirled so fast that audiences could not believe their eyes. As Variety put it: "Has he got snake hips—and how!" He died at thirty-two of internal ailments. (Photograph c. 1929)*

Just a few "Taps"
for a dear friend
of mine —
Mr Carl Van Vechten —
"Copesetickly"
Bill Robinson
Blackbirds of 1928 —

BILL "BOJANGLES" ROBINSON [LU-THER ROBINSON] (1876–1949): *Orphaned young, Robinson worked in a racing stable and danced in Washington, D.C., taverns. Before World War I, he became a vaudeville star on the Keith circuit, where he was paid up to $2,000 a week. Billed as "The Dark Cloud of Joy," he not only tap-danced but carried on a masterful patter. The best-known of all tap-dancers, Robinson brought tap up on its toes, mating it with a syncopated upright torso. He was not so much original as he was casually and perfectly controlled when laying down his "xylophonic footsteps." It wasn't until he was fifty, however, that he was "discovered" in New York, performing his famous Stair Dance in the Pepper Pot Revue and Blackbirds of 1928. Seven New York papers called him the greatest of all tap-dancers, and some added that America's only contributions to dance were Isadora Duncan and Negro-American jazz dancing. Robinson's salary soared to $6,500 a week, and in 1935 he performed in The Little Colonel, the first of several movies with Shirley Temple. His popularity broke down racial barriers, and he became known as the Jackie Robinson of dance. After earning nearly three million dollars in his long career, he died penniless at the age of seventy-three. (Photograph 1928)*

BESSIE SMITH (1894–1937): *The legendary blues singer was raised in Chattanooga, Tennessee, the daughter of a part-time Baptist minister. Smith began touring in her teens, and over the next ten years she performed in theaters and in tents with Ma Rainey, Buzzin' Barton, and Pete Werley's Florida Cotton Blossom Minstrel Show. Bisexual and alcoholic, she was a two-hundred-pound, foul-mouthed presence; as a friend noted, "Nobody messed with Bessie." Her raw, powerful voice seemed to eliminate any distance between the singer and the woes of the music. At twenty-nine she became known as the "Empress of the Blues" after her Columbia recording "Down-Hearted Blues / Gulf Coast Blues" sold 780,000 copies in six months. She was consistently a top seller for Columbia over the next eight years, but owing to an exploitive contract she received only $28,575. Whites knew her mostly through records, for she played almost entirely in all-black theaters, often in the Deep South, and gave just three performances on Broadway in the disastrous Pansy (1929). Her hit touring shows of the late 1920s (Yellow Girl Revue, Mississippi Days, Late Hour Tap Dancers, and The Jazzbo Regiment) played in Harlem's Lafayette and Lincoln theaters. In 1937, after her car hit a truck and her right arm was nearly severed, she died in the Afro-American Hospital in Clarksdale, Mississippi. Smith left an enormous legacy of blues recordings. (Photograph c. 1925)*

Songs associated with Bessie Smith:

"Gimme a Pigfoot and a Bottle of Beer"
"St. Louis Blues"

"Backwater Blues"
"Me and My Gin"

CLARA SMITH (c. 1894–1935): *After headlining with the Al Wells Smart Set tent show, Clara Smith came to New York in 1923. Columbia Records billed her as the World's Greatest Moaner, and she became, after Bessie Smith, their second best-selling blues artist. The two singers sometimes pretended to be sisters. Comparing her to Bessie Smith, Carl Van Vechten described her fluttering voice as having "more nuances of expression, a greater range of vocal color, than the Empress." (Photograph c. 1924)*

Songs associated with Clara Smith:

"Whip It to a Jelly (if You Like Good Jelly Roll)"
"Nobody Knows Duh Way I Feel Dis Mornin' "

MAMIE SMITH (c. 1883–1946): *In August 1920, Mamie Smith sang "Crazy Blues," the first recording by an African-American soloist. The Okeh recording manager changed the title from "Harlem Blues" to "Crazy Blues" because he wanted to downplay color, but when the record sold 75,000 copies in the first month, interest in the market for "race records" increased. (Reputedly, every Harlem household with a Victrola owned a copy of "Crazy Blues.") Possessing a light, clear voice, Smith was a versatile musician and an infectious performer. She followed up her hit with twenty-nine more recordings for Okeh over the next two years, toured with Mamie Smith's Jazz Hounds, and appeared in many revues at the Lafayette and Lincoln theaters. She managed to survive the Depression by touring in Europe, and in the early 1940s she made films in Hollywood (Paradise in Harlem, Murder on Lenox Avenue). (Photograph c. 1923)*

ETHEL WATERS (1896–1977):
Waters's early years in Chester, Pennsylvania, were spent on the street, stealing food, working as a domestic, marrying at thirteen. She began performing in her early twenties, when she toured in tent shows and Southern vaudeville, billed as Sweet Mama Stringbean. She made her Harlem debut at a notorious dive called Edmond's Cellar, recorded for Black Swan records in 1921, and by the mid-1920s received critical acclaim. She managed to sing ribald songs without ever seeming vulgar, and both her comedy and her pathos were expertly refined for the stage. By the end of the decade she was a well-paid Broadway star, and unlike many of her fellow performers, she survived the post-Renaissance era. She appeared in such Broadway shows as Mamba's Daughters, As Thousands Cheer, and Blackbirds of 1930 and in such movies as Cabin in the Sky and Pinky, and played her most memorable role in Carson McCullers's Member of the Wedding. In her later years she performed with the Billy Graham Crusade. (Photograph 1929)

**Songs associated with
Ethel Waters:**

"His Eye Is on the Sparrow"
"Dinah"
"Shake That Thing"
"Suppertime"
"Stormy Weather"
"Am I Blue?"
"Heat Wave"

FATS [THOMAS WRIGHT] WALLER (1904–1943): *Growing up in the musical atmosphere of the church—his father was a deacon of Harlem's Abyssinian Baptist Church and his mother sang and played the organ—Waller learned to play the piano early. As a teenager he mastered ragtime piano and stride bass, and he became a regular on the rent-party circuit. Although he published his first songs at age twenty, it was his collaboration with lyricist Andy Razaf that yielded his now-classic songs. They were originally performed in such shows as Keep Shufflin' and Hot Chocolates, and have subsequently become American standards. His nickname reflected his 285-pound weight and his extravagant, spendthrift style kept him constantly broke. (Photograph 1923)*

Songs:

"Ain't Misbehavin' " "Black and Blue"
"Honeysuckle Rose" "Squeeze Me, Zonky"
"I've Got a Feeling I'm Falling"

W. C. HANDY (1873–1958): *Raised in rural Alabama, Handy studied the organ and learned cornet from a stranded circus bandmaster. For many years at the end of the nineteenth century, he toured with the Bessemer Brass Band and Mahara's Minstrels. In 1907, he and Harry Pace formed a music publishing company. After publishing "Memphis Blues" in 1912, Handy became known as the "Father of the Blues." He didn't invent the genre, but he used his musical education to provide the blues with a formal twelve-bar structure that helped ensure its popularity. Although Handy went nearly blind in the 1920s, he continued to work as a composer and music publisher, as well as an impresario and an occasional cornetist and bandleader. Carl Van Vechten considered him the dean of black musicians. (Drawing by Miguel Covarrubias, 1926)*

Songs:

"Memphis Blues" "Jo Turner Blues"
"St. Louis Blues" "Beale Street Blues"

*Harlem at eight P.M.! That's like Holly-
wood in 1840.*
 —Carl Van Vechten

*Liquor, jazz music, and close physical
contact had achieved what decades of
propaganda had advocated with little
success. . . . Tomorrow all of them will
have an emotional hangover.*
 —Wallace Thurman

*The trouble with Prohibition is that it is
making everyone drunk. New York is
like Venice. It is swimmingly wet.*
 —Carl Van Vechten

*Greenwich Village is quite démodé by
the Negro cabarets of Harlem.*
 —New York Herald Tribune,
 May 7, 1925

HARLEM AFTER DARK: A TOUR. A broad swath of hedonists—from international chic society to Greenwich Village bohemians—considered Harlem the perfect place to cap off a night at the theater or to diffuse the tensions of a hectic business day. "Harlem is the one place that is gay and delightful however dull and depressing the downtown regions may be," novelist Max Ewing wrote his mother. "Nothing affects the vitality and the freshness of Harlem."[76]

A major element of Uptown allure was its enormous social fluidity; in this urban free zone—"a seething cauldron of Nubian mirth and hilarity," as one newspaper columnist put it[77]—the Social Register and Emily Post held no sway. The rigorously enforced rules had been carefully rewritten when, in the wake of World War I, America's social arbiters moved from the Four Hundred to Café Society; now they were simply dumped with cheerful abandon. The elite not only frequented public restaurants, but basement speakeasies, where they mingled not only with non–Social Register customers but with people of color. Blacks were employed in the best homes, not as maids and butlers, but as Charleston instructors. As one of Carl Van Vechten's characters observed, "Rilda, my pretty, there's no such thing as a set any more and you know it. Everybody goes everywhere."[78]

The tour that follows offers a trip through Harlem's emblematic clubs and dives, a view of New York's playground after midnight.

THE WHITE-ORIENTED TRADE CLUBS. A newcomer to Harlem would invariably start at Jungle Alley, for this strip of 133rd Street between Lenox and Seventh avenues provided the densest aggregation of nightclubs and cabarets in New York. Most of the big clubs catered to a predominantly white trade. *Variety* listed eleven, but the

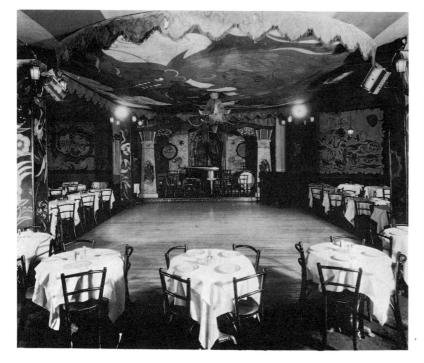

The interior of Connie's Inn (c. 1925) and the marquee from Small's Paradise (c. 1928) represent two of Harlem's Big Three Clubs; the third was the Cotton Club

uncontested Big Three were the Cotton Club, Connie's Inn, and Small's Paradise.

Carl Van Vechten once arrived at the Cotton Club's long canopy in racially mixed company and was turned away by the Mafia-hired bouncer; he vowed to boycott the club until black patrons could hear Ethel Waters singing on its stage. But it was precisely the club's racist policy which made it the most comfortable stop for a first-timer to Harlem; one could view the black-white maelstrom without actually descending into it. From the touristic vantage point of a table filled with white customers, the prefabricated exoticism neatly cho-

***Variety's* List of White-Trade Nightclubs in Harlem**

The Cotton Club
Connie's Inn
The Nest Club
Small's Paradise
Barron's
The Spider Web
The Saratoga Club
Ward's Swanee
Pod's and Jerry's Catagonia Club
The Bamboo Inn
The Lenox

Harlem is an all-white picnic ground and with no apparent gain to the blacks.
—Claude McKay

reographed on a proscenium stage a few yards away was anything but threatening. The Cotton Club was not the only Harlem club that catered to white audiences, but it was the largest, featured the most extravagant shows, charged the highest prices, and most strictly enforced the color line. No less than England's Lady Mountbatten dubbed it "the Aristocrat of Harlem."[79]

Getting the jump on the Uptown craze, mobster Owney Madden opened the Cotton Club in the fall of 1923 as the East Coast outlet for his bootleg beer. Limousines pulled up to the club's marquee, where a doorman greeted customers in ermines and gibus top hats, and they were directed to a large horseshoe-shaped room designed by Joseph Urban and filled with artificial palm trees as part of its ersatz jungle decor. The elegantly appointed tables were crowded together on two tiers and ringed by banquettes, and the menu featured not only fried chicken and barbecued spareribs, but the foreign dishes that appeared on the menus of Downtown clubs; prices were high and quality undistinguished. The black waiters stylishly negotiated their way through the crowd, although they didn't Charleston and spin their trays, as did the waiters at Small's Paradise. To enforce the Cotton Club's high tone, waiters informed customers that bottles of bootleg liquor should be carried in the pocket rather than set on the floor, and anyone who talked too loud was initially tapped lightly on the shoulder and subsequently evicted by the headwaiter.

The floor shows, which ran up to two hours, consisted of a featured act interspersed with numbers by the Cotton Club's sepia chorus line and its tuxedoed Cotton Club band. These Ziegfeldesque spectacles promoted a strictly regulated version of beauty that would be acceptable to white audiences—the homogenous sepia chorus line was composed uniformly of "high yaller" female dancers who were under twenty-one years of age and over five foot six in height.

Cotton Club

Owners:
Owney Madden
Big Frenchy De Mange

Performers:
Duke Ellington
Cab Calloway
Ethel Waters
Edith Wilson
Berry Brothers
Earl "Snakehips" Tucker

Writers:
Dorothy Fields and Jimmy McHugh
Harold Arlen and Ted Koehler

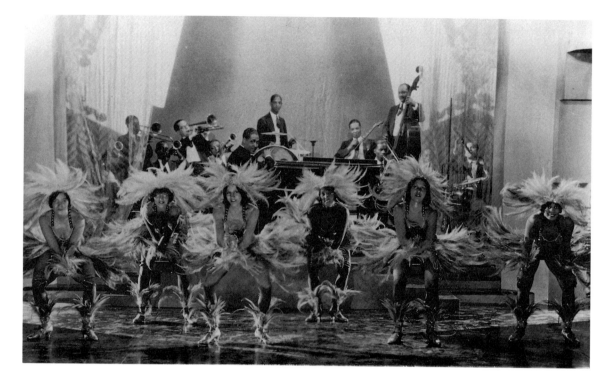

(Cab Calloway sang two songs—"She's Tall, She's Tan and She's Terrific" and "Cotton Colored Gal of Mine"—that made the club's case for the appearance of its chorus line.) The skin color of the male dancers was more varied, and the same was true for the centerpieces of the revues. "The chief ingredient was pace, pace, pace!" the shows' director Dan Healy observed. "The show was generally built around types: the band, an eccentric dancer, a comedian—whoever we had who was also a star. . . . And we'd have a special singer who gave the customers the expected adult song in Harlem."[80] Those star

Chorus line at the Cotton Club with Duke Ellington leading the band, 1929

Jungle Alley: *the stretch of 133rd Street between Lenox Avenue and Seventh Avenue known for its expensive cabarets; also known as* **Beale Street.**

names included the best in Uptown entertainment. Among the singers were Ethel Waters and Adelaide Hall. The bands included Duke Ellington and Cab Calloway, the dancers included Earl "Snakehips" Tucker, Paul Meeres ("the brown Valentino"), and "Peg Leg" Bates.

The division between the performers and the audience was more carefully maintained than in any other club in Harlem. (Even its name evoked both the antebellum South and the color of its patrons.) The club was owned by white mobsters, its shows written and directed by whites from Broadway and performed for an all-white audience. Black performers did not mix with the club's clientele, and after the show many of them went next door to the basement of the superintendent at 646 Lenox, where they imbibed corn whiskey, peach brandy, and marijuana. "It isn't necessary to mix with colored people if you don't feel like it," Jimmy Durante comforted the squeamish. The Cotton Club allowed the timid and well-heeled to cautiously dip their stylishly shod feet into the roiling waters of primitive Uptown.

WORKING-CLASS SPEAKEASIES. As the evening wore on, a visitor to Harlem might wander on to one of the side streets near Jungle Alley, where cocaine and marijuana were available (the latter ran ten joints for a dollar). Here were the less-elegant boîtes that attraced a more racially mixed crowd. Harlem was filled with these cheaper speakeasies, known as "lap joints"—police estimated nearly ten to every square block. The Sugar Cane, for example, stood at the edge of Harlem's "low-down" district, on 135th and Fifth Avenue. From the outside one saw a silent man seated in the front window who pulled a long chain connected to a bolt on the entrance door. Like many speakeasies, the Sugar Cane consisted of a raw cellar at the

bottom of a steep flight of stairs, 25 feet wide and 125 feet long. The damp subterranean space could accommodate a hundred revelers, but on Saturday nights twice that many jammed in. The crowd included only a sprinkling of white customers (for this represented the fringe of adventure), and was dominated instead by bootblacks and stevedores in silk-striped shirt sleeves and tan shoes with squared-off bulldog toes and maids and hairdressers in bright ginghams and low-scooped dresses. They gathered around the two dozen wooden tables roughly jammed together, sat on wooden or wire-legged café chairs, and drank from low-grade, bootleg liquor poured from bottles that bore fake labels from Haig & Haig, Hennessy, and Peter Dawson, or an even more crude blend known as "smoke" or "lightning." The rudimentary three-piece band accompanied a torch singer under bright white light singing "I'm Busy and You Can't Come In." As the lights revolved from blue to red, dancers filled the tiny floor, "animal beings urged on by liquor and music and physical contact," as Wallace Thurman described them.[81] When the dance floor became too crowded to execute the bump or the mess-around, patrons simply shuffled their feet in place, which was known as dancing on a dime.

The decibel level went up after 3:00 A.M., when New York's curfew law shuttered the city's legitimate cabarets. At this point, moonlighting performers dropped into the clubs that had paid off the police for "special charters." "Jazzlips" Richardson or the dancing Bon Ton Buddies, fresh from playing *Hot Chocolates* at Connie's, for example, might do a turn in exchange for food and drink. It was the custom to show approval of the performers by tossing wadded-up dollar bills at them, or rapping on the tables with glasses or small wooden hammers. The activity at institutions like the Sugar Cane continued in high key until piercing seven o'clock whistles warned that a new work day was about to begin.

From the Colored Cabaret Owners Association Rules

Female employees while entertaining will not raise their skirts higher than mid-way between the ankle and knee.

Under no circumstances will a female patron be admitted minus a male escort.

Male or female patrons will not be allowed to go to another table to request strange male or female patrons to dance.

Prop's and Managers will see that there is absolutely no mixing of strange couples.

Each Prop'r will get a careful and correct meaning of the national prohibition law, particularly the New York State Mullen-Gage Law, and study them carefully, and observe them strictly.

Exhortations at dances: **"Rock Church rock!"** **"Oh do it, you dirty no-gooder!"** **"Shake it and break it!"** **"Walk that broad! What old broad? That old black broad!"** **"Oh play it, Mr. Man!"** **"Oh suck it!"** **"Get off dat dime!"** *(stop dancing in the same place);* **"Mama, come and get your little blue-eyed baby!"** **"Jook it, papa! Jook!"**

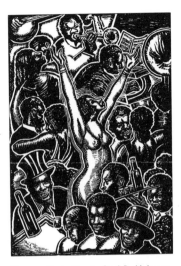

Program illustration by Paul R. Meltsner for William Jordan Rapp and Wallace Thurman's Broadway hit, Harlem, *1929*

RENT PARTIES. A Harlem visitor might wander through Harlem's residential side streets and up several flights of stairs into a crowded apartment where a rent party was in high gear. Perhaps the most indigenous of black entertainments, the rent party was an institution created in response to the sorry reality that Harlem's inflated rents were $12 to $30 a month higher than in other areas of Manhattan, while salaries paid to African Americans were lower than those of their white counterparts. The average Harlem resident spent 40 percent of his or her income on rent—and if it wasn't paid by Sunday, the landlord put the furniture on the street on Monday morning. Long and narrow "railroad" flats were cordoned off with sheets, cots were added to dining rooms, and day sleepers and night sleepers frequently used the same couch at different hours. The most inventive solution to the rent problem was a party. "That is one of the things that is so nice about our Negro friends," recalled composer Virgil Thomson. "If they can settle anything by means of a social ceremony, they will. And they have so much available—their ability to play dance music, their ability to dance, their ability to have a good time, not to mention their ability to cook."[82]

Anyone could throw a rent party. One made up a party slogan, had it cheaply printed up by the peripatetic Wayside Printer, who pushed a cart that carried rudimentary printing equipment. Cards were passed out in pool halls and laundromats and distributed to passersby along Seventh Avenue. The apartment's temporary halls were removed, the contents of the parlor and dining room cleared out, to be replaced by a dozen chairs borrowed from the local undertaker. Cheap proletarian food, redolent of the South, filled the kitchen. These events, which were Harlemized versions of the jook-joint parties of the deep South, reminded many recent immigrants

Rent party: a party with music, liquor, and food, thrown in a residence, with admission fees charged in order to raise the monthly rent. Also called social whist parties, parlor social (these two are the genteel terms); struggles, break-downs, flop-wallies, chitterling parties, razor drills, too terrible party, too bad party

of their roots. Rent parties were staged most frequently on Saturday nights and Thursday nights (when domestics often had the evening off), but one could find a rent party any night of the week. The public paid admission, ranging from a dime to a half-dollar, to be admitted into a parlor dimly lit with red lights.

Partygoers who arrived before ten danced to the radio tuned to Andy Preer's Cotton Club Syncopaters, but soon live musicians arrived and set up in the parlor. At cheaper parties the band consisted solely of a piano player who opened up the top and front of an upright piano and beat out rhythm with his feet. The more elegant pickup bands might include drums, a guitar, a saxophone, or a fife. The dancing was usually slow and sensual—"slow-dragging"—broken up by livelier performances such as a Black Bottom contest, a Charleston contest, or a breakdown. One could wander back to the kitchen to buy food or stop at a makeshift hallway bar that served bathtub gin, rye, and corn in quarter-pint portions known as "shorties," or one could stop off in a room set aside for cards or craps.

The dancing continued through the night, and the $5-per-night piano man (who improvised rather than read music) usually paced the event not only with songs but with his salty repertoire of wisecracks and shouts—"Shake that thing, Mr. Charlie!" "Do it, you dirty no-gooder!"[83] The dancers, in fresh ginghams or peg-top trousers, bright blouses or gaudy arm bands, responded energetically. As Thurman put it, "Liquor has lit the fire, music must fan it into a flame."[84] At the best rent parties, professional Harlem musicians—who called them "jumps" or "shouts"—would show up after their paying gig. By the night's end a screaming match or a switchblade fight might have broken out, but more often the peaceful partygoers tumbled home happy and exhausted. And most important, the rent got paid.

Rent Party Menu

Hopping John (rice and black-eyed peas)
Mulatto Rice (rice and tomatoes)
Okra Gumbo
Sweet Potato Pone
Chitterlings
Hog Maws
Chicken

Underground specialist: an undertaker

1 **Alhambra Ballroom,** *2110 7th Avenue (c.1929-1945): A large upstairs ballroom featuring prominent jazz bands.*

2 **Apollo Theater,** *253 W125 Street (c. 1910-): Originally the uptown location for a burlesque circuit, in the early 1920s it became the home for black jazz musicians, in the 1930s the site for Amateur Night.*

3 **Bamboo Inn,** *2389 7th Avenue (c.1923-1964): A dining and dancing restaurant and gathering place for an upscale black clientele.*

4 **Bamville Club,** *65 W129 Street (c.1920-1930): A popular music club featuring Elmer Snowdon's band and Fletcher Henderson's band.*

5 **Band Box Club,** *161 W131 Street (c.1920-1935): Run by cornetist Addington Major, its rear bar became a center for spontaneous jam sessions.*

6 **The Barbecue,** *W131 Street at 7th Avenue (c.1925-1935): "The best" rib joint in Harlem, and the first Harlem establishment to boast a juke box, the Barbecue was located directly over Connie's Inn.*

7 **Barron's Exclusive Club,** *2259 7th Avenue (c.1915-1926): An early Harlem nightclub, managed by Barron D. Wilkins until he was stabbed in 1926. Performers included Willie "The Lion" Smith, Ada "Bricktop" Smith, and Elmer Snowdon's Washingtonians (of which Duke Ellington was a member).*

8 **Capital Palace,** *575 Lenox Avenue (c.1922-1950): A large fancy nightclub where Willie "The Lion" Smith played piano.*

9 **The Clam House,** *136 W133 Street (c.1925-1933): A cabaret featuring Gladys Bentley singing bawdy double-entendre songs and wearing a top hat and tails.*

10 **Club Harlem African Room,** *388 Lenox Avenue: Known as the "Favorite Retreat for the Select and Elite," this club includes a mural painted by Aaron Douglas.*

11 **Connie's Inn,** *2221 7th Avenue (1921-1940): Opened as the Shuffle Inn (named after Shuffle Along), it was purchased by George and Connie Immerman, former delicatessen owners, who refurbished it to become one of the top three clubs. It featured Bill Robinson, Paul Meeres, Earl "Snakehips" Tucker, and the 1929 hit, Hot Chocolates, It catered to a mostly white clientele, featured a raised dance floor, gold and black tapestry decoration, and seating for 500.*

12 **Conner's,** *71 W135 Street (c.1913-1930): One of the earliest Harlem cabarets.*

13 **"The Corner,"** *131 Street and 7th Avenue: Many musicians hung out and made music on this open-air site.*

14 **The Cotton Club,** *644 Lenox Avenue (1923-1940): Managed by mobster Owney Madden as an East Coast outlet for his beer, this most extravagant of all Harlem clubs featured Duke Ellington and Cab Calloway. The strictly enforced color line was loosened somewhat at the request of Duke Ellington.*

15 **The Dark Tower,** *108-110 W136 Street (1928-1929): A'Lelia Walker tranformed her mansion into a gathering place for Harlem's artists and writers, as well as Downtowners.*

16 **Dunbar Apartments,** *a five-acre complex between 149 and 150 Streets, between 7th and 8th Avenues (c.1929-): This 500-unit complex was the residence of many of Harlem's most distinguished residents, including W. E. B. Du Bois, Countee Cullen, Paul Robeson, Fletcher Henderson, and Rudolph Fisher.*

17 **Edmond's Cellar,** *2161 5th Avenue (c.1915-1922): An early basement dive featuring "pansy" entertainment; Ethel Waters described it as "the last stop on the way down." Clientele included pimps, prostitutes, transvestites, and gamblers.*

18 **Garden of Joy,** *7th Avenue between 138 and 139 Streets (c.1918-1924): An open-air tented dance pavilion featuring performers Mamie Smith, Sidney Bechet, and Ornette Coleman.*

19 **Happy Rhone's Orchestra Club,** *Lenox Avenue and 143 Street (c.1920-1925): An early Harlem club that included among its musicians Louis Armstrong and Fletcher Henderson.*

20 **The Hobby Horse,** *205 W136 Street (c.1928-1930): A book store that became a hangout for young African-American writers.*

21 **Hollywood Cabaret,** *41 W124 Street (c.1925-1935): A popular joint that featured "pansy" entertainment.*

22 **Hot-Cha Bar and Grill,** *2280 7th Avenue (c.1930-1960): Billie Holiday was discovered here, and other performers included Jimmie Daniels.*

23 **Joplin's Boarding house,** *251 W131 Street (c.1920-1950): Run by Scott Joplin's widow, this boarding house for entertainers included among its residents Ferdinand "Jelly Roll" Morton, Eubie Blake, and Willie "The Lion" Smith.*

24 **"Jungle Alley,"** *The stretch of 133 Street between Lenox Avenue and 7th Avenue; the main drag of nighclubs.*

25 **Kaiser's,** *212 W133 Street: In its basement musicians smoked marijuana.*

26 **Lafayette Theater,** *2235 7th Avenue (1912-1964): This 1,500-seat auditorium was the first to desegregate. In its basement was the Hoofers' Club, the informal headquarters of such tap-dancers as Bill Robinson, Honi Coles, Bunny Briggs, Chuck Green, and Baby Laurence.*

27 **Leroy's,** *2220 5th Avenue (1910-1923): A cellar cabaret. Harlem's oldest cabaret, gathering place of black boxers and "swells."*

28 **Lincoln Theater,** *58 W135 Street (c.1909-1954): Harlem's first theater, with a $10,000 Wurlitzer organ, this 1,000-seat auditorium was a center for vaudeville, jazz, and silent film.*

29 **Manhatttan Casino / Rockland Palace,** *280 W155 Street (c.1910-?): Harlem's largest hall, holding 6,000 people, was the site of famous drag balls in the late 1920s and early 1930s.*

30 **Nest Club,** *169 W133 Street (c.1925-1930): A popular "Jungle Alley" jazz club featuring Elmer Snowdon's band; in 1932 it became Dicky Wells's Shim Sham Club.*

31 **"Niggerati Manor,"** *267 W136 Street: A rooming house with rent-free rooms for artists and writers; among its residents were Wallace Thurman, Langston Hughes, Richard Bruce Nugent, and Zora Neale Hurston (who gave it its name).*

32 **One-Hundred-One Ranch Club,** *101 W 139 Street (c.1920-1940): Primitive jazz in the 1920s was replaced in the 1930s by a drag-queen chorus line; home of the Shim-Sham Shimmy.*

33 **Pace Phonograph Corporation,** *257 W138 Street (1921-1924): Harlem's first recording company, founded by Harry Pace, sold to Paramount in 1924.*

34 **Pod's and Jerry's Catagonia Club,** *168 W133 Street (c.1925-1935): A popular speakeasy that featured Willie "The Lion" Smith and the hunchbacked baritone "Little Jazzbo" Hilliard.*

35 **Renaissance Casino and Ballroom,** *150 W138 Street (c.1915-?): A two-story entertainment center, featuring music, dances, receptions, and basketball games.*

36 **St. Philip's Episcopal Church,** *204 W134 Street: Designed by black architect Vertner Tandy, this was one of Harlem's most respectable churches, and the rehearsal space for the Gertrude Stein-Virgil Thomson opera, Four Saints in Three Acts.*

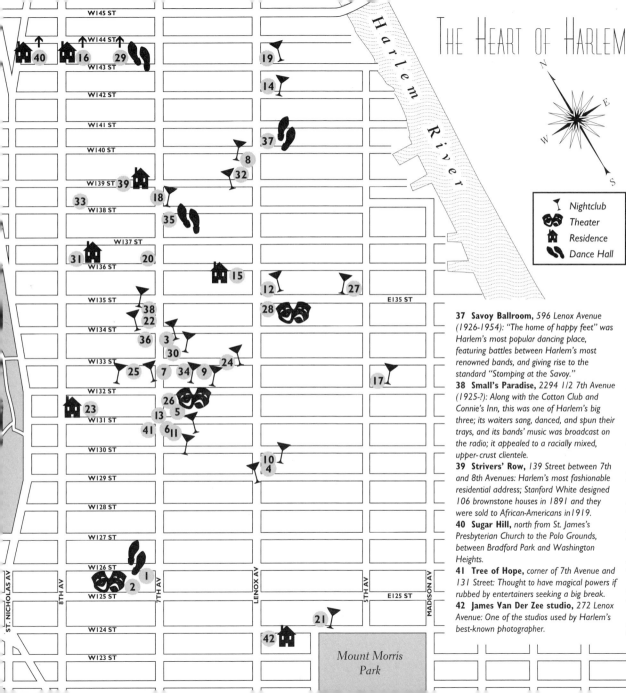

THE HEART OF HARLEM

Nightclub
Theater
Residence
Dance Hall

Harlem River

W 145 ST
W 144 ST
W 143 ST
W 142 ST
W 141 ST
W 140 ST
W 139 ST
W 138 ST
W 137 ST
W 136 ST
W 135 ST
W 134 ST
W 133 ST
W 132 ST
W 131 ST
W 130 ST
W 129 ST
W 128 ST
W 127 ST
W 126 ST
W 125 ST
W 124 ST
W 123 ST

E 135 ST
E 125 ST

ST. NICHOLAS AV
8TH AV
7TH AV
LENOX AV
5TH AV
MADISON AV

Mount Morris Park

37 Savoy Ballroom, *596 Lenox Avenue (1926-1954):* "The home of happy feet" was Harlem's most popular dancing place, featuring battles between Harlem's most renowned bands, and giving rise to the standard "Stomping at the Savoy."

38 Small's Paradise, *2294 1/2 7th Avenue (1925-?):* Along with the Cotton Club and Connie's Inn, this was one of Harlem's big three; its waiters sang, danced, and spun their trays, and its bands' music was broadcast on the radio; it appealed to a racially mixed, upper-crust clientele.

39 Strivers' Row, *139 Street between 7th and 8th Avenues:* Harlem's most fashionable residential address; Stanford White designed 106 brownstone houses in 1891 and they were sold to African-Americans in 1919.

40 Sugar Hill, *north from St. James's Presbyterian Church to the Polo Grounds, between Bradford Park and Washington Heights.*

41 Tree of Hope, *corner of 7th Avenue and 131 Street:* Thought to have magical powers if rubbed by entertainers seeking a big break.

42 James Van Der Zee studio, *272 Lenox Avenue:* One of the studios used by Harlem's best-known photographer.

Uptown we carry on till de-mented . . .
 —Parker Tyler

HOMOSEXUAL AND LESBIAN NIGHTLIFE. Advertised largely by word of mouth to those "in the life," homosexual and lesbian night-life thrived in Harlem. Greenwich Village and Harlem were the city's main areas that countenanced homosexual gatherings, and homosexual Richard Bruce Nugent recalled that the two bore many similarities. "You didn't get on the rooftop and shout, " 'I fucked my wife last night.' So why would you get on the roof and say 'I loved prick.' You didn't. You just did what you wanted to do. Nobody was in the closet. There wasn't any closet."[85] Harlem churches were strictly anti-homosexual, but the community provided a model of tolerance. Many of the Harlem Renaissance's key literary figures were homo- or bisexual (among them Claude McKay, Countee Cullen, Alain Locke, Wallace Thurman, Richard Bruce Nugent, and perhaps enigmatic Langston Hughes) as were many of Harlem's best-known performers (among them Bessie Smith, Alberta Hunter, Jackie "Moms" Mabley, Mabel Hampton, Ma Rainey, and Ethel Waters).

One heard it said that the Negroes had retained a direct virility that the whites had lost through being overeducated.
 —Malcolm Cowley

In the homosexual iconography of the period, the black male vied with the swarthy Italian youth and the sailor in uniform as the iconic love object. Negroes were also regarded as sexually flexible. (A common pick-up line at that time among available blacks: "I'm a one-way man—now, which way would you like?" And in a period when syphilis was rampant, sex between men was popularly rationalized, "Better a little shit than a chancre."[86]) The Mafia looked upon black men's attractiveness to white men as a phenomenon to exploit (nor did it hurt that Al Capone's cousin was homosexual and poet Parker Tyler reported numerous attempted seductions by gangsters).

The Gybrettas were in power. Never no wells of loneliness in Harlem.
 —Inter-State Tattler, February 22, 1929

The best known of the homosexual and lesbian hangouts was the Clam House, a long, narrow room on 133rd Street's Jungle Alley, described in *Vanity Fair* as "a popular house for revelers but not for the innocent young."[87] Downtown celebrities went on bisexual

Box-beater: *a pianist at a rent party*

Gladys Bentley, tuxedo-attired performer of double-entendre songs and headliner at the Clam House, by Carl Van Vechten, 1932

Lesbian: **bulldyke, bull–diker, bull-dycker, bulldagger, flatter**

sprees—among them were Beatrice Lillie, Tallulah Bankhead, Jeanne Eagels, Marilyn Miller, Princess Murat from Paris, and—dressed in matching bowler hats—came chanteuse Libby Holman and her heiress lover Louisa Carpenter du Pont Jenney. The only performer to publicly exploit her lesbian identity was Gladys Bentley, the Clam House's headliner. The 250-pound alto singer dressed in top hat and tuxedo, belting out double-entendre lyrics to popular songs like "My Alice Blue Gown," or "Sweet Georgia Brown," and encouraging her audiences to join in on the lewd choruses. "If ever there was a gal who could take a popular ditty and put her own naughty version to it," observed one journalist, "La Bentley could do it."[88]

Harlem's homosexual haunts were varied: bars like the Yeahman and the Garden of Joy catered to mixed crowds; "pansy entertainment" spots such as The Ubangi featured a sepia-toned female impersonator called Gloria Swanson, who belted out "Hot Nuts, get 'em from the peanut man!"; buffet flats such as Hazel Valentine's Daisy Chain offered sexual tableaux—both hetero and homo—staged in apartment chambers; homosexual house parties like those hosted by Casca Bonds and Alexander Gumby. The most spectacular homosexual events were the costume balls held at the cavernous Rockland Palace on 155th Street.

"Of course, a costume ball can be a very tame thing," reported the gossipy black weekly *The Inter-State Tattler,* "but when all the exquisitely gowned women on the floor are men and a number of the smartest men are women, ah then, we have something over which to thrill and grow round-eyed."[89] These drag balls were reported in the black press and surrealistically dramatized in America's first unashamedly homosexual novel, Charles Henri Ford and Parker Tyler's *The Young and Evil* (1933). Not all the guests were homosexual; many came to gawk. These onlookers ascended a gold-banistered

on 155th st.
the band plays
for the dresses who are men
 —Parker Tyler, "Men Only Have Eyes,
 Women Only Have Lashes"

Homosexual men: **pansy, pansie, eel-
eater, sissy,** [one with] **freakish
ways, queer, the people, the life**
(last two used by homosexuals among
themselves)

staircase to the box seats that ringed the huge ballroom and looked down on the Grand March of ersatz divas promenading beneath a colossal crystal chandelier and a sky-blue ceiling. The women mostly dressed in drably colored loose-fitting men's suits (rarely a tuxedo) while the men outdid themselves as extravagant señoritas in black lace and red fans; as soubrettes in backless dresses and huge spangles; as debutantes in chiffon and rhinestones; and as a creature called "La Flame" who wore only a white satin stovepipe hat, a red beaded breast plate, and a white sash. The Savoy Ballroom also hosted gala drag balls, where the sartorial achievements were given prizes. (Artist "Sheriff" Bob Chanler, hostess Muriel Draper, and Carl Van Vechten comprised one panel of judges, and they awarded first prize to a man who wore only a cache-sex, silver sandals, and apple-green paint.)

Harlem's gaudy conglomeration of homosexual and lesbian hangouts reflected a zone in which sexualities of all stripes could flourish. "In Harlem I found courage and joy and tolerance," observed a homosexual character in Blair Niles's 1931 novel *Strange Brother*. "I can be myself there. . . . They know all about me and I don't have to lie."[90]

GATHERING PLACE OF THE DICTIES. "The Bamboo Inn," wrote Wallace Thurman, "is *the* place to see 'high Harlem.' "[91] Inexpensive Chinese restaurants were common in Harlem, but the Bamboo Inn featured a balcony, a jazz band, and dancing in the dots of light reflected off the gyroflector revolving over the center of the dance floor. This was an ideal spot to stage a coming-out party or a matron's luncheon requiring just the mildest frisson of spontaneity. A large black bouncer stood by the entrance, and Chinese waiters silently wended through the crowd. An occasional peal of laughter broke the

One may divide people into thrills and frills . . . sex it's a false landscape only art giving it full colors . . . picked me up on Eighth Street and did me for trade in Christopher Street . . . lies there a new place called Belle's Jeans it must be horribly vulgar . . . no Miss Suckoffski smelt the worst Miss Johnnie didn't smell she just lay there . . . ninety-five percent of the world is just naturally queer and are really according to the degree of resistance . . . she's a flag that's never been taken down . . . oh you twisted piece of lilac the curtain's going up . . . the macabre is not omitted from any universe why not find it in his bread-box. . . .
—A scene at a Rockland Casino drag ball, from *The Young and Evil*, by Charles Henri Ford and Parker Tyler

Home defense officer: *a private detective hired at rent parties to prevent theft by* **clean-up men** *(thieves)*

TRUCKING

*Laban dance notation by Nicholas Na-
humck of dances popularized by African
Americans (above and opposite page)*

Dancing: **rug-cutter** *(person who cuts
up the rugs of his host with his dancing
feet; originally meant a person too
cheap to patronize regular dance halls
who went exclusively to rent parties);*
boogie woogie *(type of lively dancing;
for years in the South it meant second-
ary syphilis);* **stomp, scronching** *(low-
down dance);* **jooking** *(dancing
low-down; also, playing a musical
instrument in the style of a jook);* **foop-
ing, jig-jagging** *(slow dancing);* **shout,
bump, bumpty-bump** *(all slow one-
step dances);* **hoof, wobble, dogging,
belly rub** *(a sexy dance)*

demure hum in the room, and the opening of a few silver flasks under the white tablecloth breached the law. But over all one found at the Bamboo Inn African Americans enacting the middle-class dream. As Thurman described the crowd: "Well-dressed men escorting expensively garbed women and girls; models from *Vanity Fair* with brown, yellow and black skins. Doctors and lawyers, Babbitts and their ladies with fine manners (not necessarily learned through Emily Post), fine clothes and fine houses to return to when the night's fun has ended."[92]

SAVOY BALLROOM. To regulars it was the Sa-VOY, to newcomers it was the SA-voy, and to everybody it was "the Home of Happy Feet." This most democratic of institutions provided an Uptown alternative to Fifty-second Street's Roseland Ballroom. The $200,000 building opened on March 12, 1926, its drab but vast stucco front running the full block on Lenox Avenue between 140th and 141st streets. Four thousand first-nighters entered an elegant lobby, crowned by a magisterial cut-glass chandelier, and they ascended two flights of marble steps, checking appearances in the ribbon of mirror that ran along the stairs. With each flight the sounds of the big band grew louder, and then suddenly customers came upon the block-long dance floor, raised bandstand, loud, glinting instruments, driving music, and the surge of unpaid performers set against vibrant orange and blue decor. Fess Williams appeared that night in his diamond-and-ruby-studded suit, blowing his clarinet, followed by his Royal Flush Orchestra. Later that evening, the Savoy Bearcats performed, and at 1:30 Fletcher Henderson and his Rainbow Orchestra made their triumphal entrance.

The burnished maple dance floor was 50 feet wide and 250

feet long, and a shiny brass rail traced its perimeter. On the next step up were round-topped tables and a soda fountain dispensing Harlem steaks, Whistle, and tall mugs of root-de-toot root beer and ginger ale for a nickel each. Musicians alternated sets at the far end on two bandstands so that one band picked up the beat before the other left its post: the music never stopped at the Savoy. From these bandstands the best big-band jazz in the world blared forth—including the music of Louis Armstrong, Cab Calloway, Duke Ellington, Fess Williams, King Oliver, and Chick Webb. Jazz had been around long enough for a white band leader, Paul Whiteman, to produce his own Downtown version, but it was cool where the Savoy bands were hot.

The Savoy bands inspired extraordinary dancing—some considered it the superior alternative to Broadway revues. Tuesday night was the best night for sheer terpsichoric pyrotechnics. Called the "400 Club," it was reserved for serious dancers only, and the expanse of floor allowed everyone to hoof with complete abandon. Perhaps the most eye-catching dance was the Lindy hop, named after Lindbergh and popularized at the Savoy in 1927. An updated pre–World War I dance—the Texas Tommy—the Lindy hop alternated a syncopated box step with an accented off beat and breakaway routines. These personal showcase sections mixed everything from pinwheel spins and gyroscopic routines to the Geetchie Walk and breakneck aerial turns. Women were admitted free to the Savoy on Thursdays, and it became known as "Kitchen Mechanics' Night," which was slang for maids and cooks. Saturday night was known among Harlemites as Square's Night because the floor was crowded with Downtowners, and the most glamorous was Sunday night. Movie stars and the international set selected this evening—one might spot Osbert Sitwell, Richard Barthelmess, Princess Violet Murat, Peggy Hopkins Joyce, and Emily Vanderbilt.

SNAKE HIPS

Rhythmically it comes from the groins, the hips, and the sexual organs, and not from the belly, the interior organs, the arms and legs, as in the Hindu, Javanese and Chinese musics, or from the breast, the brain, the ears and eyes of the white races. It is angular and elliptical like the lines of a Brancusi sculpture.
—George Antheil, on African-American dancing

Take a Boston: *execute unexpected musical riffs*

Furtive rhythms of sex
Fleck the distance between us,
With sparks of Africa,
Like poppies scattered upon a desert
Fragments of archaic beauty
Thrust forward
Like moist lanterns
Lighting a faded world . . .
Teach me, O little black dancer,
The forgotten Art of Living!
 —Aubrey S. Pierce, "Harlem Dancer"

*A'Lelia Walker was the joy-goddess of
Harlem's 1920s.*
 —Langston Hughes

Kitchen mechanic: *a domestic (also*
pot wrestler)

Whatever the class distinctions among customers, they mixed on the dance floor, but the momentary sense of democracy vanished as dancers returned to their seats. "Out on the dance floor, everyone, dicky and rat, rubbed joyous elbows, laughing, mingling, forgetting differences," wrote Rudolph Fisher. "But whenever the music stopped everyone immediately sought his own level."[93]

HARLEM HOSTESS. Parties were the hub of Harlem's nocturnal culture, and they helped grease the social Renaissance. The most official of these events were held at the Civic Club and the most proper consisted of Sunday afternoon literary talks, often in French, at Jessie Fauset's home, or in one of the Dunbar Apartments. The most lavish parties were undoubtedly those thrown by A'Lelia Walker, *the* hostess of the Renaissance. Standing six feet tall, her statuesque presence was emphasized by high heels and tall plumes. The four-times-married heiress wore silk dresses and ermine coatees, paisley beaded shawls from Wanamaker's, and sable muffs, and her well-modeled head and cocoa complexion were set off by silver turbans. "She looked like a queen," observed Carl Van Vechten, "and frequently acted like a tyrant."[94] A'Lelia could afford to do both.

The hundreds of parties she threw during the 1920s were financed by the fortune she inherited from her mother, Madame C. J. Walker, whose life provides the most inspirational of black Horatio Alger stories. An orphaned child of ex-slave sharecroppers, she worked as a washerwoman. As a result of stress and poor diet, her hair began falling out when, about 1903, a large black man appeared to her in a dream and revealed a secret recipe to combat baldness. She decided to invest in her vision, and with capital of $1.50, she started a hair-straightening empire that marketed "Madame Walker's

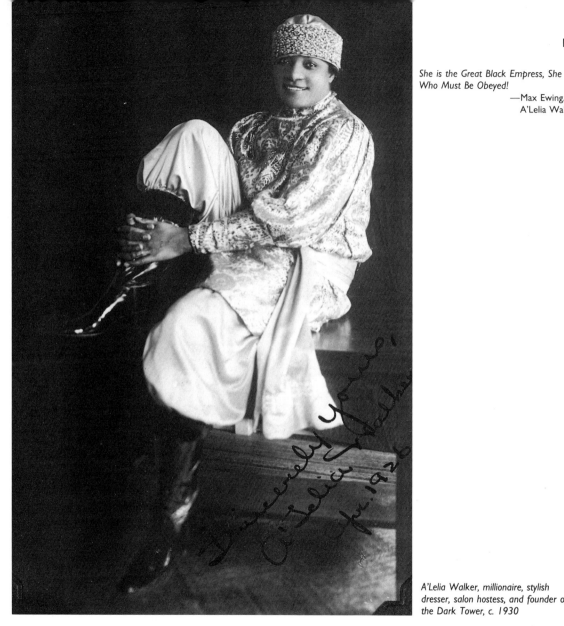

She is the Great Black Empress, She Who Must Be Obeyed!

—Max Ewing, on A'Lelia Walker

A'Lelia Walker, millionaire, stylish dresser, salon hostess, and founder of the Dark Tower, c. 1930

Right here let me correct the erroneous impression held by some that I claim to straighten the hair. I want the great masses of my people to take a greater pride in their appearance and to give their hair proper attention. . . . And I dare say that in the next ten years it will be a rare thing to see a kinky head and it will not be straightened either.
—Madame C. J. Walker

Fairy-like is she whose luxuriant well-kept tresses frame a beauty-kissed complexion.
—Advertisement for Madame Walker's products

Hair: **good hair, righteous moss, righteous grass, near my God to thee, kind hair** (all mean Caucasian-type hair); **made hair** (hair that has been straightened); **kinkout** (hair straightener)

Wonderful Hair Grower" and adapted "hot combs" to straighten the hair of black women. At the time of her death in 1919, her enterprise had yielded over $2 million as well as a mansion called the Villa Lewaro. In contrast to her mother, A'Lelia invested her energy neither in the hair culture business nor in her mother's favorite charities (her will earmarked two-thirds of the profits from the Walker empire for charity). A'Lelia instead devoted herself to developing a Harlem high society that included whites and blacks, royalty and racketeers, lesbians and homosexual men, writers and singers. Her guest list, one observer reported, "read like a blue book of the seven arts,"[95] and her parties provided an Uptown counterpart to those Carl Van Vechten threw Downtown.

A'Lelia's most elegant parties were held at the Villa Lewaro, her cream-colored Italianate mansion fifteen miles up the Hudson in Irvington, designed by Vertner Woodson Tandy, the first African American licensed to practice architecture in New York State. A'Lelia was afraid to stay at the villa alone (it was here that her mother had died of Bright's disease in 1919), so she invited guests for long weekends of ostentatious luxury. They were met by black servants in white wig, doublet, and hose and encouraged to rest in Hepplewhite furniture while enjoying her $60,000 Estey pipe organ or her twenty-four-carat gold-plated piano.

Although those weekends were the most extravagant of A'Lelia's events, the most widely attended took place in her Harlem mansion at 108-110 West 136th Street. In the fall of 1928, A'Lelia announced her interest in Harlem's cultural life. She joined her twin limestone townhouses, and, inspired by bohemian friends, she envisioned music being played there, paintings and sculpture on view, and poetry read. Although no one thought her new pursuit could compete with her passions for shopping, poker, and bridge, they were

impressed that she transformed her new cultural enthusiasm into an ongoing salon. She named her salon "the Dark Tower" after Countee Cullen's column in *Opportunity*, and she had Langston Hughes's "The Weary Blues" lettered on one wall. Guests entered through long French doors and stepped onto the blue-velvet runner that led into a splendid tearoom. They checked their hats for 15 cents and listened to a talking parrot. One might remain below to drink and dance on the parquet floor, or ascend to the top-floor library for conversation and bridge, surrounded by bookcases containing works written by African Americans.

Everything in A'Lelia's parlor-cum-tearoom-salon represented the ostentatious best that money could buy: the designer was Paul Frankel; the carpet, Aubusson; the furniture, Louis XIV; the turquoise and amethyst paste tea service, Sèvres; the drink, champagne. Sometimes the music issued from a sky-blue Victrola, but more often someone played a Knabe baby grand piano. Fresh from the Broadway revues were Alberta Hunter, Adelaide Hall, and the Four Bon Bons. Nightclub crooners included Jimmie Daniels and Gus Simons, and Taylor Gordon sang spirituals. A'Lelia's ever-present retinue—Wallace Thurman dubbed them ladies-in-waiting—included striking light-skinned women (actress Edna Thomas, Mayme White, Mae Fain) and witty homosexual men (Casca Bonds, Edward Perry) who organized the socials. For one of her most notorious (and possibly apocryphal) parties, she reversed the favors usually accorded the races—white guests were served pig's feet, chitterlings, and bathtub gin, while the black guests, seated in separate and more posh quarters, dined on caviar, pheasant, and champagne.

The Dark Tower was a fashion showcase, with blacks and whites showing off to one another. Bon vivant novelist Max Ewing described one evening to his parents in Ohio: "You have never seen

An invitation to the opening of the Dark Tower, fall 1928

We dedicate this tower to the aesthetes. That cultural group of young Negro writers, sculptors, painters, music artists, composers and their friends. A quiet place of particular charm. A rendezvous where they may feel at home to partake of a little tidbit amid pleasant, interesting atmosphere. Members only and those whom they wish to bring will be accepted. If you choose to become one of us you may register when first attending "The Dark Tower." One dollar a year. Open nine at eve 'til two in the morn.

—Invitation to opening of the Dark Tower

both races were nourished by land and sun—and she contributed money to Negro schools as a way to redress the white race's sins. The further down on the ladder of class, Mason believed, the greater an individual's chance of attaining virtue. Her attention to the New Negro was of more recent vintage, catalyzed in early 1927 by Alain Locke's lecture on African art. Locke avidly pursued Mason, and the two forged a relationship that was so ideally complementary that it would flourish until Charlotte Mason's death in 1945 at the age of ninety.

Her tongue was a knout, cutting off your outer pretenses, and bleeding your vanity like a rusty nail.
—Zora Neale Hurston, on Charlotte Mason

Both Locke and Mason thrived on exercising their covert power to pilot the course of African-American culture. Mason provided the emotional and financial base that Locke had lacked since his mother's death and his departure from Howard University a few years earlier. In turn, Mason needed an active figure to administer the program her health no longer permitted. Locke possessed the critical skills that could abet her intuitions (even though she sometimes considered his manners too much like those of white people). Epiphany ruled her life, and mystical visions guided her. Shortly after meeting Locke, she wrote: "As the fire burned in me, I had the mystical vision of a great bridge reaching from Harlem to the heart of Africa. . . ."[99] Locke became her confidant, envoy, talent scout, and chatelain. He introduced her to those he felt deserved support—these protégés included not only Hughes but also fledgling writer Zora Neale Hurston, artists Aaron Douglas and Miguel Covarrubias, and sculptor Richmond Barthé. On these writers and artists Mason expended nearly $75,000—over a half million dollars by current valuation. She desired no publicity in return—her protégés were required to maintain her anonymity by calling her "Godmother"—but her patronage exacted the more debilitating tolls of dependency, control, and infantilization. Seated on footstools at her feet, Mason's

He is too eager to be with the winner. . . . He wants to autograph all the successes, but is afraid to risk an opinion first hand.
—Zora Neale Hurston, on Alain Locke

"godchildren" showed her the aboriginal path to spirituality, allowing the aging matron to indulge her fantasies about the nobility of primitives. She, in turn, felt that she was saving them from the spurious, commercial temptations of white society—for Van Vechten, Jews, and Harlemaniacs represented to her something very like the devil and his court of satyrs. The mixture of support and dependency can be seen in her symbiotic relations with her two most promising protégés, Langston Hughes and Zora Neale Hurston.

LANGSTON AND GODMOTHER. In Langston Hughes, Mason detected not only his black heritage but also the strain of Indian blood on his mother's side. As Hughes's first visit ended, she pressed a $50 bill into his hand and explained, "A gift for a young poet." This was merely the first of many dinners in her suite overlooking the glittering lights of midtown Manhattan. Hughes stood in awe of her experience and intelligence, her silver platters and elegant furniture, her modern ideas and youthful energy; she clumped her cane in beat to "Salty Dog" and applauded Duke Ellington as well as Marian Anderson. In November 1927, Hughes entered into a formal arrangement whereby he would receive $150 each month from Mason, and in exchange for this stipend he would apprise Godmother of his every move, replete with a meticulous accounting of his expenses. Nothing in the document legally bound Hughes's career, but there was in its place an emotional mortgage to Godmother's firmly expressed sense of expectation. "You may feel, Langston, that I am pressing you forward very hard," she wrote, "but it is because I believe you have enough truth to dare to follow the urge in this late hour of the salvation of your people."[100]

It was no coincidence that Hughes began to spend less time

You are a golden star in the Firmament of Primitive Peoples. . . .
—Charlotte Mason, to
Langston Hughes

Knowing you is like Sir Percival's glimpse of the holy grail. Next to Mahatma Gandhi, you are the most spiritual person on earth.
—Langston Hughes to Charlotte Mason

*May the river of your life run deep &
strong, gathering clear mountain streams
that carry our blessed child safely to his
fulfillment.*
 —Charlotte Mason to Langston
 Hughes, on his twenty-sixth birthday

*Sometimes, I would feel like a rabbit at
a dog convention.*
 —Zora Neale Hurston, on being with
 Charlotte Mason

She was just as pagan as I.
 —Zora Neale Hurston, on
 Charlotte Mason

*Flowers to you—the true conceptual
mother—not just a biological accident.
To you of the immaculate conception
where everything is conceived in beauty
and every child is covered in truth.*
 —Zora Neale Hurston to Charlotte
 Mason

at Niggerati Manor; on Locke's recommendation, Godmother did not want that perverse wing of the Renaissance to diffuse his focus. She referred to his fellow students at Lincoln University as "that yapping crowd."[101] Nor did he attend more than a few of A'Lelia Walker's parties at the Dark Tower, even though his poem "The Weary Blues" adorned one of its walls. All his energy, Mason insisted, must be directed to writing the literature that would save the black race. Inseparable from her tyranny was her warm encouragement and material nourishment. He received suits from Fifth Avenue stores, tickets to the opera, a typist, fine bond paper, a filing case—not just the balm of previously unknown financial stability but also the accoutrements of Mason's world. Looking back, Hughes wrote, "I can only say that those months when I lived by and through her were the most fascinating and fantastic I have ever known."[102]

ZORA AND GODMOTHER. Alain Locke introduced Zora Neale Hurston to Charlotte Mason in the fall of 1927, and the bond quickly established between the two women—a mixture of the spiritual and the legal—proved to be even more symbiotic than that between Mason and Hughes. Hurston assayed her role as an untainted child of nature with more verve than any of the other "godchildren"; over dinners of capon and caviar, Hurston regaled the matron with stories and songs delivered in perfect Florida dialect. She once referred to Mason as the "guard-mother who sits in the twelfth heaven and shapes the destinies of the primitives."[103] The line between performance and sincerity was a thin one for Hurston, and she relished Mason's rapt maternal interest. So complementary were their interchanges that both women would finish the other's sentences, and could read each other's minds from afar; they soon came to believe

that their psychic bond was mystical. The effusiveness of Hurston's letters to her "true conceptual mother" demonstrates the strength of this bond: "I have taken form from the breath of your mouth. From the vapor of your soul am I made to be."[104]

On December 8, 1927, Mason drew up a rigorously legalistic contract. Hurston would receive $200 a month, a car, and a movie camera, in exchange for collecting black folklore (music, poetry, conjure, tales, songs, stories). Hurston's remuneration from Mason exceeded Hughes's, for Hurston was employed to gather the information that Mason's schedule and health prevented. The results would become Mason's property, and Hurston was enjoined from publishing anything, even fiction, without her permission. Godmother did not regard this arrangement as exploitive—she was convinced that she knew better than Hurston how to handle this invaluable trove of folklore.

Less than a week after signing the contract Hurston headed south in her new Chevrolet coupe known as "Sassy Susie." She would not return for two years. During this time she immersed herself in the life of the Southern Negro, all the while collecting folklore. She posed as a bootlegger's woman on the run, packing a chrome-plated revolver in her purse, as a hoodoo novitiate, as a rapt observer zigzagging from jook joints and logging camps to bawdy houses and river towns. She courted peril and discomfort in order to penetrate the ways of black folk. To be initiated in conjure practices, for example, Hurston lay face down, nude, for sixty-nine hours, without food or water, her navel touching a rattlesnake skin. This anthropological adventure far exceeded any fieldwork she had done for Franz Boas, and the two years provided one of the richest experiences of her life. "I am getting inside the Negro art and lore," she wrote Langston Hughes. "I am beginning to *see* really."[105] She was exhilarated

Zora Neale Hurston and "Sassie Susie" traveling in the South, 1928

I want to collect like a new broom.
—Zora Neale Hurston

that she was talking to the last survivors of the African slave ships, penetrating conjure cults, getting truer accounts than earlier anthropologists, and salvaging the lore that was fast disappearing from the twentieth-century South. Although far from Harlem, she was nevertheless carrying out the Renaissance work Locke and others had proclaimed essential: unearthing the African-American heritage.

Hurston was alternately thrilled by the freedom Mason's money allowed her and exasperated by her patron's control. The most financially beneficent of all the Renaissance patrons, Mason also guarded the lever of power most vigilantly. Hurston chafed at the conditions of her contract that prevented her from publishing any of her work or acquainting her mentor, Boas, with her findings. She knew that the black life depicted by such white playwrights as Eugene O'Neill, Paul Green, and DuBose Heyward was ersatz, and she aspired to put a more authentic rendering on stage. In her letters to Hughes she secretly shared her fieldwork, but publicly she remained mute.

After Hurston returned north in 1929, she wrote up her stories, jokes, and songs, which were then read by both Mason and her advisor, Locke. Godmother expunged supposedly dirty words from Hurston's text. "Godmother could be as tender as mother-love when she felt that you had been right spiritually," Hurston recalled. "But anything in you, however clever, that felt like insincerity to her called forth her well known 'That is nothing! It has no soul in it.' "[106] Hurston may have disagreed, but she understood the source of her support, she knew that her fieldwork was locked in Mrs. Mason's safe deposit box in a Fifth Avenue bank, and she never bit the hand that fed her. She probably had no alternative; the folklore treasure she had unearthed would remain unknown to the world for years.

Perambulation: **percolating, cruising, oozing** *(all mean promenading down the avenue);* **freewheeling** *(same, but more briskness implied);* **trucking** *(implies strolling);* **hauling** *(fleeing on foot; "Man! He cold hauled it!");* **sell out** *(run in fear);* **air out** *(leave, flee, stroll);* **stanch** *(step out)*

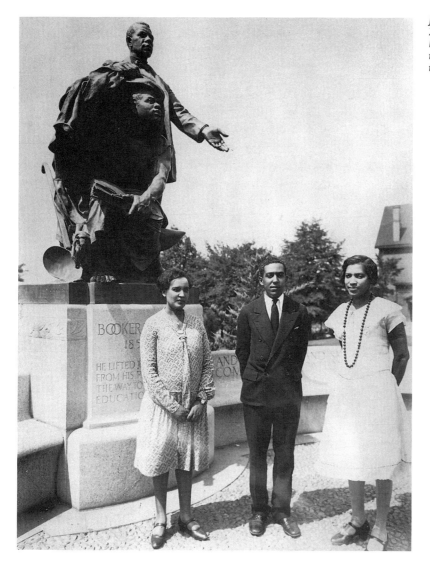

Jessie, Fauset, Langston Hughes, and Zora Neale Hurston at the grave of Booker T. Washington, Tuskegee Institute, summer 1927, on the Southern car trip that spawned Mule Bone

FLASHBACK: ZORA AND LANGSTON'S SOUTHERN IDYLL. The demise of the Harlem Renaissance would come soon, but first a look back to a month in the summer of 1927 that evoked its greatest promise and encompassed its most pervasive themes. At that moment the Renaissance's brightest lights—Langston Hughes and Zora Neale Hurston—were each returning from trips in the South, when, by chance, Hughes ran into Hurston in Mobile, Alabama. The two promptly decided to head north together in Hurston's Chevrolet coupe. Together they would experience firsthand the indigenous Southern Negro and hatch up an ambitious collaboration.

They motored through Alabama and Georgia on deeply rutted clay roads, surrounded by cotton fields and chinaberry and red gum trees, and along the way they visited some monuments of black history. They spent a night in the same Macon, Georgia, hotel as Bessie Smith ("The trouble with white folks singing blues," she instructed them, "is that they can't get low down enough."[107]) They encountered Jessie Fauset at the Tuskegee Institute—where the three visited the grave of Booker T. Washington—and Hughes alone met the reclusive black icon, George Washington Carver. Hurston and Hughes tarried at a backwoods church (where the Lord's Prayer was rendered: "Our Father who art in Heaven,/*Hollywood* be thy name!"[108]), and they saw naked children, decrepit goat carts, and dusty huts. They visited Sparta, the small town where Jean Toomer had experienced his transformation five years earlier, and here Hughes came upon an old man that reminded him of Uncle Remus. He was wearing a hat that Hughes coveted—a weather-stained mosaic of leather, baize, felt, and linoleum. "It seemed to me like the quaint soul of labor in the Old South, 'caroling softly souls of slavery,'" Hughes recalled. "It seemed to me like early dawn on the Georgia plum trees and sunlight in the cotton fields."[109] Hughes

Jook (rhymes with "took"): a low-down pleasure house, originally in the lumber, turpentine, and railroad camps of the South, cradle of the blues and black dance steps ("jukebox" is derived from this)

traded his new straw hat for it, and it was his only artifact of that trip. He wrapped the hat in tissue and deposited it in Charlotte Mason's safe deposit vault along with his manuscripts and a shawl in which a man had been killed at Harpers Ferry.

Along the way Hughes received approving messages from Charlotte Mason, who was just initiating her support of Negro writers and artists. "How wide open the door of your being is—how I love for you this experience that you are going through now—rising with the sun in the back country of the Alabama hills," Godmother wrote. "You will know, dear child, so much better what lies deeply hidden in your poetic soul and in the far reaches of your ancestral dreams."[110] As they drove along in "Sassie Susie," Hurston and Hughes traded songs, slang, and conjure potions for love and revenge.

Together they improvised plans to collaborate on a dream undertaking—a Negro opera. From their perspective *in situ* the folk materials available for such a project seemed abundant, and they believed it would resonate profoundly with the New Negro Renaissance. The opera could be the vehicle for transforming low, indigenous materials into a high cultural form, and it could offer a literary marriage between the Talented Tenth and the Niggerati. "Langston, Langston," wrote Hurston, "this is going to be big."[111]

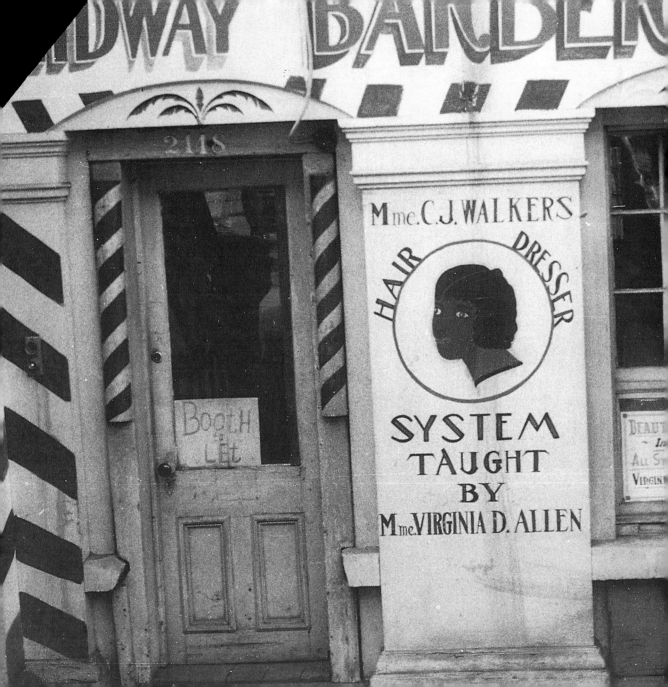

AFTER THE RENAISSANCE

Overleaf:
Midway Barber Shop by Carl Van Vechten, 1932

Inset (left to right): Zora Neale Hurston, Langston Hughes, Claude McKay, and Countee Cullen

THE **END: 1929 AND AFTER.** The Wall Street Crash of October 29, 1929, marked the close of an epoch: the era of the Charleston and speakeasies, black wunderkinds and James J. Walker, was replaced by insecurity and breadlines, overcrowding and the Scottsboro Boys. Even Carl Van Vechten forswore drinking and smoking, and within a few years his wife would declare the Harlem experience "a phase in the life of this generation. It was all very hollow."[1] The Crash ushered in a period in which white patrons attended to more immediately pressing financial matters than their support of Negro writers. "We were no longer in vogue, anyway, we Negroes," recalled Langston Hughes. "Sophisticated New Yorkers turned to Noel Coward."[2]

The impact on Harlem was devastating, although not immediate. Locke, the spokesmen for the New Negro movement, still waxed optimistical at the end of 1930—citing Langston Hughes's

The cycle that had Charlestoned into being on the dancing heels of Shuffle Along *now ended in* Green Pastures *with De Lawd.*
—Langston Hughes

The rosy enthusiasm and hopes of 1925 were . . . cruelly deceptive mirages.
—Alain Locke

Harlem is still in the process of making.
 —James Weldon Johnson

novel *Not Without Laughter* and George Schuyler's novel *Black No More* as evidence of the Renaissance's continuation. James Weldon Johnson published his book *Black Manhattan* in 1930; in retrospect, the timing of his paean to the promise of Harlem was bittersweet, for it appeared just before the Black Mecca began the precipitate slide from ghetto to slum. Blacks from around the world still migrated to one of the most densely crowded regions of the world. Prejudice grew as jobs diminished—after the Crash, unemployment in Harlem was five times that of the rest of the city. Ugly incidents such as the one in Alabama, sentencing to death the Scottsboro Boys (nine black youths aged thirteen to nineteen) on trumped-up charges of raping two white prostitutes, spotlit America's still-prevailing forces of bigotry.

The ordinary Negroes hadn't heard of the Negro Renaissance. And if they had, it hadn't raised their wages any.
 —Langston Hughes

Harlem nightlife continued to flourish until the 1933 repeal of the Volstead Act ending Prohibition finished off Uptown nightclubs. The sophisticated sounds of swing overtook the blues, and the jazz center moved down to Fifty-second Street. Save for a few institutions like Connie's, the Cotton Club, and Small's Paradise (which redecorated and became swankier), there was less emphasis on troupes of sepia chorines and extravaganza. The action moved instead to the divier speakeasies where the gin was stiffer and rockier. Because fewer blacks could afford the clubs, interracial mixing declined.

The older ones became warped by propaganda. We younger ones are mired in decadence.
 —Wallace Thurman

As the center of the New Negro movement, Harlem lost much of its centripetal force. Locke became increasingly occupied by Howard University, where his activity over the next decades shaped succeeding generations. Charles S. Johnson had left Harlem in 1928 to become the director of social sciences at Fisk University in Nashville, Tennessee, where he continued a distinguished career that culminated in his appointment as the black university's first African-American president in 1947. James Weldon Johnson followed him

V and X: *a five-and-dime store*

there in 1931 to teach English, and, in 1937, Aaron Douglas also moved to Fisk, where he taught for the next nineteen years. Jessie Fauset, having given up her position at *The Crisis* and her infatuation with Du Bois—"her best friend and severest critic"—married an insurance broker and became a housewife.[3] The last of her four novels was published in 1933. *The Crisis* was in such difficult straits that Du Bois had to forgo several months' salary to keep the magazine going, and in 1934 his editorship ended. With leaner budgets, neither *The Crisis* nor *Opportunity* published much literature.

But the demise of the Renaissance was not simply the result of a depressed economy and dispersal of its key players. The New Negro movement was also torn apart by internal contradictions (Niggerati versus Talented Tenth, politics versus art, race-building versus literature) and its external dependence on Harlemania and Negrotarians for support. As had the Greenwich Village rebels a generation ago, the New Negroes mistook art for power. Years earlier Alain Locke and W. E. B. Du Bois had each proclaimed the birth of the Harlem Renaissance; years later, they delivered its obituary.

Shortly before he relinquished the editorship of *The Crisis* in 1934, Du Bois asked why the Renaissance had never taken root: "It was because it was a transplanted and exotic thing. It was a literature written for the benefit of white people and at the behest of white readers, and starting out privately from the white point of view."[4]

Shortly before his death in 1954, Locke looked back in dry-eyed sorrow:

> Two childish maladies of the spirit—exhibitionism and racial chauvinism . . . became epidemic. . . . Once the movement took on public momentum and offered that irresistible American lure of a vogue of success, a ready means of quick rec-

For how could a large and enthusiastic number of people be crazy about Negroes forever? But some Harlemites thought the millennium had come. . . . They were sure the New Negro would lead a new life from then on in green pastures of tolerance created by Countee Cullen, Ethel Waters, Claude McKay, Duke Ellington, Bojangles, and Alain Locke.

—Langston Hughes

Now you cooking with gas!: *now you're in the groove, now you're talking*

The Harlem Renaissance movement of the antic nineteen twenties was really in-spired and kept alive by the interest and presence of white bohemians. It faded out when they became tired of the new plaything.

—Claude McKay

ognition, an easy, cheap road to vicarious compensation, this dangerous infection was on. True, it was a typically American misapprehension, a characteristic American popular abuse, but it brought about lamentably a Negro-American tragedy of the first magnitude.[5]

The end of the Harlem Renaissance is more vividly rendered, however, in personal close-ups than in such overarching generalizations.

HURSTON AND HUGHES AND MASON AND LOCKE: THE BREAK-UP.

The folk opera Langston Hughes and Zora Neale Hurston had planned in the summer of 1927 as they motored through the South didn't survive the merciless realities of the city. The scope and cost of an opera was abandoned as quixotic and visionary, but their collaboration took a new form. It became a folk comedy called *Mule Bone,* with a plot based on one of Hurston's Eatonville folktales and a dramatic structure provided by Hughes. Hurston remarked to Hughes, "You are the brains of this argosy. . . ."[6] In April 1930, the two sat down to write. Godmother had provided all material means to encourage the project—quiet rooming-house quarters in Westfield, New Jersey, a typist named Louise Thompson (briefly and disastrously married to Wallace Thurman), and her iron-willed set of expectations that something important would be written. The situation presented for Hurston and Hughes the opportunity to realize their dream of launching an authentic Negro theater. That idyllic moment would crumble; just as their collaboration represented the aspirations of the Harlem Renaissance, so did their breakup reflect the movement's end.

Pilch: house, apartment, residence

The first explosion occurred after Alain Locke reported to Charlotte Mason that there was too much horseplay and too little play being written in Westfield: Godmother snubbed Hurston and refused to speak with Hughes on the telephone. It was only in response to a long, toadying letter from Hughes that the pair were provisionally restored to "godchildren" status. Hurston abruptly headed South in May, although only the first and third acts had been completed. Hughes discerned nothing disturbing in her departure, but he should have. Louise Thompson's presence aroused Hurston's jealousy; sensing romantic interest in Hughes from Thompson, she felt like a rejected lover. Her supposition was odd, given that Hughes was widely regarded as asexual, and that neither he nor Thompson felt anything but friendship. Hurston, nonetheless, felt excluded, and on her flight from Westfield, she wrote, "I just went off to myself and tried to resolve to have no more friendships. Tears unceasing have poured down inside me."[7]

During the month of Hurston's departure, Charlotte Mason summoned Hughes to 399 Park Avenue and upbraided him for his insufficient productivity. When Hughes described that humiliating afternoon in his autobiography a decade later, he still felt an unpleasant sensation in the pit of his stomach. "That beautiful room, that had been so full of light and help and understanding for me, suddenly became like a trap closing in, faster and faster, the room darker and darker, until the light went out with a sudden crash in the dark. . . ."[8]

The unraveling was not nearly so neat as Hughes recalled it, but the effect was as crushing. Within a short time, Hughes's relationships with Mason, Alain Locke, and Zora Neale Hurston ended, and the good faith that had driven the New Negro movement seemed to have dried up.

She ain't got 'em from creeps to crown and her trotters is B flat, but her gin is regal: she's ugly from tip to toe, but serves good liquor.

For six months Hughes begged to return to Godmother's fold, taking on himself all blame for the expulsions from grace. But Mason did not accept his apologies, however unwarranted, and Hughes somatized his turmoil. He was nauseous and insomniac and his face became a rictus of pain. "I am nothing now—no more than a body of dust without wisdom, having no sight to see," he wrote Mason. "Physically and spiritually I pass through the dark valley, a dryness in my throat, a weariness in my eyes, fingers twisted into strange numb shapes when I wake up at night. . . ."[9] He wanted not only the financial stability Mason provided, but the maternal figure he craved so profoundly.

At the same time, Zora Neale Hurston copyrighted *Mule Bone* under her name and began to peddle the script to theatrical producers as solely her creation. In her letters to Mason she conducted a campaign against Hughes: "Langston is weak. Weak as water."[10] Her motives remain unclear—in addition to ownership of *Mule Bone*, she perhaps feared for her own precarious place in Godmother's beneficent heart. (Mason would expel her for the last time in 1932.) Hughes and Hurston would never reconcile, meeting again only once in their lifetimes. It was not until long after their deaths that *Mule Bone* was produced in 1991 at Lincoln Center.

Unknown to Hughes, Alain Locke was also undercutting him in letters to Mason while supporting Hughes to his face. He nominated Hughes for a Harmon Award, for example, and then complained to Mason it would "swell the false egotism that at present denies its own best insight."[11] He speculated that Hughes was suffering a nervous breakdown, that he wanted to run "a signed author's portrait racket," that he was a shameless opportunist. Perhaps Locke's actions were his final retribution for his romantic failure with Hughes, combined with Locke's desire to remain firmly within Ma-

son's good graces. Hughes never forgave him for his duplicity, not even after Locke's death.

In their heyday, the coordinated forces of Locke, Mason, Hughes, and Hurston had contributed enormously to the Harlem Renaissance. But the constellation of power was undone. With Hughes and Hurston no longer his protégés, and no one to replace them, Locke lost his position as a Renaissance culture-broker. "I hear almost no news now from New York; a younger crowd of 'Newer negroes' are dancing in the candle flame," he wrote Mason in the spring of 1931. "The older ones are nursing their singed wings."[12] Mason meanwhile retreated to her pre-Negro ideas of uplifting primitivism. She wrote Locke, "I am helping forget the discouraging things that have fallen on me from the Negroes by talking about my Indian days."[13]

The New Negro culture conglomerate was dismantled.

THE DEATH OF A'LELIA WALKER. By December 1930, A'Lelia Walker's fortune had run low, and fewer black women could afford to spend their dwindling income on hair products. A'Lelia mortgaged the Villa Lewaro. The empire that Madame C. J. Walker had built up was auctioned off at bargain-basement Depression prices—or, as the *Amsterdam News* headlines put it, "WHITE BUYERS STRIP VILLA OF TREASURES."[14] Eight months later (August 17, 1931), after a middle-of-the-night snack of lobster and chocolate cake washed down with champagne, A'Lelia's heart gave out. (Her friends told the press she had died of heartbreak.) Wearing a gold lace and tulle dress with a green velvet sash, she was laid in a Merrette Silver Solid Bronze hermetically sealed casket, and fifteen thousand filed by to view her body.

Far fewer white engraved invitations to the funeral itself were

A'Lelia knocked herself out because she wanted to be knocked out.
—Marion R. Perry, Jr., A'Lelia Walker's son-in-law

Function, fungshun: *a small, unventilated dance filled with insufficiently bathed people.* **Funk** *derives from this, meaning body odor.*

*Bust of A'Lelia Walker by Roy Sheldon,
c. 1930*

So all who love laughter
And joy and light,
Let your prayers be as roses
For this queen of the night.
—Langston Hughes,
"For A'Lelia"

sent out, but they greatly exceeded the seats in the Howell Funeral Home. Among those that squeezed inside were Harlem's literati, representatives of the Walker empire of beauty parlors, and the white Downtowners who had filled the Dark Tower. The Reverend Adam E. Clayton Powell, Senior, stood magisterially at the rostrum—looking unnervingly like De Lawd in Broadway's recent hit *The Green Pastures*—and reminded the mourners that "her establishment, the Dark Tower, was the Mecca of Negro artists."[15] Edward Perry read the poem Langston Hughes had composed for the occasion three days earlier, and Mrs. Mary McLeod Bethune recalled the labors of Madame C. J. Walker that had made A'Lelia's luxury possible. Uniformed representatives of the Walker beauty shops filed by the bier

to lay their floral tributes while the Bontemps Quartet sang "Steal Away to Jesus." "It was extremely difficult at times to hear what was being said by the speakers," noted a reporter, "so boisterous was the crowd outside."[16] Finally, after the Reverend Powell solemnly intoned "The Four Bon Bons will now sing," the cabaret quartet stepped forward to deliver Noël Coward's "I'll See You Again." As Langston Hughes recalled, "and they swung it lightly, as she might have liked it."[17] As her body was interred at Woodlawn Cemetery, a plane flew low overhead and a final floral wreath was dropped from the sky. Langston Hughes looked back on that moment and declared, "That was really the end of the gay times of the New Negro era in Harlem. . . ."[18]

You should have known A'Lelia Walker. Nothing in this age is quite as good as THAT. . . . *What a woman!*
—Carl Van Vechten

THE END OF WALLACE THURMAN. The ringleader of Niggerati Manor, Wallace Thurman, was unrepentantly bohemian to his untimely end at the age of thirty-two. He battled tuberculosis, alcoholism, poverty, his wife of six months (Louise Thompson), and racking self-doubt. He constantly questioned his literary ability—and nothing he wrote assuaged his doubts. He had written a hit Broadway play *(Harlem)*, two novels about the Harlem Renaissance *(The Blacker the Berry, Infants of the Spring)*, edited two magazines *(Fire!!, Harlem: a Forum of Negro Life)*, written a muckraking novel about the appalling conditions at City Hospital on Welfare Island *(The Interne)*, and two B-movie screenplays *(Tomorrow's Children, High School Girl)*. When his doctor warned him that his tuberculosis jeopardized his life, Thurman returned to New York in a flashy suit and, renouncing his motto of "civilized tippling,"[19] drank steadily for a month. His erratic behavior at parties rapidly slid from brilliant badinage to passing out or threatening to jump from a window. He finally collapsed. Perversely,

He wanted to be a very great writer, like Gorki or Thomas Mann, and he felt that he was merely a journalistic writer.
—Langston Hughes, on Wallace Thurman

Hot man: *a seller of stolen goods*

Wallace Thurman was Priceless.
—Eulogy read by
Reverend William Lloyd Imes
at Thurman funeral

he was sentenced to spending his six final months in the same Welfare Island City Hospital that he had disparagingly described, surrounded by patients who could not appreciate his bitter bon mots.

He died destitute—in the same week as black novelist Rudolph Fisher—and a funeral was held on Christmas Eve, 1934. The mourners, who included Countee Cullen, Aaron Douglas, and Richard Bruce Nugent, felt their generation's mortality; as a friend of Thurman's observed, "It was the first break in the ranks of the 'New Negro.' "[20] Delivering Thurman's eulogy, the Reverend William Lloyd Imes observed, "He really kept open house—to all, in all stations of life: he was at home to social lions, to the pitifully mediocre, and even to the less fortunate."[21]

He was our leader, and when he died, it all died with him.
—Dorothy West, on Wallace Thurman

Thurman's more enduring obituary is embodied in his 1932 roman à clef, *Infants of the Spring.* For one last time he brought the chief protagonists of the Harlem Renaissance to Niggerati Manor, and on them he cast his sharp, parodistic, disappointed gaze. Here was Alain Locke (Dr. Parkes) telling his protégés, "Because of your concerted storming up Parnassus, new vistas will be spread open to the entire race." Here was Richard Bruce Nugent (Paul Arbian): "Since he can't be white, he will be a most unusual Negro." Here was Langston Hughes (Tony Crews), a promising writer so personally enigmatic that Thurman concluded, "Either [Hughes] had no depth whatsoever, or else he was too deep for plumbing by ordinary mortals." Here was Countee Cullen (De Witt Clinton) as "the Negro poet laureate," and Zora Neale Hurston (Sweetie May Carr) rejoicing in her support by the Negrotarians: "Thank God for this Negro literary renaissance! Long may it flourish!"[22] But the Renaissance Thurman depicted was depleted by its preoccupation with race-building and Downtown publicity. The novel closed with a despairing image:

That's the lost generation, and we were just part of that. On the distaff side.
—Richard Bruce Nugent

. . . a distorted, inky black skyscraper, modeled after Niggerati Manor, and on which were focused an array of blindingly white beams of light. The foundation of this building was composed of crumbling stone. At first glance it could be ascertained that the skyscraper would soon crumple and fall, leaving the dominating white lights in full possession of the sky.23

EPILOGUE. The lives and careers of the New Negroes of course extended long beyond the pivotal moment of the Harlem Renaissance, and a younger generation of African-American writers followed in its wake. This saga of the New Negro is confined to abbreviated renditions of the careers of four of them—Countee Cullen, Claude McKay, Zora Neale Hurston, and Langston Hughes.

COUNTEE CULLEN. *The Black Christ and Other Poems,* the book Countee Cullen wrote while on his Guggenheim fellowship, appeared in 1929. This was his last major literary contribution. At twenty-six he was unable to break free from his constricting persona as the movement's "Black Pan" and "Black Ariel." He wrote a black-themed novel, *One Way to Heaven,* but its publication in 1932 was greeted without fanfare, no review in *The Crisis,* and even his supporter, Alain Locke, gave it only brief notice in a roundup of fifteen books he reviewed for *Opportunity.* In 1934, Cullen returned to De Witt Clinton High School, the scene of his early glory, to teach French. He remained there for the rest of his life. (Among his students was James Baldwin, who interviewed him for the school newspaper.) His last works were children's books about his pet cat, Christopher, and he seemed to recognize that his writing career was

Countee Cullen by Carl Van Vechten, June 20, 1941

Be the man you were headed toward being.
—Witter Bynner to Countee Cullen

over when, in 1945, he began selecting his favorite poems for an anthology, to be called *On These I Stand*.

On January 9, 1946, at the age of forty-two, shortly before this final monument was published, Cullen died of high blood pressure and uremic poisoning. His funeral was held in the same church where he had been married, a Harlem tribute to the boy wonder prematurely gone. The honorary pallbearers included Carl Van Vechten, Harold Jackman, Alain Locke, and Paul Robeson, and the passage through which they carried Cullen's casket was surrounded by his former students holding aloft floral tributes. The two-hour ceremony

Funeral of Countee Cullen, January 12, 1946

Hurston published only two more books in the last twenty years of her life. Her autobiography, *Dust Tracks on a Road*, published in 1942, was charming and unreliable, bowdlerized by her publisher, J. P. Lippincott. Her last book, *Seraph on the Sewannee*, appeared in 1948. The positive reviews she received for her book were overshadowed by the near-simultaneous accusations of sexual abuse by a ten-year-old boy. Although the charges were verifiably false, a black tabloid (Baltimore's *Afro-American*) squeezed her tale between sensational stories of a "Bathtub Killer of Young Mother" and "Seven Milwaukee Men Held in Sex Case Probe"—and, most distressingly, her novel was quoted to reveal incriminating "links" between her novel and her life.[26] Feeling that her people and her work had been turned against her, she became profoundly depressed. "My country has failed me utterly," she wrote Carl Van Vechten and Fania Marinoff. "My race has seen fit to destroy me without reason, and with the vilest tools conceived of by man so far."[27]

A summary of Hurston's dozen years after her last novel suggest precipitous decline: she worked as a $30-a-week maid, as an Air Force librarian, writing only occasionally. She completed a long and unpublished "Life of Herod the Great," and some magazine pieces and letters to the editor that sounded both Republican and pro-segregation. She died on January 28, 1960, three months after becoming a ward of the Lucie County welfare home; at her open-casket funeral she wore a bright pink dressing gown and fuzzy slippers, and then she was laid to rest in an anonymous grave in the segregated Garden of the Heavenly Rest cemetery. But the years had not been entirely bleak for her. Early on, Hurston had learned to handle adversity, and she took great pleasure in living on a houseboat, tending a well-kept garden, papaya trees, and playing with her big brown and white dog named Sport. With characteristic pluck, she looked back

sonification of death
tin comes." [Bert

seemed peculiarly deracinated—Cullen was the only black poet read, and not a single spiritual was sung. His seventy-eight-year-old ex-father-in-law, W. E. B. Du Bois, delivered the most telling eulogy:

> That Countee Cullen was born with the Twentieth Century as a black boy to live in Harlem was a priceless experience. . . . Yet, as I have said, Cullen's career was not finished. It did not culminate. It laid [a] fine, beautiful foundation, but the shape of the building never emerged. . . .24

ZORA NEALE HURSTON. Only after September 1932—when Zora Neale Hurston finally left the well-feathered nest provided by Charlotte Mason—were her books published. Hurston hit her stride in the mid-1930s, producing in rapid succession five books, drama, stories, and essays. The folklore that she had collected under Mason's aegis was published in 1935—seventy folk tales with background explanation—under the title *Mules and Men*. Shortly thereafter she wrote her acknowledged masterpiece, *Their Eyes Were Watching God* (1937).

Like much of her work, the novel revealed its roots in the black folk of Eatonville, but her writing grew increasingly personal, and she based the main characters on her parents. Although her anthropological studies had been instrumental to her development, she subsequently began to question the objective verities of Papa Franz Boas. "I needed my Barnard education to help me see my people as they really are," she told a reporter in 1935. "But . . . I had to go back, dress as they did, talk as they did, live their life, so that I could get into my stories the world I knew as a child."25 Hurston had come full circle.

Martin: a p
No *("Wait till M*
hai *Williams])*

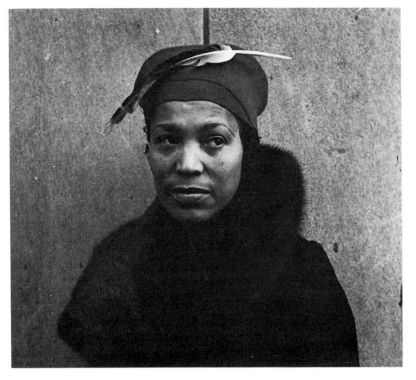

Zora Neale Hurston by Carl Van Vechten, November 9, 1934

in a letter to her first husband: "The world has gotten some benefits from us, though we had a swell time too. We Lived!"[28]

Thirteen years after her death, the young African-American writer Alice Walker made a pilgrimage to Florida, seeking the grave of the anthropologist/novelist who had inspired her own writing. She got no leads from the residents of Eatonville—who had little idea who Hurston was—but finally a mortician directed her to a sprawling, snake-infested field. Amidst overgrown weeds, Walker discovered a sunken rectangular patch that she determined contained the remains

Go when the wagon comes: leave in the face of power ("You may be talking or acting biggity now, but you will cool down when enough power gets behind you. They all go when the wagon comes." [Hurston])

of Zora Neale Hurston. Although Walker couldn't afford the monument she felt was most fitting—a striking black stone called "Ebony Mist"—she bought a plain gray marker, and on it she had engraved an epitaph taken from a poem by Jean Toomer: "Zora Neale Hurston: 'A Genius of the South.'"

CLAUDE McKAY. Claude McKay had left Harlem just before the Renaissance formally began, and he returned just after it had ended. Max Eastman rounded up some of the old Negrotarians to provide the necessary money for McKay's return from Europe, and the destitute author gratefully wrote, "And I feel better all over with the thought of a *voyage* and going '*home.*'"[29] When he docked in New York on February 1, 1934, and checked into the Harlem YMCA, the forty-three-year-old author was more corpulent and more world-weary than when he had shipped out as a stoker twelve years earlier. But his first newspaper interview showed McKay to be as abrasively independent as ever. "Well, the Negro intellectuals have been boasting for years that I could not come back," he told the *Amsterdam News.* "So maybe I just came back to prove them wrong—as usual."[30]

Setting down roots in Depression Harlem proved grim; McKay had quarreled with many of the New Negro leaders, he had no money and no means of support, and he felt betrayed by the Communist party that was gaining strength in Harlem. He hoped to resuscitate a progressive Negro community through a new magazine that would offer a black version of *The Liberator.* His prospectus for the magazine described the Renaissance as "a mushroom growth" that hadn't touched the life of workaday Negroes, and he aspired to publish an alternative that avoided both the racial chauvinism of the Talented Tenth and the prescribed class-consciousness of the Communist

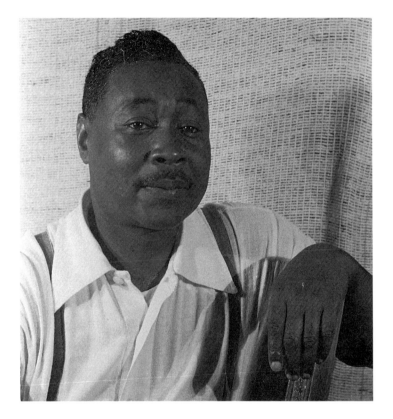

Claude McKay by Carl Van Vechten, July 25, 1941

party. But McKay's magazine came to nothing, as did his subsequent attempt to forge a Negro writers' guild.

McKay's literary career ended with the 1930s, in two retrospective accounts of his life and milieu—his autobiographical *A Long Way from Home* (1937) and *Harlem: Negro Metropolis* (1940). Although each received some positive reviews, neither sold well, and their publication provided the perfect opportunity for Negro leaders to avenge his attacks on them. Alain Locke delivered the most damn-

Whip it to the red: *beat your head until it's bloody*

ing appraisal of McKay: "And so, he stands to date, the *enfant terrible* of the Negro Renaissance, where with a little loyalty and consistency he might have been at least its Villon and perhaps its Voltaire."[31]

McKay lived until 1948, when he died of congestive heart failure at the age of fifty-seven. He was bereft of his earlier radical idealism, a last-minute convert to Catholicism, out of step with black opinion, unable to interest a publisher in his "Selected Poems." But his stringent independence provided a model for later African-American intellectuals, and his belief that the black community needed "a group soul" provided one forerunner for "black power" ideology that characterized a branch of the 1960s' political Negro movement. The best eulogy for McKay's life were the closing words of his autobiography: "All my life I have been a troubadour wanderer, nourishing myself mainly on the poetry of existence."[32]

LANGSTON HUGHES. Just after midnight on June 14, 1932, Langston Hughes clambered up the gangplank of the *Europa*. The last passenger to board the ship bound for Europe, his arms were laden with a typewriter, jazz and blues records, clothes, and a Victrola, and his mind was filled with extravagant hopes. Hughes looked upon this transatlantic crossing as a voyage of personal discovery as important as the trip a decade earlier when he shipped out for Africa. "YOU HOLD THAT BOAT," he had cabled, "CAUSE ITS AN ARK TO ME."[33] Instead of the racial motherland of Africa, his new destination was the socialist mecca of Russia.

Looking jaunty in his gray flannel slacks and striped sailor's jersey, he presented a more sanguine picture than that of the previous year's ruined protégé. The calm twelve-day crossing offered Hughes the opportunity to reflect on his life since the cataclysmic break with Charlotte Mason, Zora Neale Hurston, and Alain Locke.

Sender: used as a compliment for one who can get you to do something ("Solid sender!" [Hurston])

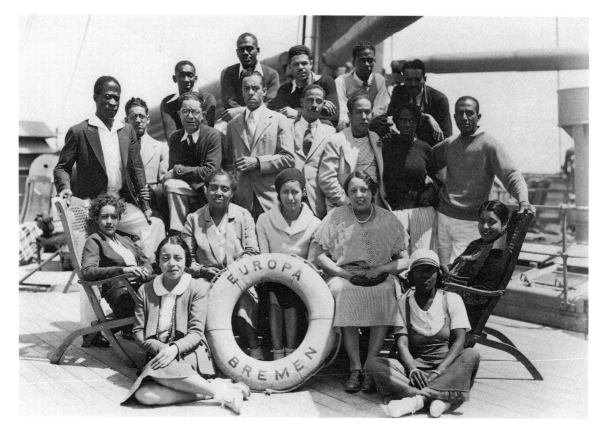

Langston Hughes (second row, third from left) and associates bound for Russia, June 1932

In the meantime, he had survived "the ways of white folks" (as he would entitle a collection of stories) by taking his poetry directly to the people. Financed by the Rosenwald Fund, Hughes had toured through the deep South and West in a Model A Ford sedan, and at each stop he recited his poetry, hawked affordable poetry pamphlets, and discussed the Scottsboro Boys and the Negro cause. The racism he witnessed in Depression America was daunting: Jim Crow laws were abundantly in effect (even Booker T. Washington's Tuskegee

Derision: **playing the dozens, slip-ping in the dozens, dat's your mammy** (all deriding the ancestors of your opponent); **Mammy** (an insult, never used by blacks in any other way); **storm buzzard** (shiftless, homeless character); **gum beater** (a blowhard, braggart, idle talker); **dusty butt** (cheap whore); **sooner** (anything cheap or mongrel; originally applied to a mon-grel dog who would eat anything, even excrement—"He'd sooner eat stuff as pork chops"—later applied to cheap clothes or shabby person); **free schools** (said with a sad shake of the head when something stupid is done; "Free schools and dumb Negroes" or "Free schools, pretty yellow teachers, and dumb Negroes" [Hurston]) **Big Boy, Biggie** (sometimes used to mean a stout man, but originally in the South it was a prime insult meaning a fool; "Don't call me no Big Boy. Elephant is bigger than me and he got a name"); **park ape** (an ugly, underprivileged black); **bozo** (a silly person); **jay-bird** (a simpleton); **Oscar** (a dumbbell); **ah-ah** (a male fool); **ain't got 'em** (has no virtues)

Institute had a "whites-only" guesthouse), such intellectuals as Allen Tate refused to meet him, and fear of the redneck vigilantes like those who had jailed the Scottsboro Boys was omnipresent. (In a heartfelt gesture, Hughes read through bars to the doomed young men, but they evinced more interest in his cigarettes than in his poetry.) Not only had Hughes's seven months on the road shored up his sense of personal identity, but his closeup view of the chasm between races had also radicalized his politics.

Reflecting his new radicalism, Hughes shared third-class com-partments on the *Europa* with a twenty-two-person delegation of so-cialists. They were planning to depict America's racial relations in a Soviet film, supported both by Soviet authorities and by sympathetic American leftists such as Waldo Frank, Floyd Dell, and Whittaker Chambers. Most of the young cast for *Black and White* (as the film was entitled, after a poem by Mayakovski) had little performing ex-perience but aspirations that were both professional and political. Coincidentally, Alain Locke resided in the *Europa*'s first-class quar-ters, spending Charlotte Mason's funds for a trip abroad and nega-tively reporting to her, once again, on their former protégé. (Hughes declined to shake Locke's hand.) The combination of Locke in a first-class compartment and the Russia-bound group below-decks merely dramatized Hughes's break from his old life and fueled his excite-ment for a new life that combined politics and film celebrity.

Black and White was never shot—for reasons that combined a comically inadequate script, an inexperienced director, and a cast that could neither act nor sing—but Hughes's participation in such an idealistic venture signaled the peripatetic, political life Hughes would lead throughout the 1930s. He was always moving on—trav-eling across Russia on a fourteen-month journey, lecturing through-out America, and addressing International Congresses of radicals. As

Opposite page: Langston Hughes and Carl Van Vechten by Richard Avedon, February 16, 1963, New York City

I would rather have a kitchenette in Harlem than a mansion in Westchester.
—Langston Hughes

a triple-threat writer, leftist, and Negro, Hughes was an ideal icon for radical causes; in Nancy Cunard's words, Hughes became "the travelling star of coloured America."[34]

Hughes was also outspoken in his poetry; in 1932 he wrote "Good Morning Revolution," and within a few months he wrote "Goodbye Christ." Rejecting America's central tenets—God and capitalism—the once-dissembling charmer now wore his radical sentiments on his sleeve. But Hughes did not write only in leftist magazines like *New Masses*; he also needed to support himself as a working writer. In addition to his political calls to arms, Hughes wrote a Broadway melodrama (*Mulatto*) that ran a year and provided his most regular financial sustenance, children's verse, and commercial magazine fiction. His first film script (*Way Down South*), featuring capering darkies, represented a serious lapse from the political aspirations of *Black and White*.

During this period Hughes proved more adept at addressing Congresses than in writing well—the race propagandizing he had so effectively resisted during the Harlem Renaissance had given way to political propagandizing. Marking the twentieth anniversary of its publication of "The Negro Speaks of Rivers," *The Crisis* reprinted Hughes's youthful poem beside his new essay, "The Need for Heroes." A comparison between the two was both poignant and disconcerting, for the work of the nineteen-year-old poet was far more evocative than the flat utterance of the middle-aged writer who ponderously proclaimed, "It is the social duty of Negro writers to reveal to the people the deep reservoirs of heroism within the race."[35]

Hughes returned to Harlem a few months later, and the site of his early success would become his home for the remaining twenty-five years of his life. As his militant tone of the 1930s soft-

I'm laughing to keep from dying.
—Langston Hughes,
in his final days

ened, Hughes was embraced as a patriot. In sharp contrast to his fellow New Negroes, Hughes's output never slackened during the remaining years of his life. A virtual writing machine, he became a household word among the broad black audience who read his ubiquitous newspaper columns, poems, song lyrics, and anthologies. During the 1950s, for example, Hughes averaged two books a year, in addition to librettos and articles.

The radical edge of his younger years was transformed into a persona that was genial, chubby, and sexless. He observed that his books were becoming "simpler and simpler and younger and younger." But he was nevertheless hounded by the anti-Communist forces of the early 1950s, frequently attacked by Walter Winchell, and interrogated by Joseph McCarthy himself on March 26, 1953. Hughes acquitted himself honorably and mildly at the hearings, naming no names but distancing himself from earlier poems and radical associations. So humble were his answers that when he asked after an hour, "Am I excused now, sir?" McCarthy released him as a "friendly witness." (In contrast, eighty-three-year-old Du Bois had defied the committee and been indicted in 1951 for his unwavering socialist beliefs, and he had publicly defended the Rosenbergs.) When Hughes compiled his *Selected Poems* in 1959, the political poems from the 1930s were notably absent. As his fellow New Negroes died, Hughes became one of the last surviving representatives of the Harlem Renaissance, revered as the "Dean of Negro writers."

From his childhood on, Hughes had successfully masked pain and emotion, and it was in this manner that he died on May 22, 1967. Not wanting to trouble friends about acute abdominal pains, he taxied himself to Polyclinic Hospital, admitted himself as James L. Hughes, and kept his hospitalization a secret during the two weeks between his admittance and his death. His funeral, a celebration of

There I was, tapping my toes and humming while y'all played, and I didn't know whether to cry for Langston or clap my hands and laugh!
—Lena Horne

the poet, featured a service of blues, jazz, poems, and reminiscences, concluding with Duke Ellington's "Do Nothing Until You Hear from Me." The day ended at a crematory as a dwindling group of his closest friends joined hands. As Hughes's body was wheeled toward the flames, they recited in unison the legendary poem of his early years, "The Negro Speaks of Rivers."

THE NEGRO SPEAKS OF RIVERS

I've known rivers:
I've known rivers ancient as the world and older than the flow
 of human blood in human veins.

My soul has grown deep like the rivers.

I bathed in the Euphrates when dawns were young.
I built my hut near the Congo and it lulled me to sleep.
I looked upon the Nile and raised the pyramids above it.
I heard the singing of the Mississippi when Abe Lincoln went
 down to New Orleans, and I've seen its muddy bosom turn
 all golden in the sunset.

I've known rivers:
Ancient, dusky rivers.

My soul has grown deep like rivers.

—Langston Hughes, 1920

ACKNOWLEDGMENTS

This book depended on the research of a community of scholars who have done pioneering work on the Harlem Renaissance; their individual contributions are cited in footnotes. I greatly benefited from careful readings of the manuscript by Bruce Kellner, Robert O'Meally, and Robert Atkins. Frank Driggs, who compiled the most comprehensive recording of the music of Harlem, provided helpful information on Harlem's performers of the 1920s. Text material by George Hoefer, accompanying Frank Driggs's record *The Sounds of Harlem*, was useful in locating clubs on the map of Harlem. A'Lelia Bundles shared information about A'Lelia Walker from her forthcoming biography. Tom Wirth provided information about and illustrations by Richard Bruce Nugent. For help in locating illustrations I am grateful to the staff of the Schomburg Center for Research in Black Culture, Lori Misura of Yale's Beinecke Library, Eric Garber, Robert Hemenway, Dolores Sheen and the Sheenway School and Culture Center, Eric Himmel, Francisco Drohojowski and Saun Ellis, the National Portrait Gallery, David Wojciechowski, David Thaxton, and the Howard Greenberg Gallery. For miscellaneous aid and support I thank Mason Cooley, Salleigh Rothrock, Andrew Harmon, Tom Blewitt, Jesse Levitt, Jane Goldberg, and Robert Caserio. Shelley Wanger, my editor, encouraged inventiveness and marshaled a fine staff, including Fearn Cutler, Kristen Bearse, Cheryl Cipriani, Kathy Grasso, Altie Karper, Jeanne Morton, and Lan Nguyen, in producing the first volume of what we hope will become a long-lived series.

NOTES

Foreword

1. W. E. B. Du Bois, "The Conservation of Races," cited in Wilson J. Moses, *The Golden Age of Black Nationalism, 1850–1925* (Hamden, Conn.: Archon, 1978), p. 134.

2. James, in Ann Charters, "Variations on a Generation," *The Portable Beat Reader* (New York: Viking, 1992), p. xv.

The New Negro Movement Is Born

1. Quoted, obituary of Moe Gale, *New York Times,* September 3, 1964.

2. Wallace Thurman, *Negro Life in New York's Harlem* (Girard, Kan.: Haldeman-Julius Publications, 1928), p. 43.

3. Nora Mair, in Jeff Kisseloff, *You Must Remember This: An Oral History of Manhattan from the 1890s to World War II* (New York: Harcourt Brace Jovanovich, 1989), p. 282.

4. Rudolph Fisher, *The Walls of Jericho* (New York: Alfred A. Knopf, 1928), p. 189.

5. W. E. B. Du Bois, *The Souls of Black Folk* (Greenwich, Conn.: Fawcett, 1961; orig. pub. 1903), pp. 3–4.

6. *Harlem Home News,* July 1911; in Jervis Anderson, *This Was Harlem: A Cultural Portrait, 1900–1950* (New York: Farrar, Straus & Giroux, 1981), p. 53.

7. Konrad Bercovici, "The Black Blocks of Manhattan," *Harper's,* October 1924; reprinted in Bercovici, *Around the World in New York* (New York: Century, 1924), p. 87.

8. Claude McKay, *A Long Way from Home* (New York: Harcourt, Brace & World, 1970; orig. pub. 1937), p. 49.

9. "Old Fifteenth Given Rousing Reception," *New York Age,* February 22, 1919.

10. Du Bois, *Souls of Black Folk,* p. 16.

11. Langston Hughes, "Tribute to W. E. B. Du Bois," *Freedomways,* First Quarter, 1965, p. 11.

12. McKay, *A Long Way from Home,* p. 110.

13. Raymond Logan, interview with David Levering Lewis; in "Voices from the Renaissance," Special Collections, Schomburg Center for Research in Black Culture.

14. Du Bois, quoted in Arnold Rampersad, *The Art and Imagination of W. E. B. Du Bois* (Cambridge, Mass.: Harvard University Press, 1976), p. 87.

15. W. E. B. Du Bois, "Criteria of Negro Art," *The Crisis* 32 (October 1926):292.

16. W. E. B. Du Bois, "Negro Writers," *The Crisis* 19 (April 1920):298–99.

17. Fauset to W. E. B. Du Bois; in Herbert Aptheker, ed., *The Correspondence of W. E. B. Du Bois,* vol. 1, *Selections: 1877–1934* (Amherst: University of Massachusetts Press, 1973), p. 95.

18. Fauset, quoted in David Levering Lewis, *When Harlem Was in Vogue* (New York: Alfred A. Knopf, 1981), p. 122.

19. Fauset, in Carolyn Wedin Sylvander, *Jessie Redmon Fauset: Black American Writer* (Troy, N.Y.: Whitson, 1981), p. 64.

20. Fauset, in Abby Arthur Johnson, *Propaganda and Aesthetics: The Literary Politics of Afro-American Magazines in the Twentieth Century* (Amherst: University of Massachusetts Press, 1979), p. 43.

21. James Weldon Johnson, "The Negro's Place in the New Civilization," speech delivered August 12, 1920; in Lewis, *When Harlem Was in Vogue*, p. 148.

22. Johnson, in Kenneth Kinnamon, "James Weldon Johnson," *Dictionary of Literary Biography,* vol. 51 (Detroit: Gale Research Press, 1987), p. 170 [originally *Along This Way*].

23. James Weldon Johnson, ed., *The Book of American Negro Poetry* (New York: Harcourt, Brace, 1959; orig. pub. 1922), p. 9.

24. Alain Locke, "The Role of the Talented Tenth," *Howard University Record* 12 (December 1918):17.

25. Locke to Langston Hughes, n.d.; quoted in Jeffrey Conrad Stewart, "A Biography of Alain Locke: Philosopher of the Harlem Renaissance," Ph.D. diss., Yale University, 1979, p. 272.

26. Locke, in Arthur Paul Davis, *From the Dark Tower* (Washington, D.C.: Howard University Press, 1974), p. 52.

27. Johnson to Alain Locke, March 7, 1924; quoted in Stewart, "Alain Locke," p. 261.

28. Richard Bruce Nugent, interview with David Levering Lewis; in "Voices from the Renaissance."

29. Bontemps, "Arna Bontemps Talks About the Harlem Renaissance," in L. M. Collins, "The Harlem Renaissance Generation: An Anthology," manuscript, Fisk University Library, 1972, p. 216.

30. Johnson, quoted in Patrick J. Gilpin, "Charles S. Johnson: Entrepreneur of the Harlem Renaissance," in Arna Wendell Bontemps, ed., *The Harlem Renaissance Remembered* (New York: Dodd, Mead, 1972), p. 238.

31. Charles S. Johnson, "The Negro Renaissance and Its Significance," in "The Speeches of Charles Spurgeon Johnson," manuscript, Fisk University, n.d.

32. Alain Locke, *Opportunity* 2 (May 1924):143.

33. Johnson, in Ethel Ray Nance, "The New York Arts Renaissance 1924–26," *Negro History Bulletin* 31 (April 1968):19.

34. W. E. B. Du Bois, *The Crisis* 31 (January 1926): 140.

35. Alain Locke, "Negro Youth Speaks," Locke, ed., *The New Negro* (New York: Albert & Charles Boni, 1925), p. 47.

36. Claude McKay, *My Green Hills of Jamaica and Five Jamaican Short Stories*, ed. Mervyn Morris (Kingston, Jamaica: n.p., 1970), p. 70.

37. McKay, *A Long Way from Home*, p. 40.

38. Claude McKay, "Review of *Home to Harlem*," *McClure's* 40 (June 1928):81.

39. McKay to Max Eastman, July 29, 1919; in Wayne F. Cooper, ed., *The Passion of Claude McKay: Selected Poetry and Prose* (New York: Schocken Books, 1973), p. 11.

40. McKay, *A Long Way from Home*, p. 31.

41. Max Eastman, *Love and Revolution: My Journey Through an Epoch* (New York: Farrar, Straus & Cudahy, 1964), p. 222.

42. Eastman, in Cooper, *Passion of Claude McKay*, p. 84.

43. McKay, *A Long Way from Home*, pp. 112, 110.

44. Ibid., p. 103.

45. Robert Littel, Review of *Harlem Shadows* and James Weldon Johnson, ed., *The Book of American Negro Poetry*, *New Republic* 26 (July 12, 1922):196.

46. Lewis, *When Harlem Was in Vogue*, p. 53.

47. McKay, *A Long Way from Home*, pp. 149–50.

48. Johnson to Claude McKay, August 21, 1930; in Wayne F. Cooper, *Claude McKay: Rebel Sojourner in the Harlem Renaissance* (Baton Rouge: Louisiana University Press, 1987), p. 169.

49. McKay, *A Long Way from Home*, p. 168.

50. McKay to Jean Toomer, June 27, 1922; in Cooper, *Passion of Claude McKay*, p. 160.

51. Frank to Jean Toomer, n.d.; in Lewis, *When Harlem Was in Vogue*, pp. 66–67.

52. Toomer, in Darwin T. Turner, Introduction to Jean Toomer, *Cane* (New York: Horace Liveright, 1975; orig. pub. 1923), p. xiii.

53. Toomer, "Outline of the Story of the Autobiography"; in Lewis, *When Harlem Was in Vogue*, p. 60.

54. Ibid.

55. Toomer, in Cynthia Earl Kerman, *The Lives of Jean Toomer: A Hunger for Wholeness* (Baton Rouge: University of Louisiana Press, 1987), p. 72.

56. Toomer, in Darwin T. Turner, ed., *The Wayward and the Seeking: A Collection of Writings of Jean Toomer* (Washington, D.C.: Howard University Press, 1980), p. 114.

57. Toomer to Frank, April 22, 1922; in Kerman, *Lives of Toomer*, p. 83.

58. Toomer to Frank, August 21, 1922; in ibid., p. 89.

59. Toomer, in Lewis, *When Harlem Was in Vogue*, p. 65.

60. Frank to Toomer, April 25, 1922; in Kerman, *Lives of Toomer*, p. 86.

61. Toomer to Frank, April 26, 1922; in ibid., p. 87.

62. Waldo Frank, *Memoirs of Waldo Frank*, ed. Alan Trachtenberg (Amherst: University of Massachusetts Press, 1973), p. 105.

63. Toomer, in Turner, *Wayward and Seeking*, p. 123.

64. Toomer, in Waldo Frank, Foreword to Jean Toomer, *Cane* (New York: Horace Liveright, 1923), p. i.

65. Frank, Foreword to *Cane*, p. ii.

66. Toomer, in Nellie Y. McKay, *Jean Toomer, Artist: A Study of His Literary Life and Work, 1894–1936* (Chapel Hill: University of North Carolina Press, 1984), p. 183.

67. Du Bois, in Rampersad, *W. E. B. Du Bois*, p. 192.

68. Cullen to Toomer, September 29, 1923; in Kerman, *Lives of Toomer*, p. 108.

69. Brathwaite, in Turner, Introduction to *Cane*, p. ix.

70. Toomer, in Kerman, *Lives of Toomer*, p. 112; Toomer, in Lewis, *When Harlem Was in Vogue*, p. 71.

71. Hughes, in Arnold Rampersad, *The Life of Langston Hughes*, vol. 1, *1902–1941: I, Too, Sing America* (New York: Oxford University Press, 1986), p. 50; originally, Hughes, "The Fascination of Cities" (1925), *The Crisis* 31 (January 1926).

72. Langston Hughes, "My Early Days in Harlem," *Freedomways* 3 (Summer 1963):312.

73. Hughes to Alain Locke, February 10, 1923; in Rampersad, *Langston Hughes*, p. 56.

74. Jessie Fauset, "Our Book Shelf," *The Crisis* 31 (March 1926):239.

75. Cullen to Locke, January 1, 1923; in Rampersad, *Langston Hughes*, p. 67.

76. Hughes to Cullen, April 7, 1923; in ibid., p. 63.

77. Hughes to Cullen, March 7, 1923; in ibid.

78. Ibid., p. 64.

79. Cullen to Locke, January 12, 1923; in ibid., p. 67.

80. Locke to Hughes, n.d.; in ibid., p. 69.

81. Locke to Hughes, February 10, 1923; in ibid., p. 68.

82. Locke to Cullen, March 15, 1923; in ibid.

83. Hughes to Locke, n.d.; in ibid., p. 69.

84. Hughes to Locke, n.d.; in ibid., p. 70.

85. Langston Hughes, *The Big Sea* (New York: Alfred A. Knopf, 1940), p. 98.

86. Ibid., p. 10.

87. Hughes to Carrie M. Clark, July 3, 1923; in Rampersad, *Langston Hughes*, p. 74.

88. Hughes, *Big Sea*, p. 11.

89. Ibid., p. 163.

90. Hughes to Cullen, March 11, 1924; in Rampersad, *Langston Hughes*, p. 85.

91. Locke to Hughes, n.d.; in ibid., p. 92.

92. Locke to Hughes, n.d.; in ibid., p. 93.

93. Locke to Hughes, n.d.; in ibid.

94. Cullen to Locke, November 23, 1924; in ibid., p. 98.

95. Langston Hughes, "L'histoire de ma vie"; in ibid.

Harlem Is Fashionable

1. Johnson, in Bontemps, *The Harlem Renaissance Remembered*, p. 227.

2. James Weldon Johnson, *Opportunity* 3 (June 1925):176.

3. *New York Herald Tribune*, reprinted in ibid.

4. Hurston, quoted in Alice Walker, Dedication to *I Love Myself When I Am Laughing . . . and Then Again When I am Looking Mean and Impressive: A Zora Neale Hurston Reader* (Old Westbury, N.Y.: Feminist Press, 1979).

5. Fannie Hurst, "Zora Hurston: A Personality Sketch," *Yale University Library Gazette* 35 (1961):17.

6. Ibid., p. 17.

7. Hughes, *Big Sea*, p. 239.

8. Hurston, in Robert E. Hemenway, *Zora Neale Hurston: A Literary Biography* (Urbana: University of Illinois Press, 1977), p. 14.

9. Van Vechten to Fania Marinoff, June 3, 1925; Van Vechten papers, New York Public Library.

10. Hemenway, *Zora Neale Hurston*, p. 23.

11. Zora Neale Hurston, *Mules and Men* (Philadelphia: J. B. Lippincott, 1935), p. 1.

12. Lindsay, in Rampersad, *Langston Hughes*, p. 119.

13. Langston Hughes, "The Negro Artist and the Racial Mountain," *The Nation* 122 (June 23, 1926):692.

14. *Amsterdam News*, February 5, 1927; *Chicago Whip*, February 26, 1927.

15. Locke, *Saturday Review of Literature* 3 (April 9, 1927):712; Jones, *Chicago Daily News*, June 29, 1927.

16. Rampersad, *Langston Hughes*, p. 141.

17. Nugent, in ibid., p. 113.

18. Wallace Thurman, *Infants of the Spring* (New York: Macaulay, 1932), p. 236.

19. Locke, in Gerald Early, ed., *My Soul's High Song: The Collected Writings of Countee Cullen, Voice of the Harlem Renaissance* (New York: Doubleday, 1991), p. 38.

20. Clement Wood, "The Negro Sings," *Yale Review* 15 (July 1926):824.

21. Margaret Sperry, "Countee P. Cullen, Negro Boy Poet, Tells His Story," *Brooklyn Daily Eagle*, February 10, 1924.

22. Hughes, *Big Sea*, p. 275.

23. W. E. B. Du Bois, "So the Girl Marries," *The Crisis* 35 (June 1928):208–9.

24. McKay, *A Long Way from Home*, p. 321.

25. McKay to Locke, October 7, 1924; in Cooper, *Rebel Sojourner*, p. 225.

26. Du Bois to McKay, March 16, 1924; in ibid., p. 234.

27. McKay to Locke, July 27, 1926; in ibid.

28. John R. Chamberlain, "When Spring Comes to Harlem . . . ," *New York Times Book Review*, March 11, 1928.

29. Mason to McKay, March 11, 1928; in Lewis, *When Harlem Was in Vogue*, p. 225.

30. "Lady Nicotine," *Inter-State Tattler*, March 16, 1928.

31. Hughes to McKay, March 5, 1928; in Cooper, *Rebel Sojourner*, p. 243.

32. Toomer to Naumberg, n.d.; in Kerman, *Lives of Toomer*, p. 113.

33. Toomer to James Weldon Johnson, July 11, 1930; in Lewis, *When Harlem Was in Vogue*, p. 250.

34. Theophilus Lewis, "Harlem Sketchbook," *Amsterdam News*, n.d.; in Alexander Gumby papers, Special Collections, Columbia University.

35. Ibid.

36. Thurman in Granville Hicks, "The New Negro: An Interview with Wallace Thurman," *The Churchman*, April 30, 1927, pp. 10–11.

37. Thurman, in Bontemps, *The Harlem Renaissance Remembered*, p. 149.

38. Lewis, "Harlem Sketchbook."

39. Nugent, in Lewis, "Voices from the Renaissance."

40. Theophilus Lewis, "Wallace Thurman Is a Model Harlemite"; in Jervis Anderson, *This Was Harlem*, p. 209.

41. West and Nugent to David Levering Lewis; in Lewis, "Voices from the Renaissance."

42. Thurman, *Infants of the Spring*, p. 194.

43. Theophilus Lewis, "Harlem Sketchbook," *Amsterdam News*, January 5, 1935.

44. Alain Locke, "The Legacy of the Ancestral Arts," Locke, ed., *The New Negro* (New York: Albert & Charles Boni, 1925), p. 254.

45. Douglas, *The Harlem Renaissance*; in Richard Powell, ed., *The Blues Aesthetic: Black Culture and Modernism* (Washington, D.C.: Washington Project for the Arts, 1989), p. 24.

46. Thurman, *Infants of the Spring*, p. 59.

47. Nugent, in Thomas H. Wirth, ed., "Lighting Fire!!" unpaginated broadside in facsimile publication of *Fire!!*

48. Nugent to James Hatch; in Rampersad, *Langston Hughes*, p. 106.

49. Rean Greaves, *Baltimore Sun*; in Chidi Ikonné, *From Du Bois to Van Vechten: The Early New Negro Literature 1903–1926* (Westport, Conn.: Greenwood Press, 1981), p. 110.

50. Thurman, in Bontemps, *The Harlem Renaissance Remembered*, p. 154.

51. Cullen, *Opportunity*, March 1928; in Darryl Pinckney, "The Sweet Singer of Tucka-

hoe," *New York Review of Books*, March 5, 1992.

52. Hughes, "The Negro Artist and the Racial Mountain," *The Nation* 127 (June 23, 1926): 692.

53. Herzl, in Hasia Diner, *In the Almost Promised Land: Jewish Leaders and Blacks, 1915–1935* (Westport, Conn.: Greenwood Press, 1977), p. 76.

54. Schuyler to Carl Van Vechten, November 4, 1950; quoted in Leon Coleman, "Carl Van Vechten Presents the New Negro," *The Harlem Renaissance Re-examined* (New York: AMS Press, 1987), p. 108.

55. Llewelyn Powys, in Bruce Kellner, *Carl Van Vechten and the Irreverent Decades* (Norman: University of Oklahoma Press, 1968), p. 141.

56. Carl Van Vechten, "A Cockney Flower Girl and Some Negroes," *Trend*, May 1914, p. 111.

57. Van Vechten to H. L. Mencken, June 25, 1922; in Lewis, *When Harlem Was in Vogue*, p. 98.

58. Sterling Brown, "Negro Character as Seen by White Authors," *Journal of Negro Education* 2 (January 1933):182.

59. Osbert Sitwell, "New York in the Twenties," *Atlantic*, February 1962, p. 41.

60. Marinoff, in *London Sunday Herald*, May 22, 1927.

61. Max Ewing to his parents, May 9, 1929; Ewing Papers, Yale Collection of American Literature, Beinecke Library, Yale University.

62. Hughes, *Big Sea*, p. 251.

63. Kellner, *Carl Van Vechten*, p. 201.

64. Van Vechten, in *The Crisis* 31 (March 1926): 219.

65. Gwendolyn Bennett, "The Ebony Flute," *Opportunity* 4 (November 1926):357.

66. Du Bois, in Rampersad, *Langston Hughes*, pp. 134–35.

67. Lincoln Kirstein, "Carl Van Vechten: 1880–1964," in Lincoln Kirstein, *By With To & From*, ed. Nicholas Jenkins (New York: Farrar, Straus & Giroux, 1991), p. 34.

68. Thurman, *Negro Life in New York's Harlem*, p. 17.

69. George Chester Morse, "The Fictitious Negro," *The Outlook and Independent*, August 21, 1929, p. 648.

70. Benjamin Brawley, in *Black World*, May 1951, p. 14.

71. H. L. Mencken, Editorial, *American Mercury* 12 (October 1927):159.

72. Max Ewing to his parents, April 1927; Ewing Papers.

73. Edward Jablonski, *Harold Arlen, Happy with the Blues* (New York: Da Capo, 1985), p. 54.

74. Darius Milhaud, *Notes Without Music* (New York: Alfred A. Knopf, 1953), p. 136.

75. Mencken, Editorial, *American Mercury* 12 (October 1927):159.

76. Max Ewing to his parents, May 21, 1929; Ewing papers.

77. In Allen Schoener, ed., *Harlem on My Mind: 1900-1968* (New York: Random House, 1969), p. 80.

78. Carl Van Vechten, *Parties: Scenes from Contemporary New York Life* (New York: Alfred A. Knopf, 1930), p. 76.

79. Mountbatten, in James Haskin, ed., *The Cotton Club* (New York: Random House, 1977), p. 37.

80. Dan Healy, in ibid., pp. 40–41; Jablonski, *Harold Arlen*, p. 35.

81. Thurman, *Negro Life*, p. 27.

82. Thomson, interview with the author, December 1988.

83. Thurman, *Negro Life*, p. 44.

84. Thurman, *Infants of the Spring*.

85. Nugent, in Kisseloff, *You Must Remember This*, pp. 288–89.

86. Thomas Anderson, interview with the author, 1991.

87. Charles Shaw, quoted in Eric Garber, "Gladys Bentley: The Bulldagger who Sang the Blues," *Out-look* 1 (Spring 1988).

88. Bill Chase, *New York Age*, quoted in ibid.

89. Geraldyn Dismond, "Social Snapshots," *Inter-State Tattler*, February 22, 1929.

90. Blair Niles, *Strange Brother* (New York: Arno Press, 1975; orig. pub. 1931), p. 210.

91. Thurman, *Negro Life*, p. 30.

92. Ibid.

93. Fisher, *Walls of Jericho*, p. 74.

94. Carl Van Vechten, "A'Lelia Walker," in Bruce Kellner, ed., *Keep A-Inchin' Along: Selected Writings of Carl Van Vechten About Black*

Art and Letters (Westport, Conn.: Green-wood Press, 1979), p. 154.

95. "Royalty and Blue-Blooded Gentry Entertained by A'Lelia Walker . . ." *Amsterdam News*, August 26, 1931.

96. Max Ewing to his parents, April 29, 1929; Ewing papers.

97. Nugent, interview with David Levering Lewis; in Lewis, "Voices from the Renaissance," p. 3.

98. Richard Bruce Nugent, "On the Dark Tower," Federal Writers Program/Special Collections, Schomburg Center for Research in Black Culture.

99. Mason to Hughes, May 1, 1932; in Rampersad, *Langston Hughes*, pp. 147–48.

100. Mason to Hughes, September 9, 1928; in ibid., p. 159.

101. Mason to Hughes, May 6, 1928; in ibid., p. 159.

102. Hughes, *Big Sea*, p. 316.

103. Hurston, in Hemenway, *Zora Neale Hurston*, p. 139.

104. Hurston, in ibid., p. 109.

105. Hurston, in ibid., p. 112.

106. Hurston, in ibid., p. 108.

107. Hughes, *Big Sea*, p. 296.

108. Rampersad, *Langston Hughes*, p. 153.

109. Hughes, *Big Sea*, p. 299.

110. Mason to Hughes, August 3, 1927; in Hughes Papers, Yale University, previously unpublished.

111. Hurston to Hughes, March 8, 1928; in Rampersad, *Langston Hughes*, p. 182.

After the Renaissance

1. Fania Marinoff, in Floyd G. Snelson, "Van Vechten's Desert 'Gay Spots' of Harlem," *Pittsburgh Courier*, January 23, 1932.

2. Hughes, *Big Sea*, p. 334.

3. Fauset, in *Opportunity* 3 (June 1925):176.

4. Du Bois, quoted in Rampersad, *W. E. B. Du Bois*, p. 199.

5. Alain Locke, "Self-Criticism: The Third Dimension in Culture," *Phylon* 11 (Fall 1950):391.

6. Hurston to Hughes, July 10, 1928; in Rampersad, *Langston Hughes*, p. 183.

7. Hurston, in Hemenway, *Zora Neale Hurston*, p. 141.

8. Hughes, *Big Sea*, p. 325.

9. Hughes to Mason, draft, August 15, 1930; in Rampersad, *Langston Hughes*, p. 188.

10. Hurston to Mason, January 20, 1931; in ibid., p. 196.

11. Locke to Mason, n.d.; in ibid., p. 198.

12. Locke to Mason, March 29, 1931; in ibid., p. 200.

13. Mason to Locke, n.d.; in ibid., p. 193.

14. *Amsterdam News*, December 3, 1930.

15. *New York Age*, August 29, 1931.

16. Ibid.

17. Hughes, *Big Sea*, p. 246.

18. Ibid., p. 247.

19. Thurman to Harold Jackman, August 30, 1930; in Lewis, *When Harlem Was in Vogue*, p. 279.

20. Dorothy West, "Elephant's Dance," *Black World*, November 1970, p. 85.

21. Unidentified newspaper story, in Wallace Thurman folder, James Weldon Johnson Collection, Beinecke Library, Yale University.

22. All quotations in paragraph from Thurman, *Infants of the Spring*, pp. 234, 59, 232, 230.

23. Ibid., p. 284.

24. W. E. B. Du Bois, "The Winds of Time," *Chicago Defender*, January 1946.

25. Hurston, in Hemenway, *Zora Neale Hurston*, p. 215.

26. Ibid., p. 321.

27. Ibid.

28. Ibid., p. 323.

29. Claude McKay, "Note of Harlem," *Modern Monthly* 8 (July 1934):368.

30. McKay, in *Amsterdam News*, February 7, 1934.

31. Alain Locke, "Spiritual Truant," *New Challenge* 2 (Fall 1937):83.

32. McKay, *A Long Way from Home*, p. 354.

33. Hughes to Louise Thompson, June 6, 1932; in Rampersad, *Langston Hughes*, p. 241.

34. Cunard, in Faith Berry, *Langston Hughes: Before and Beyond Harlem* (New York: Citadel Press, 1992; orig. pub. 1983), p. 259.

35. Langston Hughes, "The Need for Heroes," *The Crisis* 48 (June 1941):185.

Sources For Marginal Quotations

The following sources are for quotations in the margins and for those set off by rules in the text.

Page ix "Complex works of art": Paul Rosenfeld, "When New York Became Central," *Modern Music*, Summer 1946, p. 84.

Page 3 "Harlem, I grant you": Alain Locke, ed., *The New Negro* (New York: Albert & Charles Boni, 1925), p. 7.

Page 4 "What a crowd!": Geraldyn Dismond, *Inter-State Tattler*, quoted in Roi Ottley, *The Negro in New York: An Informal Social History, 1625–1940* (New York: Praeger, 1969), p. 174.

Page 4 "A seething cauldron": In Allen Schoener, ed., *Harlem on my Mind: 1900–1968* (New York: Random House, 1969).

Page 5 "Papa is mad": These rent party slogans are drawn from Ira de a Reid, "Mrs. Bailey Pays the Rent," in Arthur Davis and Michael Peplow, eds., *The New Negro Renaissance: An Anthology* (New York: Holt, Rinehart & Winston, 1975), pp. 167–70, and from Ottley, *The Negro in New York*, p. 38.

Page 6 "Chant another song of Harlem": In Alexander Gumby Papers, Special Collections, Columbia University.

Page 6 "267 was a house": Nugent, in Jeff Kisseloff, *You Must Remember This: An Oral History of Manhattan from the 1890s to World War II* (New York: Harcourt Brace Jovanovich, 1989), p. 286.

Page 7 "My whole deal was getting": Isabel Washington Powell, in Kisseloff, *You Must Remember This*, p. 283.

Page 7 "Man, we *strolled* in Harlem": Fax, in ibid., p. 282.

Page 8 "Why, it is just like the Arabian Nights": Ellington, in Jervis Anderson, *This Was Harlem: A Cultural Portrait, 1900–1950* (New York: Farrar, Straus & Giroux, 1982), p. 142.

Page 10 "Harlem . . . Harlem": Horne, June 1928; in Alexander Gumby Papers, Special Collections, Columbia University.

Page 11 "It is the Mecca": Crowell, "The World's Largest Negro City," *Saturday Evening Post*, August 8, 1925.

Page 14 "I'd rather be a lamppost in Harlem": In Robert E. Hemenway, *Zora Neale Hurston: A Literary Biography* (Urbana: University of Illinois Press, 1977), p. 29.

Page 16 "The great mission of the Negro": Du Bois, quoted in Arnold Rampersad, *The Art and Imagination of W. E. B. Du Bois* (Cambridge, Mass.: Harvard University Press, 1976), p. 191.

Page 16 "How can a Negro be conservative?": Garvey, in David Levering Lewis, *When Harlem Was in Vogue* (New York: Alfred A. Knopf, 1981), p. 42.

Page 17 "In a sea of fish": Nugent to David Levering Lewis, n.d.; in Lewis, "Voices from the Renaissance," Special Collections, Schomburg Center for Research in Black Culture.

Page 17 "Dr. Du Bois stands": Claude McKay, *A Long Way from Home* (New York: Harcourt, Brace & World, 1970; orig. pub. 1937), p. 110.

Page 19 "We want the earth beautiful": W. E. B. Du Bois, *The Crisis* 31 (January 1926).

Page 24 "My tragedy is that": Locke to Hughes, n.d. [c. 1923]; in Yale Collection of American Literature, Beinecke Library, Yale University.

Page 25 "This one who lives by quotations": Hurston, in Hemenway, *Zora Neale Hurston*, p. 242.

Page 25 "I do like being": Locke to Hughes, February 10, 1922; in Yale Collection of American Literature, Beinecke Library, Yale University.

Page 27 "Subtly the conditions": Locke, *The New Negro*, p. 8.

Page 28 "What American literature decidedly needs": Van Doren, in "The Debut of the Younger School of Negro Writers," *Opportunity* 2 (May 1924):145.

Page 29 "The younger generation comes": Locke, *The New Negro*, p. 47.

Page 33 "Oh, Jamaica was a happy place": Claude McKay, *My Green Hills of Jamaica* (Kingston, Jamaica: n.p., 1970), p. 78.

Page 34 "Poor, painful black face": McKay, *A Long Way from Home*, p. 145.

Page 34 "There is a searing hate": Claude McKay, *Harlem Shadows* (New York: Harcourt, Brace & Co., 1929).

Page 36 "It must be tragic": Shaw to McKay, n.d.; in ibid., p. 61.

Page 37 "Harlem! . . . Its brutality": McKay, in Lewis, *When Harlem Was in Vogue*, p. 228.

Page 37 "If we must die": Claude McKay, *Selected Poems of Claude McKay* (New York: Harcourt, Brace & Co., 1953), p. 36.

Page 38 "I was a zealot": McKay, *A Long Way from Home*, p. 14.

Page 39 "Go, better than stand": Ibid., p. 150.

Page 39 "In America it is much": Claude McKay, letter to the editor, *Bolshevik*, December 3, 1922.

Page 41 "Jean was like a god": Nugent to David Levering Lewis, n.d.; in Lewis, "Voices from the Renaissance."

Page 42 "I am not like them": Toomer, "Story of the Autobiography"; in Lewis, *When Harlem Was in Vogue*, p. 62.

Page 42 "I was a bit of chaos": Toomer, in Nellie Y. McKay, *Jean Toomer, Artist: A Study of His Literary Life and Work, 1894–1936* (Chapel Hill: University of North Carolina Press, 1984), p. 180.

Page 43 "You have definitely": Toomer to Frank, March 24, 1922; in Cynthia Earl Kerman, *The Lives of Jean Toomer: A Hunger for Wholeness* (Baton Rouge: University of Louisiana Press, 1987), p. 90.

Page 43 "Here were cabins": Toomer, "On Being an American"; in ibid., p. 84.

Page 44 "My seed was planted in *myself*": Toomer to Anderson, December 18, 1922; in Lewis, *When Harlem Was in Vogue*, p. 64.

Page 45 "Spartanburg, how curiously": Toomer to Frank, November 1922; in Kerman, *Lives of Toomer*, p. 91.

Page 45 "The Negro of the folk-song": Toomer, in ibid., p. 98.

Page 45 "For Toomer, the Southland": Frank, Foreword to Jean Toomer, *Cane* (New York: Boni & Liveright, 1923).

Page 46 "Pour O pour that parting soul in song": Jean Toomer, *Cane* (New York: Horace Liveright, 1975; orig. pub. 1923), p. 21.

Page 47 "Some inner substance": Paul Rosenfeld, *Men Seen: Twenty-four Modern Authors* (Freeport, N.Y.: Books for Libraries Press, 1967), p. 230.

Page 47 " 'Cane' was a swan song": Toomer, in Darwin T. Turner, Introduction to Toomer, *Cane*, p. xxii.

Page 49 "If you asked any Negro": Owen Dodson, "Countee Cullen (1903–1946)," *Phylon*, First Quarter, 1946, p. 20.

Page 50 "I was in love with Harlem": Langston Hughes, "My Early Days in Harlem," *Freedomways* 3 (Summer 1963):312.

Page 52 "Nobody loves a genius child": Hughes, in Arnold Rampersad, *The Life of Langston Hughes*, vol. 1, *1902–1941: I, Too, Sing America* (New York: Oxford University Press, 1986), p. 22.

Page 53 "Why should I want to be white?": Langston Hughes, "The Negro Artist and the Racial Mountain," *The Nation* 122 (June 23, 1926):693.

Page 56 "Langston was like the legendary Virgin": Nugent, in Rampersad, *Langston Hughes*, p. 46.

Page 56 "For me it was the 'Great Adventure' ": Langston Hughes, "L' Histoire de ma vie," quoted in Rampersad, *Langston Hughes*, p. 76.

Page 57 "He is really squeezing life": Cullen to Harold Jackman, July 20, 1923; in ibid., p. 76.

Page 57 "Langston is back from his African trip": Cullen to Locke, November 24, 1923; in ibid., p. 81.

Page 57 "We'll dance!": Hughes to Cullen, July 24, 1924; in ibid., p. 89.

Page 59 "Kid, stay in Harlem!": Hughes to Cullen, March 11, 1924; in ibid., p. 85.

Page 59 "See Paris and die": Locke to Cullen, July 26, 1924; in ibid., p. 92.

Page 65 "Oh! this New Negro Art": George S. Schuyler, "Shafts & Darts," *The Messenger* 8 (August 1926):239.

Page 66 "In some places the autumn of 1924": Arna Bontemps, "Harlem the Beautiful," *Negro Digest* 15 (January 1965):62.

Page 66 "Negro stock is going up": Rudolph Fisher, "The Negro Storms Harlem," *American Mercury* 12 (August 1927).

Page 67 "It was not a spasm": Johnson, *Opportunity* 3 (June 1925):176.

Page 68 "Zora would have been Zora": Nugent, in Hemenway, *Zora Neale Hurston*, p. 70.

Page 69 "But I am not tragically colored": Hurston, "How It Feels to Be Colored Me," *The World Tomorrow*, 1928.

Page 71 "When Zora was there": Brown, in Hemenway, *Zora Neale Hurston*, p. 61.

Page 72 "LITTLE DAVID PLAY ON YOUR HARP": Hughes and Van Vechten, in Rampersad, *Langston Hughes*, p. 110.

Page 73 "Droning a drowsy syncopated tune": Langston Hughes, *Selected Poems of Langston Hughes* (New York: Alfred A. Knopf, 1959), p. 33.

Page 75 "I, too, sing America": Hughes, *Selected Poems*, p. 275.

Page 76 "The mood of the blues": Langston Hughes, *Fine Clothes to the Jew* (New York: Alfred A. Knopf, 1927).

Page 78 "Speaking of aiming for the stars": Bennett to Cullen, August 28, 1925; in Lewis, *When Harlem Was in Vogue*, p. 50.

Page 78 "What is Africa to me?": Countee Cullen, *Color* (New York: Harper & Bros., 1925), pp. 36–37.

Page 79 "I doubt not God is good": Cullen, *Color*, p. 3.

Page 81 "My destiny is to travel": McKay, *A Long Way from Home*, p. 193.

Page 81 "Color-consciousness was": Ibid., p. 245.

Page 82 "Why, you are wearing": Locke and McKay, in ibid., p. 312.

Page 83 "I created my Negro characters": Ibid., p. 228.

Page 83 "I feel distinctly like": Du Bois, quoted in Lewis, *When Harlem Was in Vogue*, p. 225.

Page 84 "One ought to be": Toomer, in Kerman, *Lives of Toomer*, p. 125.

Page 84 "Ever since I came": Toomer to Frank, September 23, 1923; in Kerman, *Lives of Toomer*, p. 113.

Page 86 "Perhaps I am the incarnation": Thurman to Hughes, February 6, 1926; in Rampersad, *Langston Hughes*, p. 119.

Page 87 "He was a strange kind": Langston Hughes, *The Big Sea* (New York: Alfred A. Knopf, 1940), p. 258.

Page 87 "He was black in a way": Nugent interview with David Levering Lewis; in Lewis, "Voices from the Renaissance."

Page 89 "Those were the days": Theophilus Lewis, "Harlem Sketchbook," *Amsterdam News*, n.d., in Alexander Gumby Papers, Special Collections, Columbia University.

Page 89 "Thurman fitted into this crowd": Dorothy West, "Elephant's Dance," *Black World*, November 1970, p. 78.

Page 90 "Your problem, Langston": Douglas to Hughes, n.d.; in Richard Powell, ed., *The Blues Aesthetic: Black Culture and Modernism* (Washington, D.C.: Washington Project for the Arts, 1989), p. 24.

Page 91 "Fy-ah": Hughes, Foreword to *Fire!!*, p. 1.

Page 92 "Let art portray things": Countee Cullen, "The Dark Tower," *Opportunity* 6 (March 1928):90.

Page 93 "So many of the Negro": McKay, *A Long Way from Home*, p. 317.

Page 93 "I do not care": W. E. B. Du Bois, "Criteria of Negro Art," *The Crisis* 32 (October 1926):291.

Page 93 "Every phase of Negro Life": Cullen, "The Dark Tower," p. 90.

Page 94 "A race that hums opera": Cited in Chidi Ikonné, *From Du Bois to Van Vechten: The Early New Negro Literature, 1903–1926* (Westport, Conn.: Greenwood Press, 1981), p. 109.

Page 94 "They would be expected to": Charles S. Johnson, "The New Frontage on American Life," in Locke, ed., *The New Negro*, p. 297.

Page 95 "Negroes in America": Thurman, in Arna Wendell Bontemps, ed., *The Harlem Renaissance Remembered* (New York: Dodd, Mead, 1972), p. 152.

Page 95 "I discover therein that one": Hughes to Locke, n.d.; in Rampersad, *Langston Hughes*, p. 160.

Page 97 "The Negrotarians have a formula": Wallace Thurman, *Infants of the Spring* (New York: Macaulay, 1932), pp. 139–40.

Page 99 "You can see I am hardly": Van Vechten to Marinoff, May 6, 1925; Van Vechten Papers, New York Public Library, Astor, Lenox, and Tilden Foundations.

Page 99 "And we'll get drunker": Carl Van Vechten, *Parties: Scenes from Contemporary New York Life* (New York: Alfred A. Knopf, 1930), p. 79.

Page 100 "If Carl was a people": Hurston, in Fannie Hurst, "Zora Hurston: A Personality Sketch," *Yale University Library Gazette* 35 (1961):18.

Page 101 ". . . indubitably now is the psychological moment": Van Vechten to Hughes, n.d.; in Rampersad, *Langston Hughes*, p. 122.

Page 102 "Nigger Heaven!": Carl Van Vechten, *Nigger Heaven* (New York: Alfred A. Knopf, 1926).

Page 102 "Cheap French romance, colored light brown": In Bruce Kellner, *Carl Van Vechten and the Irreverent Decades* (Norman: University of Oklahoma Press, 1968), p. 213.

Page 103 "Anyone who would call a book *Nigger Heaven*": Cited in *New York Call*; in Ikonné, *From Du Bois to Van Vechten*, p. 32.

Page 103 "It's Harlem and anything goes": Edward Doherty, "Hot Harlem," *New York Daily Mirror*, July 1929.

Page 104 "Then Harlem nights became": Hughes, *Big Sea*, p. 226.

Page 105 "Maybe these Nordics": Rudolf Fisher, "The Caucasian Storms Harlem," *American Mercury*, August 1927, p. 398.

Page 105 "It was going to be necessary": Thurman, *Infants of the Spring*, p. 187.

Page 105 "Ecstasy seems": Joseph Wood Krutch, "Black Ecstasy," *The Nation,* October 26, 1927.

Page 106 "I couldn't forget": In McKay, *A Long Way from Home,* pp. 346–47.

Page 107 "The worship of jazz": Virgil Thomson, "The Cult of Jazz," *Vanity Fair,* June 1925.

Page 108 "First we got jazz": Lorenz Hart, *The Complete Lyrics of Lorenz Hart* (New York: Alfred A. Knopf, 1986), p. 97.

Page 124 "Harlem at eight P.M.!": Van Vechten, *Parties,* p. 34.

Page 124 "Liquor, jazz music": Thurman, *Infants of the Spring,* p. 187.

Page 124 "The trouble with Prohibition": Van Vechten, interview in *Los Angeles Evening Herald,* January 20, 1927.

Page 126 "Harlem is an all-white picnic": McKay, *A Long Way from Home,* p. 133.

Page 128 "When it comes to pep": In Schoener, *Harlem on My Mind,* p. 80.

Page 129 Colored Cabaret Owners Association Rules: Alexander Gumby Papers, Special Collections, Columbia University.

Page 134 "Uptown we carry on till de-*mented*": Tyler to Charles Henri Ford, c. December 1929. Courtesy Charles Boultenhouse.

Page 134 "One heard it said": Malcolm Cowley, *Exile's Return: A Narrative of Ideas* (New York: W. W. Norton, 1934), p. 230.

Page 136 "on 155th st.": Tyler, in *Contemporary Verse* 24 (February 1929).

Page 137 "One may divide people": Charles Henri Ford and Parker Tyler, *The Young and Evil* (New York: Gay Presses of New York, 1989; orig. pub. 1933), drawn from pp. 152–65.

Page 139 "Rhythmically it comes from the groin": Antheil, in Nancy Cunard, ed., *Negro* (New York: Frederick Ungar, 1970; orig. pub. 1933), p. 214.

Page 140 "Furtive rhythms of sex": Pierce, in *Contemporary Verse* 24 (February 1929).

Page 140 "A'Lelia Walker was the joy-goddess": Hughes, *Big Sea,* p. 245.

Page 141 "She is the Great Black Empress": Ewing to his parents, April 29, 1929; in Ewing Papers, Yale Collection of American Literature, Beinecke Library, Yale University.

Page 142 "Right here let me correct": Madame Walker, from the Walker collection of A'Lelia Bundles.

Page 143 "We dedicate this tower": Dark Tower invitation, from the Walker collection of A'Lelia Bundles.

Page 145 "Her power filled the rooms": Hughes, *Big Sea,* p. 315.

Page 145 "We have trampled": Mason to Locke, n.d.; in Jeffrey Conrad Stewart, "A Biography of Alain Locke: Philosopher of the Harlem Renaissance," Ph.D. diss., Yale University, 1979, p. 325.

Page 146 "Her tongue was a knout": Zora Neale Hurston, *Dust Tracks on the Road* (Philadelphia: J. P. Lippincott, 1942), p. 129.

Page 146 "He is too eager": Hurston, in Hemen-
 way, *Zora Neale Hurston*, p. 131.

Page 147 "You are a golden star": Mason to
 Hughes, September 9, 1928; in Ramper-
 sad, *Langston Hughes*, p. 159.

Page 147 "Knowing you is like Sir Percival's":
 Hughes to Mason, September 28, 1932;
 in ibid., p. 199.

Page 148 "May the river of your life": Mason to
 Hughes, February 1, 1928; in ibid., pp.
 158–59.

Page 148 "Sometimes, I would feel": Hurston,
 Dust Tracks, p. 129.

Page 148 "She was just as pagan": Ibid., p. 128.

Page 148 "Flowers to you": Hurston to Mason,
 n.d.; in Hemenway, *Zora Neale Hurston*,
 p. 109.

Page 150 "I want to collect": Hurston, in ibid.,
 p. 115.

Page 157 "The cycle that had Charlestoned":
 Hughes, *Big Sea*, p. 334.

Page 157 "The rosy enthusiasm": Alain Locke,
 "Harlem: Dark Weather Vane," *Survey
 Graphic* 25 (August 1936).

Page 158 "Harlem is still in the process": James
 Weldon Johnson, *Black Manhattan* (New
 York: Atheneum, 1972; orig. pub. 1930),
 p. 281.

Page 158 "The ordinary Negroes hadn't heard":
 Hughes, *Big Sea*, p. 228.

Page 158 "The older ones became warped": Thur-
 man, *Infants of the Spring*, p. 221.

Page 159 "For how could a large and enthusias-
 tic": Hughes, *Big Sea*, p. 228.

Page 160 "The Harlem Renaissance movement":
 Claude McKay, *Harlem: Negro Metropo-
 lis* (New York: E. P. Dutton, 1948),
 p. 248.

Page 162 "Dear child, what a hideous spectre":
 Mason to Hughes, June 6, 1930; in Ram-
 persad, *Langston Hughes*, p. 186.

Page 162 "You love me": Hurston to Mason, No-
 vember 25, 1930; in ibid., p. 193.

Page 162 "What can we do but let him fall":
 Locke to Mason, March 5, 1930; in
 Lewis, *When Harlem Was in Vogue*,
 p. 259.

Page 163 "A'Lelia knocked herself out": Marion
 R. Perry, from the Walker collection of
 A'Lelia Bundles.

Page 164 "So all who love laughter": Hughes, in
 Alexander Gumby Papers, Special Col-
 lections, Columbia University.

Page 165 "You should have known A'Lelia": Van
 Vechten, in Bruce Kellner, ed., *Keep
 A-Inchin' Along: Selected Writings of
 Carl Van Vechten About Black Art and
 Letters* (Westport, Conn: Greenwood
 Press, 1979), p. 282.

Page 165 "He wanted to be": Hughes, *Big Sea*,
 p. 238.

Page 166 "He was our leader": West, in Phyllis R.
 Klotman, "Wallace Henry Thurman,"
 Dictionary of Literary Biography, vol. 51
 (Detroit: Gale Research, 1987), p. 273.

Page 166 "That's the lost generation": Nugent to David Levering Lewis, n.d.; in Lewis, "Voices from the Renaissance."

Page 168 "Be the man you were headed": Bynner to Cullen, November 22, 1929; in Lewis, *When Harlem Was in Vogue*, p. 276.

Page 169 "What happened to Countee?": Hughes to Arna Bontemps, January 14, 1946; in Charles H. Nichols, ed., *Arna Bontemps–Langston Hughes Letters, 1925–1967* (New York: Dodd, Mead, 1980), p. 203.

Page 178 "I would rather have": Hughes, in Arnold Rampersad, *The Life of Langston Hughes*, vol. 2, *1941–1967: I Dream a World* (New York: Oxford University Press, 1988), p. 146.

Page 178 "I'm laughing to keep from dying": Hughes, in ibid., p. 422.

Page 179 "There I was, tapping my toes": Horne, in ibid., p. 425.

Page 181 "I've known rivers": Hughes, *Selected Poems*, p. 4.

1920

The Harlem Stock Exchange is founded.

The Howard Players' productions at New York's Belasco Theater mark the beginning of the black university theater movement.

James Weldon Johnson becomes the chief executive officer of the National Association for the Advancement of Colored People (NAACP).

The Theatrical Owners and Bookers Association (TOBA), the black circuit of performers, is founded.

W. E. B. Du Bois's *Darkwater* is published.

January—*Brownies' Book,* a magazine for black youth, edited by W. E. B. Du Bois and Jessie Redmon Fauset, is published by the NAACP; it continues until December 1921.

April—In *The Crisis* Du Bois first declares there is an imminent "renaissance of American Negro literature."

Spring—Langston Hughes, a high school senior, writes "When Sue Wears Red," his first poem of distinction reflecting a black identity.

June—Zora Neale Hurston receives an associate's degree from Howard University.

July—Shortly after graduating from high school, Langston Hughes writes "The Negro Speaks of Rivers."

August—Jean Toomer attends a party given by editor Lola Ridge, bringing him into contact with Greenwich Village writers, including Waldo Frank.

November—Eugene O'Neill's *The Emperor Jones,* starring Charles Gilpin, opens at the Provincetown Playhouse.

1921

Countee Cullen publishes his first poem, "I Have a Rendezvous with Life," in the De Witt Clinton High School literary magazine.

The Light, a weekly newspaper for blacks, appears; its title is changed to *Heebie Jeebies* in 1925 and to *The Light and Heebie Jeebies* in 1927.

Harry Pace founds the Black Swan Phonograph Corporation, producing best-selling "race records" by Mamie and Bessie Smith.

The New York Public Library at 135th Street holds an exhibition of artworks by African-American artists, including Henry Tanner, Meta Fuller, and Laura Wheeler Waring.

Zora Neale Hurston publishes her first story, "John Redding Goes to Sea," in Howard University's literary magazine, *Stylus.*

February—Claude McKay returns to New York from a two-year stint in England, and Max Eastman invites him to become associate editor of *The Liberator.* McKay accepts and continues in the post until June 1922.

May 23—*Shuffle Along,* by Noble Sissle and Eubie Blake, the first musical revue written and performed

by African Americans, opens at the David Belasco Theater. It launches the careers of cast members Josephine Baker and Florence Mills.

June—Langston Hughes's poem "The Negro Speaks of Rivers" is published in *The Crisis*.

September 4—Hughes arrives in New York and enrolls at Columbia University, where he will remain until June 1922.

Fall—Hughes goes to the office of *The Crisis* and meets Jessie Redmon Fauset and W. E. B. Du Bois.

Fall—Jean Toomer is the acting principal of Sparta Agricultural and Industrial Institute, in Sparta, Georgia; his stay in the small town inspires *Cane*.

November—The Shuffle Inn (named after the revue *Shuffle Along*) opens; it is soon taken over by Connie and George Immerman, and becomes Connie's Inn.

December—Jean Toomer first sends pieces to *The Liberator*, where Claude McKay reads them and encourages "Miss Toomer."

1922

Legislation sponsored by Congressman L. C. Dyer of Missouri is passed in Congress, making lynching a federal crime.

Marian Anderson begins her career in New York's Town Hall.

Alain LeRoy Locke begins corresponding with Countee Cullen, whom he has met through Jessie Fauset.

Langston Hughes begins incorporating blues into his poetry.

Early spring—Jean Toomer begins to visit Alain Locke's home, where he meets Countee Cullen and others.

Harcourt, Brace and Company publishes James Weldon Johnson's anthology *The Book of American Negro Poetry*.

The Harmon Foundation is established to promote black participation in the fine arts.

Spring—Claude McKay's *Harlem Shadows* is published by Harcourt, Brace; it is considered the first major book of the Negro Renaissance.

July—Jean Toomer decides to collect his pieces in a unified book called *Cane*.

Fall—Langston Hughes meets Countee Cullen at the 135th Street Library and begins a friendship.

September—*The Liberator* first publishes Jean Toomer.

September 20—Claude McKay ships out as a stoker, en route to Russia and the Fourth Congress of the Third Communist International; he will not return to America for twelve years. A few nights before the departure, James Weldon Johnson throws a farewell party for McKay that is remembered as "the first getting together of the black and white literati on a purely social plane."

September—Countee Cullen matriculates at New York University on a New York State Regents Scholarship; he will graduate in 1925.

October—Langston Hughes signs on as a deckhand for a dock-bound ship up the Hudson.

1923

National economic recovery begins, marking six years of unprecedented growth.

The Lafayette Stock Company, a purveyor of serious drama in Harlem for seven years, ends.

Bessie Smith records "Down-Hearted Blues" and "Gulf Coast Blues" and becomes famous.

January—*Opportunity: A Journal of Negro Life* is founded by the National Urban League, with Dr. Charles S. Johnson as its editor. The magazine continues until winter 1949; Johnson's editorship ends in 1928.

January 4—In Moscow, Claude McKay addresses the ecumenical council of Marxism on the failure of socialism to transcend racism in America.

February—Countee Cullen and Alain Locke begin a campaign to seduce Langston Hughes.

May—Willis Richardson's *The Chip Woman* is produced by the National Ethiopian Art Players and becomes the first serious play by a black writer on Broadway.

May—Jean Toomer meets Waldo Frank's wife, Margaret Naumberg, and begins an affair that ends the Naumberg-Frank marriage and the Frank-Toomer friendship.

June—Claude McKay speaks at the Fourth Congress of the Third International in Moscow.

June 23, 1923—Langston Hughes arrives in Africa (the Azores) on the *West Hesseltine*; he returns to New York in October.

September—Jean Toomer's *Cane* is published by Boni and Liveright.

Fall—Claude McKay moves to Paris and joins the expatriate crowd.

Fall—Mobster Owney Madden opens the Cotton Club, Harlem's largest nightclub.

1924

Jazz becomes popular with white Downtowners.

Countee Cullen wins the Witter Bynner Poetry Competition for the best poem by an undergraduate.

Louis Armstrong comes to New York and joins Fletcher Henderson's orchestra at the Roseland Ballroom; it becomes the most popular dance band in New York.

Aaron Douglas arrives in Harlem from Kansas City. He begins studying with Winold Reiss, and develops a style of "geometric symbolism."

Walter White's *The Fire in the Flint* is published by Alfred A. Knopf; reading this book reawakens Carl Van Vechten's interest in black culture.

January—Langston Hughes ships out to Holland, deserts, and goes to Paris, where he works in Parisian cabarets; he returns to New York November 10, 1924.

January—A. R. Orage leads Gurdjieff dances in New York, marking the beginning of the Gurdjieff community craze in America, which attracts Jean Toomer, Aaron Douglas, and Wallace Thurman.

March—Albert and Charles Boni publishes *There Is Confusion*, by Jessie Redmon Fauset; it is the first novel by a woman of the Harlem Renaissance.

March 21—*Opportunity* stages a "coming-out party" at the Civic Club for black writers; many white writers and publishers are present. Alain Locke acts as master of ceremonies. This event is often considered the formal launching of the New Negro movement. It provides the impetus for a Black Writers' Guild (membership includes Langston Hughes, Countee Cullen, Jessie Fauset, and Eric Walrond) and the planning of an issue of the *Survey Graphic* for an issue on "The New Negro."

May 15—Paul Robeson stars in Eugene O'Neill's *All God's Chillun Got Wings*.

July 19—Jean Toomer sails to France to study with Gurdjieff.

July 31—Alain Locke and Langston Hughes, after a long correspondence, meet face to face in Paris.

August—*Opportunity* announces its first literary contest; winners are announced May 1, 1925.

October—*The Crisis* announces its first literary contest. In the same month it begins KRIGWA, a workshop to help guide black writers and artists and "help the development of beauty in the souls of black folk." Within two years it has six branches throughout the country.

November—Countee Cullen's poems are published in four prominent white magazines: *Harper's, Century, American Mercury,* and *Bookman.*

December—Zora Neale Hurston publishes "Drenched in Light," a short story, in *Opportunity.*

1925

Viking publishes James Weldon Johnson's anthology *The Book of American Negro Spirituals.*

Dark Laughter, Sherwood Anderson's novel depicting black life, is published.

The Brotherhood of Sleeping Car Porters is founded.

Hall Johnson organizes a choir to "preserve the integrity of the Negro spiritual."

January—Zora Neale Hurston moves to New York.

February 12—The "First American Jazz Concert" is staged at the Aeolian Hall.

March 1—A special issue of the *Survey Graphic,* edited by Alain Locke, is published; devoted to African-American culture, it provides the germ for a larger book, *The New Negro.*

May 1—*Opportunity* holds its first literary awards dinner at the Fifth Avenue Restaurant, near Twenty-fourth Street. Winners include Langston Hughes, Countee Cullen, and Zora Neale Hurston.

Spring—Jean Toomer begins teaching Gurdjieff principles in Harlem (ends a year later).

June—Alain Locke is dismissed from Howard University owing to his advocacy of black history and higher salaries.

August 14—The first *Crisis* awards ceremony is held at the Renaissance Casino at 138th Street and Seventh Avenue; Countee Cullen wins first prize.

Labor Day—Wallace Thurman arrives in New York.

Fall—Small's Paradise opens and becomes one of Harlem's most successful nightclubs.

September—Zora Neale Hurston begins attending Barnard, where she will study anthropology with Franz Boas until 1927. During this period she also works for Fannie Hurst as secretary/chauffeur.

December—At a dinner at the Wardman Park Hotel, Vachel Lindsay announces that he has discovered a "Negro busboy poet," and reads Langston Hughes's poetry to the audience.

December—*The New Negro,* an anthology edited by Alain Locke, is published by Boni and Liveright, illustrated with work by Winold Reiss, Aaron Douglas, and Miguel Covarrubias.

1926

W. C. Handy's *Blues: An Anthology* is published.

Countee Cullen becomes assistant editor of *Opportunity* and begins to write a regular column, "The Dark Tower."

The Carnegie Corporation buys Arthur Schomburg's collection of Afro-Americana; it will become the basis for the Schomburg Center for Research in Black Culture.

January—The William E. Harmon Foundation announces its first awards to African-American writers, artists, and professionals.

February—Jessie Fauset ends her fiction editorship at *The Crisis.*

February—John Alden Carpenter's ballet *Skyscrapers* introduces jazz to the Metropolitan Opera.

February—Langston Hughes's *The Weary Blues* is published by Alfred A. Knopf. Hughes enrolls in Lincoln University on a scholarship from Amy Spingarn, graduates June 1929.

February—Carter G. Woodson founds Negro History Week.

March 12—The Savoy Ballroom opens.

March through November—*The Crisis* publishes responses to the question: "The Negro in Art: How Shall He Be Portrayed?" Among the respondents: Carl Van Vechten, H. L. Mencken, Alfred A. Knopf, Sinclair Lewis, Sherwood Anderson, Langston Hughes, Countee Cullen, Jessie Fauset, and Charles W. Chesnutt.

May 3—The Krigwa Players establish a Little Negro Theater and stage three plays at the 135th Street branch of the New York Public Library. They declare that Negro theater must be: 1) About us. 2) By us. 3) For us. 4) Near us.

Summer—Langston Hughes lives at Niggerati Manor on 136th Street.

June—Countee Cullen receives a master's degree in English from Harvard.

July—Langston Hughes and Zora Neale Hurston first discuss creating an opera that would authentically render black folklife.

Early summer—Seven younger members of the Renaissance (Langston Hughes, Zora Neale Hurston, Wallace Thurman, Aaron Douglas, John P. Davis, Richard Bruce Nugent, and Gwendolyn Bennett) decide to found a magazine that provides a more experimental outlet for African-American writing than *The Crisis* or *Opportunity*.

November 1—Florence Mills dies.

November—The single issue of *Fire!!* appears; edited by Wallace Thurman, it is the Renaissance's counterpart of an avant-garde little magazine.

1927

The Harlem Globetrotters established.

Louis Armstrong and Duke Ellington gain recognition.

Viking publishes James Weldon Johnson's *God's Trombones: Seven Negro Sermons in Verse.*

Alain Locke and Montgomery Gregory edit *Plays of Negro Life: A Source-Book of Native American Drama.*

January—Knopf publishes Langston Hughes's *Fine Clothes to the Jew.*

February—Charlotte van der Veer Quick Mason hears a lecture by Alain Locke on African art and decides to become a patron of the New Negro.

April 16—Langston Hughes first visits Charlotte Mason in her Park Avenue apartment.

May—Paul Green's *In Abraham's Bosom*, featuring an all-black cast, wins a Pulitzer Prize.

Summer—Langston Hughes and Zora Neale Hurston meet by chance in Mobile, Alabama, and drive through the South together; along the way they encounter Jessie Fauset, Bessie Smith, and George Washington Carver.

Fall—A'Lelia Walker decides to "go in for culture," and on October 15 opens a tea-room salon called "The Dark Tower"; it becomes the meeting ground for high Harlem, bohemian Harlem, and Downtown.

Mid-September—Zora Neale Hurston first meets Charlotte Mason, introduced by Alain Locke.

October—*Porgy*, by DuBose and Dorothy Heyward, opens on Broadway.

November 5—Langston Hughes and Charlotte Mason enter into a formal agreement that Hughes will receive $150 a month to pursue his writing.

December 8—Zora Neale Hurston enters into a formal agreement with Charlotte Mason, giving Hurston $200 a month in exchange for contractual power; the initial agreement is to cover two years. Hurston departs December 14 to do fieldwork in the South; she will not return for two years.

1928

The Lindy hop is made famous at the Savoy Ballroom and the Manhattan Casino.

Five novels by African-American writers are published: Rudolph Fisher's *The Walls of Jericho,* Nella Larsen's *Quicksand,* Jessie Fauset's *Plum Bun,* Claude McKay's *Home to Harlem,* and W. E. B. Du Bois's *Dark Princess.*

Julia Peterkin's white-authored black-themed novel, *Scarlet Sister Mary,* wins the Pulitzer Prize.

March—Claude McKay's *Home to Harlem* is published and becomes the first best-selling novel by a black writer.

April 9, 1928—Countee Cullen and Nina Yolande Du Bois are married by Cullen's adoptive father at Salem Methodist Church; James Weldon Johnson is a special guest, and Langston Hughes ushers.

June 30—Cullen sails to Europe with Harold Jackman, not with his wife.

June—*The Messenger,* founded in 1917 and edited by A. Philip Randolph and Chandler Owen, ends publication.

Summer—Langston Hughes works on his novel *Not Without Laughter* in Westfield, New Jersey.

September—Wallace Thurman marries Louise Thompson; the marriage goes on the rocks within six months.

August 24—Charles S. Johnson resigns as editor of *Opportunity.*

November—*Harlem: A Forum of Negro Life,* a magazine edited by Wallace Thurman, is published (one issue).

1929

January 19—Ernst Krenek's jazz opera, *Jonny Spielt Auf,* opens at the Metropolitan Opera. Written in 1918 and premiered in Germany, it features a white baritone in blackface as the Negro jazz-band leader.

February—The Negro Experimental Theater is founded.

February—Wallace Thurman's play *Harlem,* written with William Jourdan Rapp, opens at the Apollo Theater on Broadway and becomes the most successful play to date written by a black playwright.

October 24—The stock market plunges.

Wallace Thurman's novel *The Blacker the Berry* is published.

Claude McKay's novel *Banjo* is published by Harper and Brothers.

Countee Cullen's *The Black Christ* is published by Harper and Brothers.

Connie's Hot Chocolates opens Fats Waller's *Ain't Misbehavin'* on Broadway.

1930

Alfred A. Knopf publishes James Weldon Johnson's *Black Manhattan.*

February 26—Marc Connelly's *The Green Pastures* opens on Broadway.

Zora Neale Hurston begins organizing her field notes that will be published as *Mules and Men*.

April—Hurston and Langston Hughes begin working on *Mule Bone*. Both are living in Westfield, New Jersey, at Charlotte Mason's behest, with Louise Thompson (briefly Wallace Thurman's wife) as secretary. Hurston leaves in June, with the play unfinished.

July—Langston Hughes's novel *Not Without Laughter* is published by Knopf.

SELECTED NONFICTION BIBLIOGRAPHY

Bontemps, Arna Wendell, ed. *The Harlem Renaissance Remembered*. New York: Dodd, Mead, 1972. A collection of essays.

Cooper, Wayne F. *Claude McKay, Rebel Sojourner in the Harlem Renaissance: A Biography*. Baton Rouge: Louisiana University Press, 1987.

Hemenway, Robert. *Zora Neale Hurston: A Literary Biography*. Urbana: University of Illinois Press, 1977.

Huggins, Nathan Irvin. *The Harlem Renaissance*. New York: Oxford University Press, 1971. A pioneering study of the era.

Hughes, Langston. *The Big Sea*. New York: Alfred A. Knopf, 1940. Autobiography.

Kellner, Bruce, ed. *The Harlem Renaissance: A Historical Dictionary of the Era*. Westport, Conn.: Greenwood Press, 1984. Complete listings accompanied by 100–2,000–word annotations.

Kerman, Cynthia Earl. *The Lives of Jean Toomer: A Hunger for Wholeness*. Baton Rouge: University of Louisiana Press, 1987.

Lewis, David Levering. *When Harlem Was in Vogue*. New York: Alfred A. Knopf, 1981. The most comprehensive study of the Harlem Renaissance.

Lewis, David Levering, ed. *The Portable Harlem Renaissance Reader*. New York: Viking, 1994. The best single source of Harlem Renaissance nonfiction, fiction, and poetry.

McKay, Claude. *A Long Way from Home*. New York: Harcourt, Brace & World, 1970. Originally published 1937. Autobiography.

Rampersad, Arnold. *The Life of Langston Hughes*. Vol. 1, *1902-1941: I, Too, Sing America*. New York: Oxford University Press, 1986.

Thurman, Wallace. *Negro Life in New York's Harlem*. Girard, Kan.: Haldeman-Julius Publications, 1928. The best contemporary account.

the Son" from *Cane* by Jean Toomer, and excerpts from papers of Jean Toomer. James Weldon Johnson Collection, Yale Collection of American Literature, Beinecke Rare Book and Manuscript Library, Yale University. Reprinted by permission.

Illustration Credits

Pages xiv–1 Courtesy of Frank Driggs.

Page 1 Courtesy of Brown Brothers.

Page 5 Private collection.

Page 12 Courtesy of Brown Brothers.

Pages 14, 15 Both photographs courtesy of the National Archive.

Page 18 Courtesy of the Photographs and Prints Division, Schomburg Center for Research in Black Culture, The New York Public Library, Astor, Lenox and Tilden Foundations.

Page 20 Courtesy of the Photographs and Prints Division, Schomburg Center for Research in Black Culture, The New York Public Library, Astor, Lenox and Tilden Foundations.

Page 24 Courtesy of the Photographs and Prints Division, Schomburg Center for Research in Black Culture, The New York Public Library, Astor, Lenox and Tilden Foundations.

Page 26 Courtesy of the Carl van Vechten Memorial Collection of Afro-American Arts and Letters, Millersville University, Millersville, Pennsylvania.

Pages 30, 31 All drawings courtesy of the National Portrait Gallery.

Page 33 Courtesy of the Yale Collection of American Literature, Beinecke Rare Book and Manuscript Library, Yale University.

Page 35 Courtesy of Photographs and Prints Division, Schomburg Center for Research in Black Cul-

ture, The New York Public Library, Astor, Lenox and Tilden Foundations.

Page 40 Courtesy of the Moorland-Spingarn Research Center, Howard University.

Page 43 Courtesy of the Yale Collection of American Literature, Beinecke Rare Book and Manuscript Library, Yale University.

Page 44 Courtesy of the Yale Collection of American Literature, Beinecke Rare Book and Manuscript Library, Yale University.

Page 46 Courtesy of the Yale Collection of American Literature, Beinecke Rare Book and Manuscript Library, Yale University.

Page 48 Courtesy of the Photographs and Prints Division, Schomburg Center for Research in Black Culture, The New York Public Library, Astor, Lenox and Tilden Foundations.

Page 51 Photograph by Nickolas Muray; Courtesy of the Yale Collection of American Literature, Beinecke Rare Book and Manuscript Library, Yale University, and Mimi Muray.

Page 52 Courtesy of the Yale Collection of American Literature, Beinecke Rare Book and Manuscript Library, Yale University.

Page 56 Photograph by Nickolas Muray; Courtesy of the Yale Collection of American Literature, Beinecke Rare Book and Manuscript Library, Yale University, and Mimi Muray.

Page 58 Courtesy of the Yale Collection of American Literature.

Page 59 All drawings by permission of Thomas H. Wirth.

Page 61 Drawing by Aaron Douglas.

Page 62 All photographs courtesy of Frank Driggs.

Page 62 All photographs courtesy of Frank Driggs.

Page 63 Courtesy of the Shepherd Gallery Association, New York.

Page 68 Courtesy of the Yale Collection of American Literature, Beinecke Rare Book and Manuscript Library, Yale University.

Page 70 Courtesy of the Sheen Educational Foundation.

Page 74 (left) Courtesy of Alfred A. Knopf, New York.

Page 74 (right) Courtesy of the Yale Collection of American Literature, Beinecke Rare Book and Manuscript Library, Yale University.

Page 78 Courtesy of the Yale Collection of American Literature, Beinecke Rare Book and Manuscript Library, Yale University.

Page 80 Courtesy of the Yale Collection of American Literature, Beinecke Rare Book and Manuscript Library, Yale University.

Page 82 Courtesy of the Yale Collection of American Literature, Beinecke Rare Book and Manuscript Library, Yale University.

Page 83 Courtesy of Berenice Abbott/Commerce Graphics Limited Inc.

Page 84 Courtesy of the Waldo Frank Papers, Special Collection, Van Pelt Library, University of Pennsylvania.

Page 85 Courtesy of the Yale Collection of American Literature, Beinecke Rare Book and Manuscript Library, Yale University.

Page 86 Courtesy of the Yale Collection of American Literature, Beinecke Rare Book and Manuscript Library, Yale University.

Page 87 Courtesy of the Yale Collection of American Literature, Beinecke Rare Book and Manuscript Library, Yale University.

Page 89 Courtesy of the Photographs and Prints Division, Schomburg Center for Research in Black Culture, The New York Public Library, Astor, Lenox and Tilden Foundations.

Page 90 By permission of Thomas H. Wirth.

Page 98 Photograph by Nickolas Muray; Courtesy of the Yale Collection of American Literature, Beinecke Rare Book and Manuscript Library, Yale University, and Mimi Muray.

Page 100 Courtesy of Bruce Kellner.

Page 102 Courtesy of the Yale Collection of American Literature, Beinecke Rare Book and Manuscript Library, Yale University.

Page 104 Courtesy of Frank Driggs.

Page 108 All photographs courtesy of Frank Driggs.

Page 110 Courtesy of the Yale Collection of American Literature, Beinecke Rare Book and Manuscript Library, Yale University.

Page 111 Courtesy of the Photographs and Prints Division, Schomburg Center for Research in Black Culture, The New York Public Library, Astor, Lenox and Tilden Foundations.

Page 112 (left) Courtesy of the Yale Collection of American Literature, Beinecke Rare Book and Manuscript Library, Yale University; and the Estate of Carl Van Vechten, Joseph Solomon, executor.

Page 112 (right) Courtesy of Frank Driggs.

Page 113 Courtesy of Frank Driggs.

Page 114 Courtesy of Frank Driggs.

Page 115 Courtesy of the Yale Collection of American Literature, Beinecke Rare Book and Manuscript Library, Yale University.

Page 116 Courtesy of the Yale Collection of American Literature, Beinecke Rare Book and Manuscript Library, Yale University.

Page 117 (left) Courtesy of the Photographs and Prints Division, Schomburg Center for Research in Black Culture, The New York Public Library, Astor, Lenox and Tilden Foundations.

Page 117 (right) Courtesy of Frank Driggs.

Page 118 Courtesy of Frank Driggs.

Page 119 Courtesy of the Yale Collection of American Literature, Beinecke Rare Book and Manuscript Library, Yale University.

Page 120 Courtesy of Frank Driggs.

Page 121 (left) Courtesy of Frank Driggs.

Page 121 (right) Courtesy of the Yale Collection of American Literature, Beinecke Rare Book and Manuscript Library, Yale University.

Page 122 Courtesy of the Yale Collection of Amer-

ican Literature, Beinecke Rare Book and Manuscript Library, Yale University.

Page 123 (left) Courtesy of Frank Driggs.

Page 123 (right) Courtesy of the Yale Collection of American Literature, Beinecke Rare Book and Manuscript Library, Yale University.

Page 125 Both photographs courtesy of Frank Driggs.

Page 127 Courtesy of Frank Driggs.

Page 130 Courtesy of the Yale Collection of American Literature, Beinecke Rare Book and Manuscript Library, Yale University.

Page 135 Courtesy of the Yale Collection of American Literature, Beinecke Rare Book and Manuscript Library, Yale University.

Pages 138–139 Diagrams by Nicholas Nahumck, reprinted with permission of Simon & Schuster Macmillan from its Schirmer Books publication, *Jazz Dance* by Marshall Stearns and Jean Stearns. Copyright © 1964, 1966 by Jean Stearns and the Estate of Marshall Stearns.

Page 141 Courtesy of the Walker Collection of A'Lelia Perry Bundles.

Page 143 Courtesy of the Yale Collection of American Literature, Beinecke Rare Book and Manuscript Library, Yale University.

page 145 Courtesy of the Yale Collection of American Literature, Beinecke Rare Book and Manuscript Library, Yale University.

Page 149 Courtesy of the Yale Collection of American Literature, Beinecke Rare Book and Manuscript Library, Yale University.

Page 151 Courtesy of the Yale Collection of American Literature, Beinecke Rare Book and Manuscript Library, Yale University.

Page 153 © 1995 Estate of Richard Bruce Nugent/ Tom Wirth.

Pages 154–155 Courtesy of the Yale Collection of American Literature, Beinecke Rare Book and Manuscript Library, Yale University; and the Estate of Carl Van Vechten, Joseph Solomon, executor.

Page 164 Courtesy of the Walker Collection of A'Lelia Perry Bundles.

Page 167 Courtesy of the Yale Collection of American Literature, Beinecke Rare Book and Manuscript Library, Yale University; and the Estate of Carl Van Vechten, Joseph Solomon, executor.

Page 168 Courtesy of the Photographs and Prints Division, Schomburg Center for Research in Black Culture, The New York Public Library, Astor, Lenox and Tilden Foundations.

Page 171 Courtesy of the Yale Collection of American Literature, Beinecke Rare Book and Manuscript Library, Yale University; and the Estate of Carl Van Vechten, Joseph Solomon, executor.

Page 173 Courtesy of the Yale Collection of American Literature, Beinecke Rare Book and Manuscript Library, Yale University; and the Estate of Carl Van Vechten, Joseph Solomon, executor.

Page 175 Courtesy of the Yale Collection of American Literature, Beinecke Rare Book and Manuscript Library, Yale University.

Page 177 © Richard Avedon. Courtesy of Richard Avedon.

Page 180 Drawing by Aaron Douglas.

Endpaper (left) Reprinted by permission of Thomas H. Wirth.

Endpaper (right) Reprinted with the permission of the National Urban League.

ABOUT THE AUTHOR

Dr. Steven Watson is an independent scholar and curator interested in the group dynamics of the twentieth-century avant-garde. He is the author of *Strange Bedfellows: The First American Avant-Garde.*

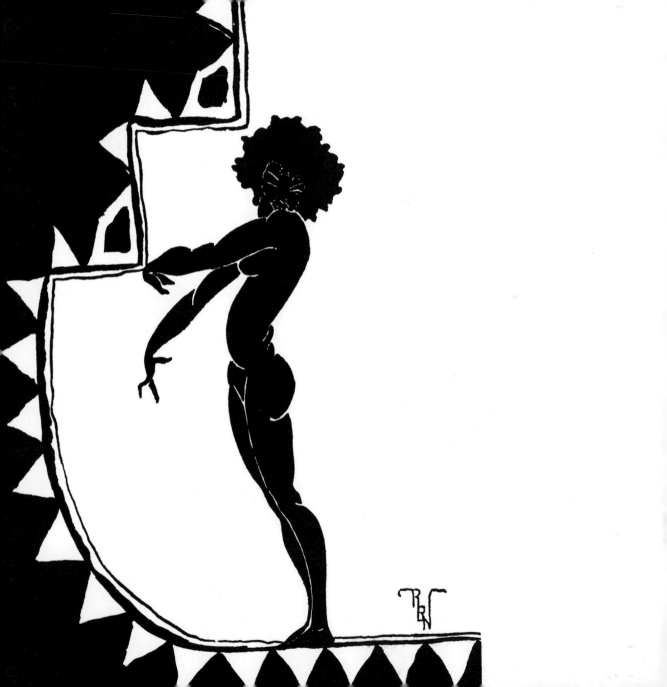